SCOTTISH KIRKYARDS

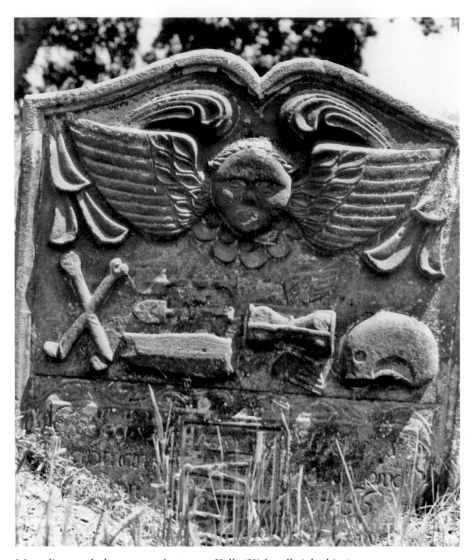

Mortality symbols on a tombstone at Kells (Kirkcudbrightshire)

SCOTTISH KIRKYARDS

DANE LOVE

AMBERLEY

For my parents,
Dane Thomas Love and
Sheila Agnes Boyd Love

First published 1989

Amberley Publishing Plc
Cirencester Road, Chalford,
Stroud, Gloucestershire, GL6 8PE

www.amberley-books.com

British Library Cataloguing in Publication Data.
A catalogue record for this book is available from the British Library.

ISBN 978 1 84868 700 4

Typeset in 10pt on 12pt Sabon.
Typesetting and Origination by FONTHILLDESIGN.
Printed in the UK.

CONTENTS

Dane Love is the author of numerous books on Scotland in general and on Ayrshire in particular, where he lives with his wife and two children. He is descended from Robin Love, who fought for Bonnie Prince Charlie at the battles of Prestonpans and Culloden. He is the Honorary Secretary of the Scottish Covenanter Memorials Association and a Fellow of the Society of Antiquaries of Scotland. Dane Love is the author of *Scottish Covenanter Stories, The Man Who Sold Nelson's Column* – a collection of Scottish frauds and hoaxes, *Scottish Ghosts, Jacobite Stories*, as well as various books on Ayrshire places and history.

www.dane-love.co.uk

By the same author:

The History of Auchinleck – Village & Parish
Pictorial History of Cumnock
Pictorial History of Ayr
Scottish Ghosts
The Auld Inns of Scotland
Guide to Scottish Castles
Tales of the Clan Chiefs
Scottish Covenanter Stories
Ayr Stories
Ayrshire Coast
Scottish Spectres
Ayrshire: Discovering a County
Ayr Past and Present
Lost Ayrshire
The River Ayr Way
Ayr – the Way We Were
The Man Who Sold Nelson's Column
Jacobite Stories
The History of Sorn – Village & Parish
Legendary Ayrshire
The Covenanter Encyclopaedia

ILLUSTRATIONS

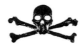

INTRODUCTION

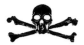

The kirkyards of Scotland have attracted my attention for many years. As a young boy I had to pass an old graveyard on my way from home to school, and hardly a day went by when my friend Brian Alexander and I were not to be found within it, exploring the old tombstones. There was a small headstone on whose back were carved a skull and cross-bones, giving us visions of pirates on the high seas; a railed-off enclosure with a large memorial to a banker had us wondering whether any money would be buried with him, and we thought we had made an amazing discovery when we found a headstone to 'Robert Burns' – when our teachers and parents eventually convinced us that Burns was buried at Dumfries, we decided that it must certainly commemorate some relation of his. The graveyard was up the brae from the school a bit, on the opposite side of the road, and it was fortunate that the school bell was within earshot, for many a morning had us dashing down the brae after the bell had rung, to line up with the rest of the class.

Our teacher must have discovered that kirkyards interested us, for on a couple of warm summer afternoons, our schoolwork duly completed, the whole class went to the graveyard armed with sheets of newsprint and jotters, pencils and crayons, with the intention of finding something of interest. Those inscriptions recording child deaths or men of war were copied into our books, and we made rubbings of interesting patterns on the stones, newsprint and crayon being a cheap rubbing kit. One boy discovered a stone to his nineteenth century ancestors, with his name and that of his farm. It all did wonders to kindle youthful spirits and fire the imagination, and I have been going to kirkyards ever since, noting graves of interest and studying the carvings on the memorials.

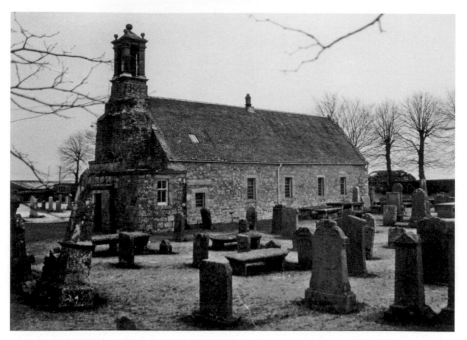

The old kirk of Pettinain (Lanarkshire). The large upper lintel over the small square window is in fact a fourteenth century floral cross slab

In the Victorian era virtually every local history or district guide-book listed tombstones which tourists in that area should not miss, memorials with inscriptions which were worth reading, or the graves of folk who were noted in some way during their life. Then, for many years, kirkyards were ignored, left overgrown with ivy and long grass, and even those cemeteries still in use were frequented by mourners and no one else. Now the tide is again turning: the kirkyard is again being appreciated as a place full of history, a garden of peace within large towns or cities, and tourist leaflets and guides are yet again beginning to list tombstones and monuments in the district.

The change is still taking place, however, for many towns with excellent kirkyards have yet to realize that they contain a considerable amount of tourist potential within them, something that should be made more presentable and credit-worthy of the town. In many cases local people do not appreciate just what a fund of unusual memorials exists within their town, assuming that only those towns which have many historical buildings surviving have anything of historical interest within their kirkyards. In other cases it is the councils or cemetery-owners which fail to maintain the kirkyards in a presentable state. Much should be done to create a greater awareness of our kirkyard heritage, and this book hopes

to do that to some extent, but a considerable amount of re-educating is required in many areas to start the ball rolling.

It is often surprising to many people to discover how many folk visit kirkyards for various reasons. Naturalists find them a wonderful source of plant life, for the topsoil and turf in kirkyards have never been disturbed to any great extent for centuries, so that rare meadow plants, usually killed off by intensive ploughing and reseeding, survive in these acres of sanctuary. Old tombstones, usually made from local stone, are home to innumerable lichens, their colour in evening sunlight a wonder to the eye. Many such fungal growths are as old as the stone itself, perhaps up to 300 years old, and still spreading at a pace even slower than the snail which may journey up and down a tombstone within an hour. Animal life in kirkyards is also surprisingly common, from birds to tree-mammals such as squirrels to rabbits, which are seen scuttling back and forth in many burial places.

Genealogists, too, are frequenters of kirkyards. On many occasions I have met people who are searching for their ancestors. Probably they are returning from some distant part of the world to which their forebears emigrated, in many cases only a generation ago, but it is still the same thing which draws them to the kirkyards. They note down inscriptions bearing the same surname as their own, listing dates of deaths and ages, and once back home they will sit for hours and piece together each fragment of information, building up a tree of descent.

Kirkyards welcome all sorts of people. Some are just curious, perhaps on holiday and happening to pass a quiet burial ground to which they are drawn; others find kirkyards a place where the character of an area can be found in a single acre; local historians find them a place of never-ending inspiration, for a tombstone might reveal a person's occupation, cause of death or dwelling-place, leading the researcher to study old newspapers and records to find out more about each case.

Surveys of kirkyards have been carried out over a long period of time and by different groups or individuals for various reasons. The Scottish Genealogical Society is in the process of listing inscriptions from every gravestone which predates 1855 (the year of compulsory birth, marriage and death registration) in order to simplify ancestral research and preserve facts on stones which are liable to be lost, through either vandalism or erosion. The Church of the Latter Day Saints is undertaking similar research, and in some areas workers from employment creation agencies have undertaken kirkyard surveys, recording inscriptions and unusual tombstones. In some parishes a pure labour of love has resulted in every inscription being noted in full, an example being the parish of Dailly (Ayrshire), where David Hunter has copied every inscription from the

old kirkyard into a large book which he has found most useful on many occasions, answering queries he receives from abroad and furthering his own local research.

All this research and recording is important for two reasons. One is that the inscriptions on many tombstones become illegible over a period of time, due to the weather, and they contain information on birth and death dates from a time prior to compulsory registration (before 1855). The second reason is that a number of kirkyards and old cemeteries are susceptible to vandalism. Should a headstone be toppled, it can be re-erected (if the owner is known and can afford it), but if a memorial stone is broken as a result, the descendant (if any) often has no interest in causing its re-erection, particularly if he did not know those commemorated on the stone. In these cases the local authorities, who are responsible for the upkeep of most kirkyards, usually have the broken stone removed, or else shifted to a corner of the kirkyard where old stones are buried. It is surprising to note how many old tombstones have become edging kerbs for paths within the cemetery, or are incorporated in the cemetery wall. This 'tidying' of kirkyards rids us of many important memorials, stones which can never be replaced, for the cost in carving copies or replacements of many fine old tombstone sculptures would today be prohibitive.

Modern historians look back in bewilderment and anger at the folk of last century and earlier who defaced ancient memorials either by breaking them up to build stone dikes or by so altering them that their original quality is defaced. Examples include the Pictish symbol stones, many of which are broken and built into church walls (one of them, at Abdie in Fife, was altered to take a sun-dial), and the early Christian crosses of Whithorn, used for many years as gate-posts. Should the historian of the future be allowed to look back to the present time and berate us for allowing carvings of the sixteenth to eighteenth centuries to become neglected and destroyed? A national register of important tombstones is urgently needed, one which will list every single stone of importance, either for its carvings or for its historical significance. This could be undertaken by groups like Historic Scotland or the Royal Commission on Ancient and Historic Monuments of Scotland, who already list important buildings and earlier carvings, or else by a similar board for tombstones. Some memorials are already looked after by different organizations – many graves of Burns' friends and associates have been replaced or restored by Burns clubs from all over the world; in the same way the graves of Covenanters are maintained by the Scottish Covenanter Memorials Association – but a larger and better-funded organization is required for historic tombstones in general.

Peden's gravestone, Cumnock (Ayrshire)

Charles Rogers, in *Scottish Monuments and Tombstones*, hoped that his books would '... awaken public attention to the degraded condition of country churchyards'. His two volumes are not recent publications – they date from 1871 and 1872, so the problem of kirkyard maintenance is not a modern one. Rogers' books may have helped make certain members of society more aware of their kirkyard heritage, and to assist in their preservation. Hopefully the present volume will be instrumental in awakening the attention of the public of the present time, almost 140 years after Rogers' plea.

Dane Love
Auchinleck

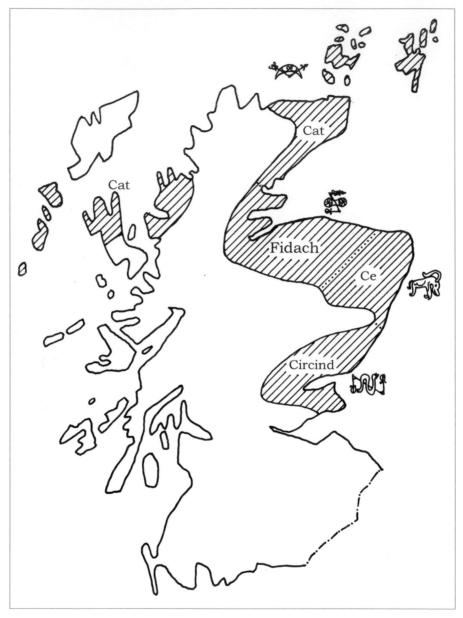

Distribution of Pictish symbol stones, with the symbols which may have belonged to the chiefs of particular regions

1
EARLY TIMES

Since death is one of the most significant parts of a person's 'life', ever since the beginning of time man has made much of his burial customs.

Stone Age men (living before about 4000 BC), who raised extensive and elaborate stone buildings, such as those at Skara Brae in Orkney, also built stone edifices in which to bury their dead. These were the chambered cairns, stone structures composed of slabs of rock positioned in a rectangular fashion so as to create a chamber, with a narrow passageway leading into it, piled over with a loose covering of boulders and stones. The passageways were usually blocked off by tight-fitting slabs, which were removed as required, for these cairns were used to bury several bodies, each community or family having one of their own, extending many of them over centuries of use. At a number of sites the stone mound has been plundered as a source of building-material, leaving intact only the actual chamber, usually because it was composed of rocks too heavy for the farmers to remove. The remaining stones are known as cists – within the cemetery of Largs (Ayrshire) one has been re-erected from elsewhere in the parish.

The men of the Bronze Age (c. 4000-1200 BC) also built cairns in which to bury their dead, but in their case these mounds of stone were less elaborate than the Palaeolithic equivalent, containing not chambers but a beaker, or earthenware pot, in which the cremated ashes of the dead chief were placed. Sometimes a funeral fire was raised on the spot beforehand, cremating the corpse, and once the flames had subsided, a heap of stones or earth was raised over it and the beaker. In a number of cases, however, the bodies were not cremated initially, being simply buried beneath the mound.

Stone and earthen henges were also used for burials at times. These constructions, which comprised a circular ditch or two enclosing a circle of stones or even wooden stakes, were used for sun-worship, arranged so that they could predict solstices. At some henges cremated remains have been discovered during excavations. These are rare, as are the enclosed cremation cemeteries, circular earthen banks enclosing areas used for depositing the ashes of the dead.

The missionaries who introduced Christianity to Scotland from the fourth century AD onward went about it in a logical fashion, one which would cause the least disruption to the pagan worshippers. They slowly introduced the new God as a replacement for the pagan idols, gradually phasing out the old forms of worship. Patrick, Bishop of the Hebrides, is known to have told Orlygus, one of his missionaries, to travel across Scotland and build a church wherever he found standing stones or stone circles.

Kirkyards and kirks occupying prehistoric sites must number in the hundreds or thousands, although in most cases nothing visible of the ancient memorials survives. Ancient sites can still be identified by a number of pointers, one being the fact that the oldest burial grounds were usually circular or elliptical in plan. This may be due to their occupying some prehistoric site which was itself circular in plan or to their being marked out with a length of rope centred on a standing stone or burial mound. Some of the small parish kirkyards throughout Scotland still retain this circular shape – for example, those at Tulliebole (Kinross-shire), Lamington (Lanarkshire) and Urr (Kirkcudbright), the latter being elliptical.

Another means of identifying an ancient site is by plotting ley-lines, the imaginary lines which join together sites of antiquity, first discovered in the 1920s by Alfred Watkins. Should two or more lines cross within a church building or within a kirkyard, this is a good pointer to the site's antiquity, indicating that some ancient edifice stood there prior to the present church. Watkins plotted hundreds of leys all over Britain, discovering that in some English counties virtually every parish church had been built according to these lines.

There are some kirkyards throughout Scotland in which standing stones can still be seen, such as Strathblane, Balfour (near Laurencekirk) and Cardross. Occasionally complete stone circles may be found, such as that in the kirkyard of Midmar in Aberdeenshire, in which the circle comprises seven menhirs and one recumbent. This was not the original site of the kirk: its predecessor stands in ruins half a mile to the south; when, in 1787, a new kirk was to be erected, the ground adjacent to the circle was thought more suitable. Aberdeenshire contains the most known references connecting kirk sites with stone circles, others being known to have existed at Daviot, Culsalmond and Fetterangus, and there are a couple of places

within the county where a stone circle which survives is known locally as 'the auld kirk' – perhaps, as is suggested by Nigel Tranter in *The Eastern Counties,* because the ancient missionaries used the pagan worship sites for Christian services until such time as a church could be built.

Other ancient monuments which became the site of latter kirks and kirkyards include Iron Age (post-1200 BC) forts (as in Skirling in Peeblesshire and Inverurie in Aberdeenshire), Norman Mottes (Tweedsmuir in Peeblesshire and Kildrummy in Aberdeenshire), burial cairns (Biallaid, near Newtonmore in Inverness-shire), souterrains (Pictish earth-houses – Arbroath, Angus) and cup-and-ring marked rocks (unexplained Bronze Age carvings – Cill Chiarain on Islay and Barevan near Nairn).

In some places the Christians altered pagan memorials slightly so that they suited their form of worship, yet let the pagans continue much as before, except that they were now worshipping the real God. In the sixth century the two standing stones of Laggangairn (Wigtownshire) were inscribed with Christian crosses.

Affected in the same way, to some extent, were the Pictish symbol stones, the earliest examples containing solely Pictish emblems, such as the mirror and comb, 'elephant' crescents, V-rod and Z-rod. As Christianity was introduced, emblems common to both cultures were found on the same stone, usually a Christian cross, complete with Celtic knotwork, around which are found the Pictish symbols. Some of these stones have the Pictish and Christian symbols on opposite sides. Later, as the Pictish symbols were

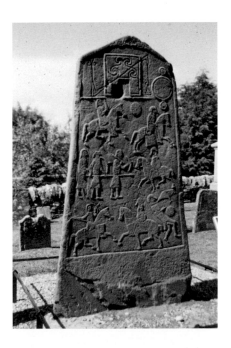

Pictish symbols on a headstone at Aberlemno (Angus)

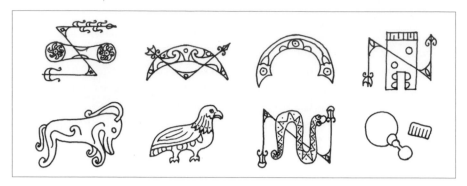

The most common symbols found on Pictish carved stones

suppressed, the memorials comprised slabs with ornate Christian crosses and, in most cases, equestrian soldiers. These three stages of development have been divided into three classes, Class I being those stones containing purely Pictish symbols, Class II those stones bearing both Christian crosses and Pictish symbols, while Class III stones are usually crosses or cross-slabs on which horsemen appear. In many kirkyards of the east coast (from Fife north to Orkney) these Pictish stones can still be seen, in some cases, as at St Vigeans (Arbroath) and Aberlemno (both Angus), protected as Ancient Monuments.

There has been some doubt as to whether these stones are in fact grave-markers, for in most cases no burial is associated with them. The symbols are thought to represent families and the alliances made between them, important in a matrilineal culture; hence the symbols usually appear in groups of pairs. When a mirror and/or comb are present, they are believed to represent bridewealth, the giving of gifts to the family who supplied the bride. The four main kingdoms of the Picts are thought to have had the crescent and V-rod, serpent and Z-rod, double disc and Z-rod and 'elephant' as symbols of the kingly line, perhaps equivalent to modern heraldry.

Christianity is believed to have reached Scotland in AD 397, when St Ninian landed at Whithorn, although there are theories that there were Christians in the country already and that Ninian arrived as a result of their calling. He built the first stone church in Scotland at Whithorn, using lime-mortared stones covered in plaster – hence its name, 'the white house'. The foundations of this building were discovered during excavations around the small cathedral in the village, making it the most important place of Christian pilgrimage in Scotland. Here is preserved the oldest Christian memorial in existence in Scotland, the Latinus stone, so called because the inscription states that Barrovadus had it erected in memory of his grandfather, Latinus,

and a daughter. It dates from the middle of the fifth century, indicating that Latinus was a near contemporary of Ninian himself. Many other early Christian stones are protected in a museum there and are worth seeing.

Like many of the early missionaries, Ninian established himself a cave as a place of refuge where he could study Christ's works alone. The remains of his cave are found on the coast to the south of Whithorn, carved Christian crosses still discernible on the rock face. Across Luce Bay from Ninian's Cave is another example, known locally as 'the Old Chapel at the Mull' (of Galloway), reputedly occupied by Medana, a female Irish saint. A number of other caves survive throughout Scotland, many, like Ninian's, containing inscribed crosses on the walls. These include Eilean Mor MacCormaig (Argyll), the refuge of St Abban, the caves of Wemyss (Fife) and An Uaimh Shiante ('the holy cave') on Loch Torridon.

Early missionaries and saints who journeyed across parts of Scotland where there were no caves improvised to a certain extent. They built cells for themselves – that is, semi-subterranean vaults in which they spent much of their time meditating. These cells were known as *cilles* by the Gaels, hence the common prefix 'Kil' in many Scottish parish names, usually followed by a saint's name or a corruption thereof. In a number of cases, however, 'Kil' is just a diminution of 'kirk'. These *cilles* survive in many locations, mainly on the more remote western islands and seaboard, although remnants of others can be seen on the mainland lowlands and uplands. In an example of the latter, at Broughton in Peeblesshire, the cell, founded in the seventh century by St Llolan, has been restored. It is a barrel-vaulted chamber, covered with turf, entered by a modern doorway, the key for which is available from a shop in the village. Another cell survives on Inchcolm, in the Firth of Forth, reputedly occupied by a Culdean hermit who befriended King Alexander I (reigned 1107–24) when his ship had to anchor there in a storm. On Eileach an Naoimh ('Island of the Saints'), the second largest Garbh-eileach island, there is another, and also an early Christian monastery, surely one of the most remotely established, built on the spot where the sixth century Eithne, the mother of St Columba, is believed to be buried.

Mention of islands brings to mind the fact that many ancient burial grounds were established on small islets, in the sea or freshwater lochs. These are most commonly found within the Western Highlands but can also be found all over Scotland, on either river islands or estuary islets. A few of these island graveyards are still in use to this day, although burial within them is now rare, many being virtually covered in graves. Some of those islands which have long since become disused contain no, or comparatively few, modern-type headstones, being covered instead in unhewn and uninscribed slabs or pillars. It is often worth taking an

The graveyard on Innis Buidhe, Killin (Perthshire)

inflatable boat to travel to some of the islands, although care should obviously be taken in sea waters, with their dangerous tides and currents. A couple of islands, however, such as Eilean Tioram at the head of Loch Nevis, are connected to the mainland by a bar of sand or salt flats.

There are some clans which have for centuries buried their chiefs on islands, notable examples being the MacDonalds of Glencoe, who were interred on Eilean Munde, off the shores of Ballachulish, the MacGregors, who were buried on Innis Cailleach in Loch Lomond, and the MacNabs, who lie on Innis Buidhe, an island in the river at Killin.

This island-burying habit may stem from royal example, for the kings and queens of Scotland were for centuries laid to rest on the island of Iona. The 'Iona Boat Song' is a slow dirge sung to a tune believed to originate from the years when the monks took the dead across the Sound of Iona to their place of rest. According to tradition, forty Scottish kings are buried there, as well as two Irish monarchs and a French king. The last monarchs to be interred on the island were King Duncan I, slain in 1040 by Macbeth, and the assassin also, who succeeded him as king, himself killed in 1057 at Lumphanan.

The traditions and beliefs of the pagans were slow to die out, remaining in use for many years after Christianity had been established. In a number

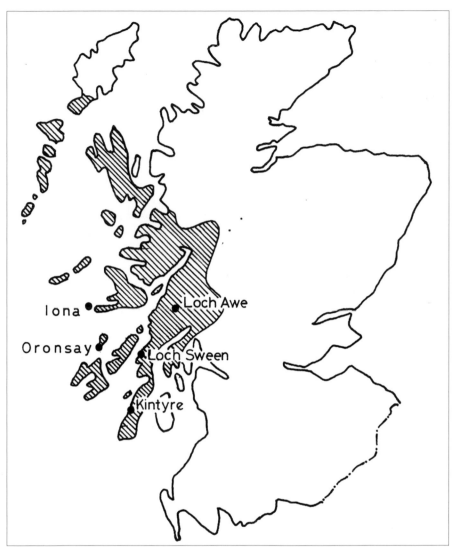

Distribution of West Highland graveslabs and associated carvings, showing the five main centres

of cases the original pagan beliefs behind these traditions had long since been forgotten, but they still remained anathema to the clerics of the new Church. One of the longest surviving pagan services was that of Beltane, from the Gaelic *Bealltainn*, held on the first day of May. Originally Beltane was a fire-worshipping ceremony, but the Christian apostles persuaded the Celts to alter it to a thanksgiving to God for supplying such great elements as the sun, this being the beginning of the growing season in earnest. As the years passed, there were attempts to phase out what must have

degenerated to 'sun-worshipping', but even as late as 1598 on the first day of May the parishioners of Drumelzier in Peeblesshire built bonfires on the summits of local hills – for which they were called to the kirk session and put on trial. Backward children were submerged in a pool at St Medan's cave (Old Chapel at the Mull, Wigtownshire) at Beltane, in the belief that it would cure them of their 'simpleness'.

Some kirkyards contain burial-markers which date from Viking times (the ninth and tenth centuries), these being the distinctive 'hogback' stones, slabs which have a raised centre, like a roof, the ridge curved slightly and the roof comparison emphasized by the fact that many are tegulated along the sides – that is, carved to look like slates or shingles. Indeed, it was Viking houses that these stones were based on, some gables even having the beams carved on them, although none of this type survives in Scotland. Hogbacks were first introduced to the British Isles in Yorkshire, where a number survive, but the use of them died out in England long before it did north of the border. Scottish hogbacks are commonly found in the east central Lowlands, although the largest single collection of them, five examples, was located in Govan kirkyard, now moved to within the kirk. The stones all date from between the middle of the tenth century to the early twelfth century. As well as tegulations, they sometimes include Christian crosses (the later examples), ornate latticework or wild beasts, the early examples looking like muzzled bears, the later more dragon-like.

Although the kirk at Govan is not regularly open to the public, it is worth arranging access to see the collection of ancient stones there, which also includes cross shafts and a stone sarcophagus, claimed to have belonged to St Constantine, king and martyr who died c. 576 AD. All the hogbacks are

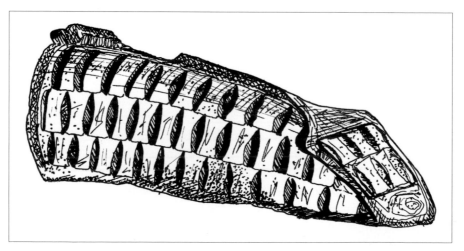

Hogback tombstone, now in Meigle museum (Perthshire)

carved from sandstone blocks, and each measures over six feet in length. Originally they may have had crosses or marker stones at the head and foot of the grave, as early accounts of other examples remark; a hogback which survives at Papa Westray in the Orkney Isles retains one of these markers in place.

In the western Highlands and islands groups of masons produced memorials of a distinctive style: wheel crosses, cross slabs and ornately carved graveslabs. These slabs were more advanced, as far as carving went, than the contemporary grave-markers to be found in the rest of Scotland. The best of stone seems to have been used where possible, meaning that these memorials have survived in pristine condition in many instances, although some have suffered badly. The main centres ('schools') of production of these stones were on Iona, centred on the abbey, Oronsay (the priory), Kintyre (perhaps Saddell Abbey) Loch Sween (Keills chapel) and Loch Awe (perhaps centred around Inishail). There is a theory that the Loch Awe school of carvers were itinerant, for their work is found on a variety of stone types, indicating that they probably selected their slabs from near where they were to be erected. Each school produced a distinctive type of carving and, as the areas they served overlap considerably, it is presumed that they were not all contemporary. The stone crosses are very grand and are often to be found in the most unlikely locations, on sites which today are far from habitation but which in the days of their erection were probably populous. The carvings on these crosses include scenes from biblical sources, including the crucifixion of Christ, the fine cross known as MacMillan's Cross at Kilmory in Knapdale having one of the clearest examples. Common to many are the intertwined foliate patterns, the leaves taking distinctive shapes. Celtic knotwork is found in panels, and others contain animals of the Highlands. The cross at Kilmory also has a most spectacular hunting scene on it, showing the hunter with his axe and hunting horn, with three dogs pursuing a stag.

Graveslabs contain much the same sort of carvings, although claymores are more common on these, usually surrounded by leafy vines and animals and in some cases with a detailed West Highland style of galleon at their foot. These slabs are usually tapered, being narrower at the foot than the head, and one is in the form of an irregular octagon. Some memorials contain inscriptions, and these often assist in dating the stones, for if they do not tell us outright when they were erected, the style of lettering can often be a pointer. Prior to 1500, Lombardic capitals were used, and after 1500 the Black Letter style of writing was adopted. The sorts of persons commemorated by these memorials tend to be of the medieval upper classes: clan chieftains and their immediate families, clergymen or craftsmen who were held in high regard.

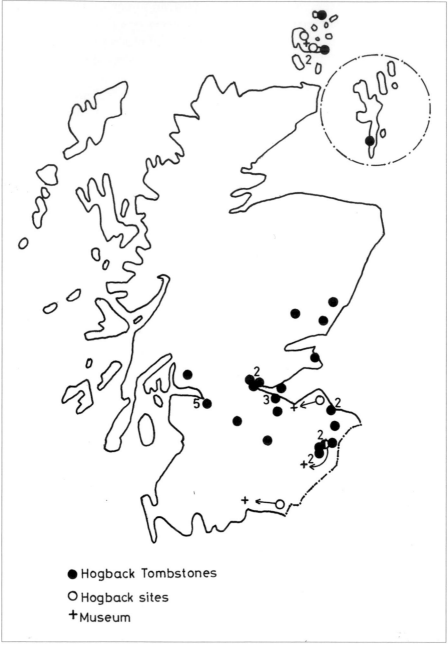

Distribution of hogback tombstones in Scotland. Figures refer to number of stones at each site

Some of the West Highland memorials contain effigies or incised carvings depicting the deceased, giving a detailed description of what the better-off folk of the time wore. Knights are shown in their long pleated tunic (aketon), their shoulders covered with chainmail, their heads sporting a bascinet (a pointed steel helmet). In their hands they hold shields charged with heraldry, and longswords, which may be hanging from a belt. In Iona Abbey is an effigy of Abbot John MacKinnon, showing him wearing his full Mass vestments, the Lombardic inscription having been carved prior to his death, for the date when he died (1500) has never been added.

It is even known in a few cases who the masons who carved such stones were, for on the MacDuffie Cross at Oronsay Priory a Latin inscription states that 'Mael-sechlainn O' Cuinn, mason' made it. Many of the slabs and carved stones have been obtained from a single quarry, located at Doide on the shores of Loch Sween, from where they were shipped to various points on the west coast for erection; one is even known to have been taken to Ireland. Historic Scotland has gathered together some of the better examples of West Highland graveslabs and placed them in protective shelters (lapidariums) at various kirkyards throughout the area, ensuring that the stones do not become more eroded or lost among overgrown grass. These collections, and others of similar merit, are to be found at Kilmartin, Kilmory, Inchkenneth, Kilberry and Glendaruel.

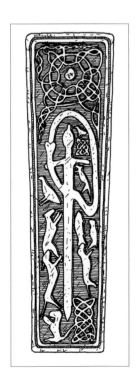

West Highland graveslab from Oronsay priory (Argyll) with Celtic knotwork, claymore, serpent, hounds chasing a fox, gamebird and salmon

The rest of Scotland's contemporary graveslabs are not as ornate as the West Highland variety, although there are a few isolated examples which are quite similar. Some are just slabs with Black Letter inscriptions around the periphery; others contain incised carvings of knights or other figures. The medieval period produced many fine sculptured effigies, however, and it is these which are the most noted relics of the period.

Medieval graveslabs in the rest of Scotland tend to be rather rare, occurring only in single, remote examples in many cases, though many have no doubt been lost below the turf or else are so badly worn as to be illegible. The slabs occur in two distinct types, the Calvary cross slabs, which are stones on which are carved distinctive crosses, and the Black Letter slabs, which simply contain inscriptions.

Calvary cross slabs, to be found all over Scotland, contain a Latin cross whose shaft rises from a stepped base, rather like a simple market cross. This base can in some instances have symbols of death, such as the skull and crossed bones, carved within. A longsword may be incised within the shaft, or in some cases placed to one side. A number of these stones contain simple heraldry, indicating to which family the memorials may have been erected, for in most cases they have no inscription; in those examples which do, it is usually very difficult to read. These cross slabs usually date from the latter part of the medieval period, from about 1400 to the time of the Reformation. Within the church hall at Urquhart, in Moray, there is an unusual example of this type of memorial which measures only twenty-five inches by eleven inches and which probably came from a child's grave.

A variation on the Calvary cross slab is the floral cross, a slender shaft from a rectangular base which has a cross head formed in a foliate style. These cross slabs probably predate the proper Calvary cross slabs, for they are a more primitive version of it and do not usually contain any inscriptions.

Black Letter slabs are so called from the style of lettering used on them, a sort of elongated Old English which, when worn, can be difficult to read. The inscriptions normally begin at the head of the stone and continue down the long side, across the bottom and back up the other side, continuing in a second spiral if necessary, although this is usually restricted to another line at the head. In the centre may be found a shield, in many cases bare of heraldry but having initials and date. These slabs generally date from the beginning of the fifteenth century also, but they remained popular for longer than the Calvary cross variety, one restored example in Irvine (Ayrshire) churchyard dating from 1596 and commemorating 'ANE HONORABLE MAN IHON PEBLIS OF BROVMLANDIS, PROVOST OF IRVINE'.

A slab from a similar period, but with a different style of lettering, was discovered in Hawick kirkyard and reads: 'HEIR LYIS ANE HONEST MAN IOHNE DEINIS QVHA VAS TENENT KYNDLIE OF HAVIK MILN AND SLAIN IN DEBAIT OF HIS NIGHTBOVRIS GEIR THE ZEIR OF GOD MDXCVI'. This example is something of a transition piece, being more like the slabs of the seventeenth century as far as lettering goes, although it is bare of the incised death or trade symbols, which were still to become popular.

Slabs with incised figures of knights also date from the medieval period, and a number of these survive. They usually have a peripheral inscription, written with Gothic-style letters, and often contain heraldry. The figures carved onto these slabs can often given a good indication of the sort of armour worn by the knight of the time, although some are more accurate than others, a slab within Stobo kirk in Peeblesshire looking rather cartoonish, yet still retaining the normal hands-clasped-in-prayer pose, the face-on position, with his claymore to one side; it has been dated to around

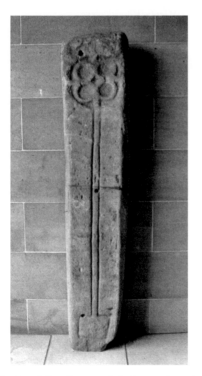

Left: Medieval floral cross slab, located in the porch of the kirk at Biggar (Lanarkshire). This probably dates from the fourteenth century

Right: Calvary cross slab showing stepped cross and claymore, located in wall at Coldingham priory (Berwickshire)

1525. A far superior example is that at Kinkell church, near Inverurie, which marks the grave of Sir Gilbert de Greenlaw, a knight who fell at the Battle of Harlaw in 1411. It depicts Greenlaw in a knight's battle-dress; by his left arm is his longsword, to the right a dirk. The stone also shows the use of Greenlaw's arms on his armour, the hunting horn and other objects chiselled faintly on his breastplate, echoing the shield above. Around the stone, the bottom half of which is broken, is a legible inscription, retaining the date.

Memorial slabs were originally designed as covers for the stone coffins (sarcophagi, plural of sarcophagus) which were common among the upper classes during the early medieval and Norman years. These stone coffins were buried in the ground, usually within the kirk building, and the slab, or lid, was placed over them, breaking the surface so as to be visible. Hundreds of these sarcophagi must survive buried beneath old kirk ruins, and the few which have been unearthed, often during alterations to church buildings, are usually kept above ground. Most sarcophagi were carved from a single block of rock and measure externally about seven feet by two feet. Some are divided into two compartments, usually a long rectangular section for the body and an adjoining circular part for the head.

One of the most important forms of medieval memorial was the canopy tomb, an ornate recess which often contained at least one effigy, depicting the deceased. These were usually located within the church building itself, sometimes in an adjacent aisle, but, with many old kirks becoming ruinous, these monuments can today be found open to the elements in some graveyards. By far the most common sort of personage commemorated by such memorials was the local laird, usually someone with a significant title, although town provosts and clerics are also commemorated. Some tombs also contain effigies of the deceased's spouse, depicted lying with him.

Following the Reformation, when burial within the church building itself became illegal, separate burial aisles were often erected adjoining the church, or else a separate mausoleum elsewhere in the kirkyard, so that some effigies are post-Reformation in date. The earliest surviving figures on tombs date from around the late thirteenth century, and the effigy remained in use, in a much more refined form, until the first half of the eighteenth century. Some effigies would have been painted in bright colours – if not all over, at least on those parts where decoration was more important, such as the shield with its heraldry. No memorials which are found outside retain this paintwork, but there are a few internal, if later, memorials which are brightly coloured, the effigies of white marble, the epitaphs picked out in gold, and the heraldry painstakingly coloured in a most accurate way.

Associated with canopy tombs are the altar-style tombs, which stand away from the walls and which comprise a stone coffin, or sarcophagus, usually richly decorated, whose lid would be removable, so that the corpse could be laid within, and upon this lay the effigy. These were erected mainly within burial aisles.

Most effigies have the deceased dressed in their best clothing, knights in armour, abbots in their ceremonial robes, ladies in their finery, and most are in the act of praying. The sides of altar tombs, and also the fronts of canopy tombs, often contain panels in which are carved small figures, representing the children of the deceased as they were at the time of death – hence larger and smaller figures. Some monuments contain many figures, depending on how many children the deceased had, although the figures on the tomb of 'the Wolf of Badenoch' (d. 1394) in Dunkeld Cathedral represent soldiers under his command.

The carvers of the West Highland School were also responsible for some effigies. Some are built within canopy tombs, like the contemporary Scottish style, placed on pedestal tombs, such as that to Abbot John MacKinnon, mentioned earlier, at Iona Abbey, or else carved to look as though the figure is lying on one of the West Highland-type slabs. Some of the latter may be only three-quarter effigies – not three-quarter length, but three-quarter depth, the sides of the effigy being joined directly to the slab, as opposed to the full effigies, where they turn into a bit of the back and are true to life in girth.

There is a very fine example of a canopy tomb by the West Highland School of Carving at Rodel Church, on the island of Harris. It was erected during the lifetime of the person it commemorates, Alexander MacLeod, (also known as Alasdair Crotach of Dunvegan), as were many memorials of this nature, so that it could gain the purchaser's approval. It justifiably did so, for it is one of the finest examples of stone carving surviving from the sixteenth century, although it is not the effigy which wins the acclaim but the rest of the tomb, which has a number of panels depicting angels, bishops, a hunting scene, the Virgin and Child, ships, castles and the twelve apostles. The tomb was prepared by Lord Alexander MacLeod of Dunvegan in the year 1528, according to the inscription, Alexander surviving until 1547. The stone is known to have been ferried across the Minch from Mull, a distance of at least ninety miles, and the carving was executed on Harris.

One of the finest pairs of early effigies is that on the island of Inchmahome, in the Lake of Menteith, which commemorates the Earl and Countess of Menteith, he dying in 1294. This memorial, although much worn, is still one of the most moving, for it shows the Earl and Countess turned partly to the side, so that they nearly face each other, and the figures

have their inner arms locked over each other's shoulder. The Countess is wearing a long, flowing robe, the Earl a tunic, with a long shield.

A fine selection of old effigies can be seen within the old kirk of St Bride in the village of Douglas, Lanarkshire, now protected as an Ancient Monument. The oldest effigy dates from the thirteenth century and depicts Marjorie Abernethy, wife of the Douglas laird, but this is a much worn example. Another effigy, of a knight, is thought to be that of one of the 'Black' Douglases, known as the 'Good' Sir James, who died in 1330 in the Iberian wars while taking the Bruce's heart to the Holy Land. The effigy of the fifth Earl of Douglas, Sir James's grandson (d. 1439), has beneath it six compartments, five of which contain representations of his children. The Earl, who was known as 'the Great Earl', is wearing a duke's coronet, for he was created Duke of Touraine by Charles VII of France for his services in leading the French army. The seventh Earl's tomb has panels along the front containing small figures, representing his six sons and four daughters, placed either side of the Douglas arms.

Effigies within canopy tombs need not always be lying down: there are some examples where the deceased is represented only by his bust, sometimes along with that of his wife. These tend to appear in later examples, such as that of Archbishop Sharp (d. 1679) in St Andrews, designed by Dutch masons, and those of the Earl and Countess of Glencairn, found at Kilmaurs in Ayrshire. On the latter memorial there are

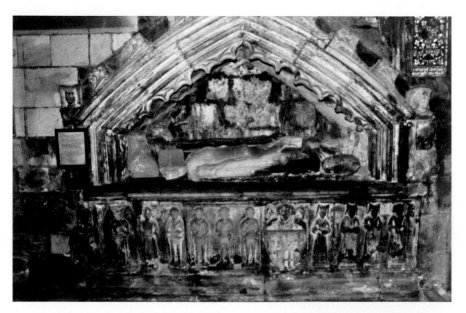

The tomb of the seventh Earl of Douglas in the old kirk of St Bride's, Douglas (Lanarkshire), maintained as an Ancient Monument

also eight lesser figures, representing their offspring, and all ten busts have their hands clasped in prayer.

Scotland has very few medieval brasses, compared with those in England. The reason is simple: the brasses were usually imported from south of the border, and during the years when they were in fashion, relations between the two countries were not favourable. One of the finest surviving examples can be seen in St Giles Kirk in Edinburgh, commemorating the Earl of Moray who was murdered by James Hamilton of Bothwellhaugh in 1570. To either side of the Moray arms are figures representing Religion and Justice. Another brass can be seen in Glasgow Cathedral, commemorating six knights of the house of Minto, dating from 1606, the knight depicted on the brass being without his head.

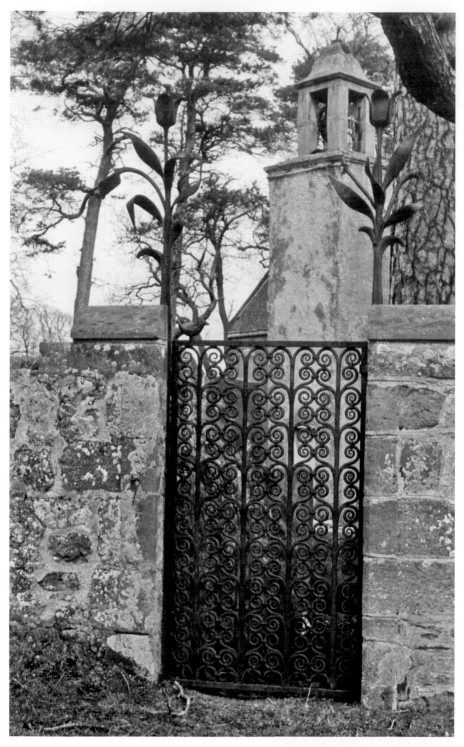

Ornate wrought-iron gate leading to Skirling kirkyard (Peeblesshire)

PLACE OF REST

It is really with the Reformation that our history of the kirkyard begins, for prior to it there was probably little to be seen in most churchyards, since lairds, their close family, ministers and others who could afford it were buried within the church floor; the poorer folk of the parish *were* buried outside, but probably without a memorial stone.

In 1588 the General Assembly of the Church of Scotland issued new rules, making church burial illegal, reinforcing earlier condemnation issued in the Book of Discipline (1560). The practice seems to have been hard to stop, even although the guidelines issued stated that ministers who allowed kirk burial would be suspended from office, for as late as 1643 the General Assembly proclaimed that no one should be buried within that part of the kirk used for hearing God's word. In 1597 the General Assembly had decreed that lairds and noblemen could build for themselves a separate burial aisle adjoining the kirk, for interring themselves and their families. Such mausoleums were slow in coming about, but gradually they became more common, and church burial was gradually suppressed. It took longer to enforce the rules in the Highlands, where even Catholicism was practised well after the Reformation, and at Boleskine (Inverness-shire) in 1684 the minister reported that, '... the floor of the church was oppressive with dead bodies, and unripe bodies had of late been raised out of their graves to give place to others for want of room, which frequently occasions an unwholesome smell in the congregation'.

We must return to the early Middle Ages to witness the creation of parishes, and their relevant kirkyards. Parishes were formed on an ecclesiastical basis, originally being the areas which supported a church, everyone living within a parish's boundaries having to pay the clergy a tax

for the upkeep of the church buildings and payment of the priest. The first recorded parish in Scotland was that of Ednam in Berwickshire, in existence at the beginning of the twelfth century, and most other lowland parishes date from around that time. It was King Edgar (r. 1097-1107) who was responsible for erecting Ednam into a parish, and his brother, Alexander I (r. 1107-24), continued this practice north of the Forth during his reign, while David I (r. 1124-53) probably designated parish boundaries for the rest of Scotland which at that time came under his jurisdiction. Over a thousand parishes were created, the majority in the south and east, for Highland parishes could be as large as 250,000 across (Farr, Sutherland), which is larger than some of the smaller counties.

The feudal system which grew up around these parishes was a well-organized system of land tenure, the laird owning most of the parish, and letting it to vassals, who in turn let it out to sub-tenants. The laird was compelled to provide a church in which his tenants could worship, and the priest's wages were paid by the laird's tenants, or parishioners, in cash, goods or kind, when the men of the parish would work the priest's fields (glebe). After many years it became the custom for the lairds to give the churches to the abbeys and cathedrals, and by the Reformation over eighty-five per cent of parishes had been so presented. The taxes then went to support these religious houses, a tenth part of the parishioners' incomes going to the abbeys to pay for the services of monks and abbots who came to the parishes to preach. The tenth part was known as 'tithe' or, in Scotland more generally, a 'teind'. Every tenth chicken, cheese, lamb, sheaf of corn and pound of butter was handed in to the church, from where it was transferred to the patronal house to support the monks.

The teind paid in grain had to be stored somewhere, resulting in the construction of teind barns near the church. Only two such buildings survive in Scotland, at Whitekirk in East Lothian and at Foulden in Berwickshire, although both are post-Reformation buildings, built by Protestant ministers for storing their glebe produce. Foulden barn, which stands in a corner of the kirkyard, is a well-built edifice of tight-fitting masonry with irregular quoins. It is a double-storeyed barn, the upper floor reached by an external stairway. Maintained by Historic Scotland, only the exterior can at present be viewed. Whitekirk's barn is a larger building, having originally been a sixteenth century tower house which in the seventeenth century was converted to a barn. It also has an external stairway to the first floor but has three storeys in total.

It was the fact that a parish wealth was transferred to the abbeys, making them extremely wealthy, and the abbeys' later abuse of their income that in some way led to the Reformation of 1560, for the abbeys had become rather lax in providing visiting clergy, some parishes were going for weeks

without seeing a monk or priest, though the teinds were still faithfully being collected. The preachings of John Knox and other 'reformers' fired up the people of Scotland to such an extent that a great change in religious practice was brought about, following changes which had swept over much of Europe. In England the process had been swifter, for King Henry VIII had broken away from Rome in order to divorce his queen and, although the king himself was conservative in doctrine and persecuted his Protestant subjects, he could not stem the tide of the Reformation. In Henry's reign (1509-47) the Bible was translated into English by William Tyndale, and soon the Scots were allowed to read it.

The Earls of Glencairn, Argyll and Morton were among the 'First Bond' of Scottish lords determined to overthrow the Church of Rome, in 1557, and within two years the full-blown sweep of 'reformation' struck Scotland: the abbeys and priories were closed down, and in every religious building what were regarded as 'monuments of idolatry' were broken up and destroyed. In a number of cases monuments of great historical significance were destroyed in error, so that on most of the mainland there are very few pre-Reformation monuments. One of the things supposed to be destroyed was the Ruthwell Cross, but the minister at the time only broke it into a number of pieces and had it buried beneath the earthen floor of the church. Many years later, in 1802, Henry Duncan, minister of the parish (and noted as the founder of the savings bank movement) had it uncovered and re-erected in the manse garden, restoring it to its former glory. The cross has since been erected within the kirk building itself, in a specially built apse on its northern side.

Little survives hale from pre-Reformation times, anything that does so remaining by sheer luck. Such an example was Glasgow Cathedral, supposed to have been destroyed but which was saved simply because the parishioners campaigned to keep it until such time as a new place of worship could be erected for the city. Fortunately this took many years to organize, and when a new kirk *was* finally erected, the more enlightened authorities realized that the old building was worth keeping. There also survive a number of pre-Reformation chapels, because they had become disused prior to the Reformation, so they were not destroyed by the reformers. In other cases only aisles of kirks were kept, because they were the burial-place of lairds and their family; many such examples can be seen throughout Scotland.

The first stones of the modern style appeared in the latter part of the sixteenth century. With kirkyard burial becoming the norm, they soon filled up to such an extent that further land had to be obtained in some parishes. In a few cases the laird would not sell any of his land for such a purpose, so ground had to be obtained by other means. In Dundee, in

1564, Queen Mary gifted to the town the former garden of the Greyfriars' monastery as a burial place; later it became known as 'the Howff'. The Queen also granted Edinburgh's citizens the use of the *'zaird'* of Greyfriars for burial, as the kirkyard of St Giles was full, and in Perth Greyfriars kirkyard had the same origin.

Churchyards were not always surrounded by walls, as would today appear to be the norm. In many parishes there seems to have been no definable extent of the kirkyard, and session records often noted with disgust that the kirkyards were overrun with cattle or sheep. In a number of cases it fell to local benefactors to have walls erected around the churchyard, as a stone in the wall of the kirkyard at Deskford (Banffshire) indicated:

> Hic jacet Joannes Anderson, Aberdoniensis,
> Who built this churchyard dike at his own expenses.

Other parishes had walls erected by such benefactors, but when the kirk session in Cumnock hoped to have a new wall erected around the old graveyard, a celebrated wit, Hugh Logan of Logan, who sat on the board, claimed that on his estate new walls were erected only should there be complaints from the tenants!

Over the years since the Reformation Scotland has evolved a fairly standard way of setting out a parish kirkyard. There are certain places for burial which were laid aside for particular people, and tombstones would generally be positioned in a precise way. A person's status to some extent dictated where he was buried, for some parts of the kirkyard had more prestige than others. The laird had first choice in picking his burial plots, and the parishioners in order of descent from him chose thereafter.

Ministers tend to be buried in a specific area of the kirkyard, so that today a row of memorial stones to the clergy is often to be seen, sometimes located along one wall of the kirkyard or along one side of the church building itself. Free Church and other denominations' ministers were sometimes interred in a separate group. Some churchyards have stones listing all ministers of the parish between certain dates, usually from the Reformation until a new kirk was built, the stone often being built into the new church wall.

In the early years burial plots were undesignated, and many an argument between different families ensued over who owned which plot. In later years these differences were resolved by the formation of plans of the kirkyard, each plot being numbered and designated by measurement from the church or kirkyard walls, trees or other objects noted in the plans. There are many stones in kirkyards to be seen with a note inscribed upon them,

usually along the top edge, stating something like 'GROUND 9 FEET BY
7'. Some go further, like a headstone in Kirkmichael kirkyard (Ayrshire)
whose inscription begins: 'This Burial Ground consists of three breadths
and two lengths. It extends a breadth on each side and two lengths to the
east of this Stone which is erected to the memory of John Greig, late in
Carston, who departed this life December the 16th 1797 aged seventy one
years.' In a similar way some tombstones are particular in stating the exact
spot where the corpse lies, as on a stone at Cuminestown, or Monquhitter
(Aberdeenshire), which was erected to James Faith:

 '... part of whom lies under and on each side of this stone'.

Most plots were planned to run in length on an east-west axis, the
headstone or other memorial usually being placed at the west end. This
was because it was thought that the Lord's second coming would be from
the east, renewing in the way the rising sun does, and the corpses were
laid feet eastwards so that they were facing in the groper direction to greet
Him. As a mark of disrespect to suicide cases or felons, they were often
buried the wrong way round in the kirkyard (if they merited churchyard
burial at all – often they would be buried outside the churchyard gate or
in a field), or in some cases on a north-south axis. The direction in which
a stone faces does not always indicate that the person was an outcast,
however, for in some parts of Scotland, in particular the north, the east-
west tradition does not seem to have held, and in various periods such
customs were unheard of. In any case, most suicides and murderers did
not merit stones.

In most kirkyards the church was located near the northern end, rather
than placed centrally, for to be buried on the northern, shadowy side of
the church was a sign of shame. This area was left for those who died in
debt, were illegitimate, had died at the correction house or were vagrants,
the poor and the 'stranger poor' (poor from another parish). Often it
is apparent today that the north side of the kirkyard was used for such
burials, as it tends to be bare or relatively free of memorial stones, for the
families of the corpses laid there were unable to afford such.

Other areas in kirkyards set aside for special burials include those for the
victims of the various epidemics. Known in most parishes as 'the Cholera
Ground', this being the most common disease from which people died;
these areas also tend to be free of memorials, for the vast numbers who
perished in a short period of time left families with many dead relatives
and little money with which to raise stones. Another reason was that the
victims were often placed in mass graves, so that each family did not own
a specific plot. The ground in which epidemic victims were interred was
never disturbed, for fear of letting the virus escape, and in many parishes
annual inspections were made to check that the turf was unbroken.

Corpses of members of different religious sects were sometimes buried in a different part of a graveyard, or else they had separate cemeteries. Until the beginning of the nineteenth century this was uncommon, for prior to then Catholicism was illegal and the other religious persuasions were far less common. It is only in the past century or so that separate burial grounds have become more fashionable, particularly in large cities where 'minority groups' have substantial membership. Thus the large cemeteries of Glasgow and other cities have separate sections for Roman Catholics, Jews, Quakers and others.

A number of plants have traditionally become associated with the kirkyard, in particular the yew tree – probably because it is a very slow-growing tree, which lives for many hundreds of years, and because it is an evergreen. As a result it has become a symbol of immortality, for trees which were seemingly old when a person was born are still growing strongly when he is carried to the grave. In the Middle Ages some kirks were decorated with branches of yew on Easter Sunday. By far the most famous yew in a Scots kirkyard is that at Fortingall in Perthshire, which is believed to be over 3,000 years old, the oldest piece of living vegetation in Europe. The tree is thought to have been held sacred in the years before Christ lived, and for centuries its wood was in demand for cobblers' awl handles. In 1776, when Thomas Pennant made his tour of Scotland, the girth of the tree was measured at fifty-six feet.

Of other trees and shrubs with kirkyard associations, mention should be made of the rowan and holly, both regarded as holy trees. The rowan was used to deter evil spirits and so was grown by the door of every croft-house. Holly has associations with Christ, its thorns representing the crown of thorns He wore at His crucifixion, its red berries the droplets of blood.

Kirkyards very often contain buildings other than churches within them. In many parish churchyards the ruins or remnants of the previous church can often be seen, its walls filled with memorials to people buried within it. These churches tend to be similarly styled: a long, low building, sometimes with an aisle on one side, a belfry on a gable, and various doorways and windows, some partly built up. Teind barns have already been mentioned, and the buildings connected with the time of the 'Resurrectionists' (such as watchtowers or mort-houses) will be dealt with later, in Chapter 8.

Gateways to kirkyards are often ornately built, having been erected as memorials to various lairds or ministers. Other churchyards are entered through gateways which have been erected as war memorials, in some cases listing, on adjoining slabs, those who died for their country. Many kirkyards have more than one entrance, the second way being used by the minister to connect the manse garden with the kirkyard. Lairds even have

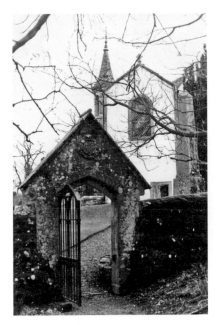 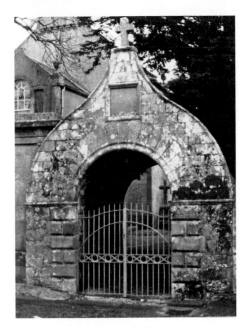

Left: Laird's gateway to the kirkyard of Culter (Lanarkshire)

Right: The lychgate at Kirkmichael (Ayrshire)

their own gateway in some parishes, the kirkyard of Culter in Lanarkshire having two such, each ornate archway with the relevant laird's arms carved on it. Nearby, but in the county of Peebles, Skirling kirkyard has very ornate gateways made of wrought iron, the gift of Lord Carmichael, who had his home here decorated with many wrought-iron artefacts, the work of Thomas Hadden of Edinburgh.

The lychgate, which so often typifies the English churchyard entrance, is far less common in Scotland, particularly in old examples. It was originally used as a place in which to change coffin-bearers, prior to the final walk to the grave mouth, taking its name from the Anglo-Saxon *lich*, meaning corpse; latterly lychgates became little more than an ornate gateway to the kirkyard in which parish notices could be posted and brides could pose with their grooms. These modern-style lychgates tend to be of a wooden construction, supporting a slated pitched roof. Some may owe their origins to the Great War, like that at Kinclaven in Perthshire, which also acts as a war memorial, or as a biblical reminder, like the two at Luss, which have texts carved on them.

Old examples of lychgates are few and far between. Many must have been demolished over the years; some, like that at Chapel of Garioch (Aberdeenshire), have been reduced to archways. The old kirkyard of St

John's in Ayr is reached through a lychgate from the Kirkport, and this building bears the date 1656, just two years later than the spectacular old kirk itself. The passageway is arched, the roof slated, and within it are two iron mortsafes (see p. 154), one dated 1816, relics of body-snatching days. In the same county, to the south of Ayr, another lychgate can be seen in the village of Kirkmichael. This gateway is similar to that of Ayr, with the exception that the roof is ogival, containing in its roofspace the old kirk bell, which tells us that it was cast by 'IOHN. MEIKLE. FOR. KIRKMICHAEL. KIRK. 1702'. Blackford in Perthshire still has a stone lychgate, as does Longside in Aberdeenshire, the latter dating from 1706.

By far the largest numbers of kirkyard buildings are the mausoleums, the burial aisles where the lairds and their families were laid to rest. A fairly high percentage of parish kirkyards contain a mausoleum, and some have more than one. These mausoleums come in two main styles: those built onto the parish church, and the free-standing variety. However, strange as it may seem at first, these two styles could be intermixed, there being examples of burial aisles attached to kirks surviving while the church became ruinous and ultimately was cleared away, leaving the mausoleum alone. Other mausoleums could be built out of part of the old church ruins.

A fair number of mausoleums were built by lairds at the same time as their country houses were built, so that in some cases investigations reveal that a famous architect was responsible for these buildings. Just such an example is the Hopetoun burial aisle which is attached to Abercorn kirk, in West Lothian: Sir William Bruce, the architect who designed the original block of Hopetoun House, also designed this burial aisle and retiral rooms for the Earl of Hopetoun, the classical block which resulted being far more dignified than the church to which it is attached and which it overpowers to some extent. It dates from 1708 and in recent years has been magnificently restored.

The Boswell mausoleum at Auchinleck in Ayrshire is one of few such buildings which are open to the public. It adjoins the old parish church which for years stood in ruins but which in 1978 was re-roofed and opened as the Boswell Museum – James Boswell, the noted diarist and Dr Johnson's biographer, being the laird of Auchinleck and buried in the vault. The mausoleum, erected in 1754, was the work of his father, Lord Auchinleck, and was probably by the same person who designed Auchinleck House, although who was responsible for the house is unknown. The mausoleum is a fairly simple building, square in plan, with a vaulted interior, externally having a stone-slabbed roof topped by an urn finial. The walls have rustic quoins at the corners and on the door facings, and the Boswell arms are carved on the north wall.

The MacQuarie mausoleum at Gruline on the island of Mull is owned by the Australian National Trust but protected on their behalf by the National Trust for Scotland. Here is buried Lachlan MacQuarie, a former governor of New South Wales, who is known as 'the Father of Australia'. He was sent to that country in 1809 to establish a national identity, to build schools, churches and roads, laying the foundations for a prosperous country, away from its Botany Bay background. MacQuarie returned to Scotland on a pension but refused a title and died in 1824.

There are hundreds of mausoleums all over Scotland – in fact, virtually every parish contains at least one, for they were the status symbols of the lairds. Of the kirkyards containing more than one, mention should be made of Airth in Stirlingshire, which has three, dating from the mid fifteenth century, 1593 and 1614. The oldest was erected about 1450 by Alexander Bruce of Stenhouse, that of 1593 by the fourth Lord Elphinstone, and the newest one by Sir James Bruce of Powfoulis. Some mausoleums are to be found upon the lairds' estates, away from the parish kirkyard, the MacQuarie mausoleum on Mull being such an example. In some cases estate mausoleums may occupy the site of an ancient church or chapel.

In Haddington is the Maitland of Lauderdale mausoleum, attached to St Mary's Kirk, built in part of 'the Lamp of Lothian', as the fourteenth century abbey was known. The Lauderdale vault contains one of the finest marble tombs in Scotland, especially since it was cleaned and painted in recent years. The inscriptions have been re-lettered in gold, the heraldry picked out in colour and the four alabaster figures re-polished. For many years this burial vault was thought to be haunted, or at least occupied by an unsettled corpse, for each time it was opened to facilitate a further burial, the coffins already there were noted to have moved from their original positions. This strange phenomenon, which attracted the superstitious to the vault each time it was opened, went unexplained until it was discovered that the water table rose at times, so that the vault filled with water, thereby floating the coffins, which, when the water subsided again, were found in a different position.

Tombstones are perhaps the items most commonly looked at by explorers of kirkyards, simply because they are the most numerous. Mention has been made of memorial stones from the medieval and earlier periods in the previous chapter, and subsequent chapters will deal with the symbolism and inscriptions which are commonly to be found on them.

Tombstones of the 'modern' variety date from around the beginning of the seventeenth century, but it was not until the eighteenth century that they became popular. In the north-west Highlands headstones did not replace slabs ('ledgers') in popularity until the beginning of the nineteenth century. The graveslabs of medieval times may have gradually evolved

Craufurd mausoleum in Kilbirnie (Ayrshire), dating from 1594

into the tombstones of modern times, the process no doubt speeded by the Reformation which disallowed church burial. The lairds were first to have memorials erected in the kirkyards to their deceased forefathers, and as time passed they became more popular with the lower classes.

Memorial stones of the modern type can be divided into three main classes – recumbent stones, erect stones, and mural memorials. Recumbent stones are the most obvious development of the graveslab and can be found in a variety of types. One of the earliest examples is the coped stone, a slab with a tapered upper surface, looking rather like a flat hipped roof, on which the inscription and mortality symbols are carved. These were most common in the seventeenth century and had an advantage over the ordinary slab in that rainwater could run off them, thereby assuring them a longer life, with less erosion due to frost shattering and other forms of weathering.

The tablestone is a slab supported on pillars, usually four or six, although some may have more. A few may have only two supports, being two smaller slabs on their end, positioned rather like inverted bed-ends. Sometimes the slab itself is rather plain, the pillars having most of the decorative work, such as symbols of death or immortality. Classical columns or decorative balusters form the supports, but in many cases these have subsequently been removed, leaving the slab to lie on the ground, as in previous centuries. A variety of the tablestone is the chest tomb, where

A tablestone with skull and crossbones on end support:
Blackadder's grave, North Berwick (East Lothian)

the sides are filled in with tablets of stone, leaving a hollow cavity beneath the slab.

Mural monuments have their origins in the memorials which were originally affixed to the internal walls of churches. Some are affixed to the external kirk walls or onto the surrounding kirkyard dike. Some are large, often with Ionic- or Corinthian-type pillars and a pediment, reaching from ground level to above the level of the dike, while others are simply tablets of stone inserted into the wall.

The erect form of memorial stone is by far the most common and occurs in a number of different types, each type being subdivided into different versions. The simple headstone in all its forms is the most numerous, and these will be dealt with in a later paragraph. Other examples of the erect memorial include crosses, obelisks, broken columns and rusticated memorials.

Crosses were common in the west Highland culture, and a number of superb examples survive throughout the western Highlands and islands, often in kirkyards, but in some cases in remote locations. Some bear inscriptions commemorating the dead but really belong to the medieval period. With the Reformation, crosses were seen as being connected with Catholicism and so lost favour, in many parishes any existing crosses being destroyed. It was not until the nineteenth century that they gained acceptance again, and one of the most common types erected owes its style to the Celtic originals, having knotwork, bosses and foliate patterns. Most seem to be made of white granite, and the wheel-cross type is very

popular. Plain-surfaced Latin crosses can also be found, but they are not as common as the Celtic Revival style.

Obelisks owe their origins to the Egyptians, who used them in pairs at the entrance to their temples. They did not gain popularity as grave-markers until the Victorian age, when in 1878 'Cleopatra's Needle' was brought to Britain and set up on the Victoria Embankment in London. Obelisks are four-square pillars, usually with a stepped base and a cuboidal block containing the inscription, surmounted by a tall shaft which tapers towards the top, which is usually finished with a pyramid. These memorials were restricted to the better-off, for they were expensive to make and are often composed of polished granite.

Broken columns are also a nineteenth century innovation, comprising a foursquare pedestal with a Corinthian column which has a ragged top as though it has been struck by lightning. The inscription was placed on the dado, often on all four sides. Broken columns are thought to symbolize Resurrection Day, when a great earthquake occurred just before Mary Magdalene met Christ following His rising. Christ, in one of His parables, used in the destruction and rebuilding of the temples as an analogy for death and resurrection.

Rusticated memorials occur in a number of different types. All are made to look like either wood or unhewn rock, and they are often carved from red sandstone. The memorials can be in the form of a cross, carved to look like the bark of trees, perched on a cairn of stones, made from a single block, or in the form of a tree trunk with its branches lopped. Others resemble natural rock, sometimes with stone flowers or animals on them.

Headstones form the greater part of kirkyard memorials, although in some parishes, particularly in the far northern Highlands and Caithness, slabs are still more numerous. All headstones are simply slabs raised on their end, but their variety will astonish the casual kirkyard visitor. No two stones seem to have been made alike in the years previous to the Great War: all stones have a different-shaped head or mouldings down each side. The former defy counting, even the simple stones having an assortment of mouldings. These are usually symmetrical about the centre, each half often being a simple traditional moulding, such as *cyma recta, cyma reversa, Scotia* or *torus*. Others owe no origins to the Greeks, being simply curlicue shapes devised by the mason. The older stones are the simplest, their heads being simply semi-circular or semi-elliptical, but as time progressed more ornate designs gained popularity. It has been speculated that each style is fairly contemporary with others of its shape throughout Scotland, but it would need a great graveyard survey to decide whether this is in fact the case. Local styles can be found, obviously all the work of the same mason, or masonic family, or else being a shape preferred by a district.

Some headstones have pediments, often containing the first words of the inscription, usually 'In memory of' or 'Sacred to', this often being written in a far more ornate style of lettering than on the rest of the stone – sometimes so ornate as to, be virtually indecipherable, and the kirkyard visitor has to go through the usual list of beginnings in order to work out what it says.

In the early nineteenth century a form of headstone was introduced which no doubt was seen as a great innovation. It was the cast-iron memorial, the whole thing being cast in a foundry and erected later in the kirkyard. There were a couple of problems with such memorials: additional inscriptions could not be added very easily, and after a time they corroded. The first problem was solved by having a cast-iron frame holding a stone tablet, but the latter problem was never solved and such memorials quickly went out of fashion.

Cast-iron headstone,
Skirling (Peeblesshire)

Modern stones are usually made of polished granite, often black in colour, or else a white granite, and usually have a gold painted inscription. Some stones are not made from a single block but are cast from granite chips and concrete. There are also a few memorials which are made of plastic, with a strengthening steel frame inside them, the inscriptions branded on by hot irons. Others may be made of glass fibre, within a mould, and a separate plastic inscriptive panel affixed to it.

Wooden memorials seem to have been fairly common in England at one time, but Scotland has few of these. It is not known whether this was because wooden memorials did not find favour in Scotland or because they have since disappeared, the wood having decayed. Some wooden memorials may have been erected only as a temporary measure, for I have seen a wooden cross in the old kirkyard of Barnweill (Ayrshire), commemorating one who is also mentioned on an adjacent tombstone. There is another at Kells (Kirkcudbright) to a victim of the Great War, also commemorated on an adjacent stone. Mort boards were wooden plaques placed at the head of a grave, in the same way a headstone is placed, and seem to have been used the length of the country. One even survives in St Magnus Cathedral, Orkney, where wood must have been in short supply.

One thing which is surprisingly rarely found on tombstones is the mason's mark, the individual symbol carved by masons on their cork so that other masons know who was responsible for the carvings. Very few such marks have been discovered on tombstones, and no one has successfully stated why this should be. It is sometimes known who was responsible for some mausoleums, and a burial enclosure of 1663 at Colmonell in Ayrshire has a short inscription stating that, 'This vork vas vrocht by Iohne Dicon, Masovne, Ayr'. Masons' marks have been found at Mochrum in Wigtownshire, on a stone of 1739, and at Pettinain in Lanarkshire. More modern tombstones can have the monumental sculptor's name on the base and may also include the lair number.

The stone from which the kirkyard memorials are made can also be of interest, from the point of view of local trends. Certain areas tend to have stones made of a particular rock, usually quarried locally. Midlothian has a hard-wearing freestone, Kilsyth used a local basalt, Nithsdale the red sandstone from quarries near Thornhill, granite in Aberdeen, and parts of Argyll Ballachulish slate. An example of just how much a local stone was used is the old kirkyard of Keil in Appin, located about seven miles from the Ballachulish quarries, where many of the quarriers are buried. During a visit there I counted only three tombstones which were not made of slate, the rest being carved from it, from eighteenth century slabs up to fairly recent ones. This slate is so hard-wearing that the guidelines put on by the mason for lettering in the eighteenth century are still fresh to this

Timber memorial, Dundonald (Ayrshire)

day. Some stone types are unfortunately rather poor-wearing, particularly when located near the coast. Even marble, which when erected would no doubt be one of the finest-looking stones, wears quickly by the action of the acid in the rain.

The type of stone available locally was not the only regional difference found in kirkyards. In some areas the traditional Scottish kirkyard layout was different in some aspects; in a few cases it could even be the exact opposite. The body being laid in an east-west direction was commonly ignored in the north-western counties of Scotland, and a number of kirks have most of their burials on the north side of the church building. The Highlands evolved a number of customs different from those in the rest of Scotland, one of the most notable being that whereas in most of the country to cut the grass on a grave was to show the corpse disrespect, Highland burial grounds were cropped by the grazing of sheep or goats. In Gaelic-speaking districts of the north and west, the tombstone inscription could be in that language, particularly in the Western Isles. No really old stones were in Gaelic, however, being instead in Latin. Gaelic verses can be found in kirkyards in non-Gaelic speaking areas, however.

Scots tombstone inscriptions have one major difference from those of England. South of the border memorial stones give wives the same surname as their husbands – that is, their married name, or else list them simply as 'Mary, his wife', with no surname. In Scotland, a woman keeps her maiden name to the grave, so that a Scots inscription would read something like 'Here lies John Logan and his wife Jean Shaw' as opposed to 'Here lie John Logan and Jean Logan, his wife'. This helps considerably for those interested in genealogical research but can be rather off-putting to non-Scots who are unaware of this tradition, sometimes giving them visions of their own illegitimate descent from such couples. Most regional variations occur in the funeral, which will be the subject of the following chapter.

3

FUNERAL CUSTOM

The burial service and the preparations made prior to the interment have evolved into a traditional sequence over many centuries, with customs surviving over a long period of time. For centuries the Scots had a fairly regular set of customs which were practised at funerals, customs which in many instances survive to this day, although modern invention has altered or adapted some, and others may have been dropped altogether.

Some funeral customs were actually the result of laws made by the Scots Parliament, others the result of centuries of development. Although many customs were universal throughout Scotland, there were also purely local customs, in some cases the exact opposite of tradition in a different part of the country.

Following a death, a series of jobs were undertaken by the immediate family or close friends to prepare the corpse for the grave and arrange the burial ceremony. One of the most important was the 'lykewake', the watching of an unburied corpse, *lyke* being a harder form of *lich*, corpse. Lykewakes originated in pre-Reformation days, the original purpose being to ward off evil spirits who were thought to try to capture the soul of the corpse for the Devil, prior to its getting the chance of ascending heavenward once it was Christianly buried in the ground. As well as preventing evil spirits from attacking the body, a more practical purpose of the lykewake was in preventing vermin nibbling at the corpse, for in many areas sanitation was still very poor, and rats and mice were rife. In later years the lykewake was necessary in order to prevent body-snatchers trying to steal the body for medical dissection. Thus, although lykewakes remained in fashion for centuries, they did in fact change in purpose.

Lid of a stone coffin
(floral cross slab) found
in the Castle Hill Church,
Ardrossan (Ayrshire)

The corpse was generally kept in one of the bedrooms of the house, usually the best room, and the family would take turns at sitting with the body. Usually two or more people remained with it at all times, although, in the case of a well-liked person or one with a large family, many more people could guard it at a time. Wakes lasted anything from a couple of days to over a week, depending on the deceased's social standing, those for lairds and the like lasting longer to allow more visitors time with the corpse, the impoverished just long enough for a joiner to nail together a coffin.

With all these visitors to the house, hospitality had to be shown, resulting in a supply of alcohol, tobacco, cheese and bread being brought into the home. This hospitality could result in considerable expense for the family of the deceased, but it would have been shameful if they did not send their departed off in a suitable manner. The alcohol supplied freely by the relatives of the deceased was in a number of instances misused, the folk watching the corpse ending up in a state of drunkenness. It was also not uncommon for people unconnected in any way whatsoever to turn up at a lykewake in order to drink a toast to the deceased. At some wakes dancing was common, singers were paid to perform, and cards and other games were played at some lykewakes.

Kirk session records list many disturbances which resulted from the liquor supplied at wakes. At length town councils made local laws which were intended to prevent such riotous behaviour, from limiting visitors to a specific number at a time to preventing all and sundry from turning up, unless they had been specifically invited. In my home town, Cumnock, a 'Covenant of Householders Regarding the Method of Conducting Funerals' was drawn up and signed by eighty-two householders. It read:

We, Subscribers, being in or near to the village of Cumnock, taking into our serious consideration that, by present method of conducting burials among us, much time is misspent and money thrown away, and that by entertainments given at many of them the Living are injured and the Dead in many cases dishonoured; and being convinced that a reform is necessary, have agreed and do by our respective subscriptions hereto annexed agree, bind and oblige ourselves to the Rules or Articles following, *viz*:-

1mo That none of us shall give any general or public entertainment either immediately before or after the Burial of our friends, and that, exclusive of the members of our family and those connected with the chief mourner by blood or relationship, we will not invite any number exceeding 12 to partake of the refreshment that may be provided suitable to the occasion, which we hereby agree shall not exceed 3 glasses of wine, or

where this cannot be purchased, one glass of spiritous liquors, and bread proportioned ...

2do That in our Invitations to Burials we shall invite persons to attend punctually at the time at which it is intended to carry forth the corpse for interment ... under the penalty of Two Shillings in case of Failzie.

3tio That the company invited shall be received at the Door of the House, where the corpse lyes at the time, by some of the relations of the deceased, with a Bow and Uncovering of the head, and the corpse being carried forth shall precede and the company follow to the place of interment.

4to That, in order to carry the above specified Reform into execution such of the subscribers as may be judged best acquainted with the mode of Burials in Towns where they are properly conducted, shall, upon being called, cheerfully give their assistance to the same.

5to That the fines raised and collected from Delinquents shall be applied for purchasing coffins and towards the necessary expense of interring the Poor in the village or neighbourhood ...

These regulations we bind and oblige ourselves to observe, as witness our respective subscriptions at Cumnock, the 5th day of May, in the year 1800.

Dogs and cats were kept well away from the corpse, cats being trapped beneath a wash-tub, for, should they cross over the deceased, the Devil could gain power over the soul. (One way of correcting such an incident was to kill the cat afterwards.) All clocks in the house were stopped at the time of death, and any looking-glasses were either covered over or turned to the wall. Visitors who came to pay their respects had to touch the face of the dead body; failing to do so would result in the visitor's suffering from nightmares for days after. A plate of salt was in many instances placed on the corpse's breast, supposedly to prevent swelling.

Placing the corpse in the coffin was known in Scotland as 'kisting', 'kist' being a hard Scots form of 'chest', or coffin. It was a government-imposed tradition: in 1686 an Act Anent Burying in Scots Linen was passed, which stated that all corpses must be covered in Scots linen graveclothes. This rule was introduced because the linen-spinners of Scotland were suffering from lack of trade, while corpses were laid to rest in graveclothes made in other countries. To prove that the burial clothes were Scots-made, the parish clergy had to list all the deceased persons of his parish and visit them all to make sure that Scots linen had been used, unless the deceased's relatives could show the minister receipts for Scots linen, vouched for by two witnesses. Failure to comply could result in hefty fines, a year's wages for an ordinary person, more for the landed gentry. It paid for people to pass on information about anyone failing to comply with the law, for they

were given half the fine, the remainder being distributed amongst the poor of the parish.

By the year of Union (1707) the troubles in the linen industry had subsided, to be replaced by others in the woollen trade. The Act of 1686 as well as an Act of 1695 ratifying the 1686 Act and enforcing further the use of home-produced linen, was altered in 1707 making it compulsory for corpses to be dressed in woollen cloth.

It became the custom to invite the minister or his elders to the actual placing of the corpse in the coffin, so they could see at first hand that the proper linen had been used. Ministers who attended the kisting to check on the proper use of graveclothes gradually introduced short services. Prayers were said, the Bible was quoted, and psalms were sung. As kisting usually took place on the evening prior to the burial ceremony, during what was still the lykewake, the hospitality shown previously was extended to include those present at the kisting. A meal was often prepared, and drink was available.

The use of coffins did not become common in Scotland until a few years after the Reformation, when the Church of Scotland introduced rules stating that all should be carried to the grave mouth on a bier, a frame like stretcher containing a reusable coffin. Its base was hinged, so that when it was placed in the grave a lever was drawn, hauling the bier up again but leaving the corpse below. These 'common' coffins cost as much as four or five times the prices of an ordinary coffin but, as they were used on numerous occasions, they soon repaid the outlay. Parishes bought their own, but many craft guilds had superior examples, usually more decorative, which were used at the burial of guild members.

Ordinary coffins were made by the local joiner or cabinetmaker, the price, varying according to the finish and quality. The simplest coffins, used to bury the poor, were usually paid for by the kirk session, although after the introduction of the 1845 Poor Law the Inspector of the Poor paid for it from government funds. Prices ranged from 8 shillings (a week's wages) for a basic coffin (in 1759) to over £12 in 1773 for the Duchess of Perth's coffin.

Some of the more remote parts of Scotland did not use coffins for burial, in many cases because of the lack of wood. Corpses in these localities were simply wrapped in a winding-sheet and laid to rest in the ground within it. Latterly, however, with increased transportation, coffins were brought in from other parts of the country to supply the demand.

Associated with coffins were the mortcloths, sheets which were draped over the coffin while it was being carried from the deceased's home to the kirkyard. Mortcloths were purely decorative, although they may owe their origins to those buried uncoffined, for the bodies wrapped in

winding-sheets also had a mortcloth over them. An Act of 1684 forbade the decoration of coffins with ornate metalwork, so the mortcloth grew in popularity from then on. As with 'common' coffins, trades guilds and parishes had mortcloths of their own which were hired out to those who could afford them. Various qualities were available in most parishes, so that a person's social standing was reflected in which mortcloth was used at their funeral. In the larger towns and cities there could be as many as five or six grades of mortcloth, on hire from 10 or 15 shillings down to nothing, in the case of paupers.

Some parishes which had only one mortcloth still varied the charge for hire, dependent on whom one was. King Edward parish in Aberdeenshire, for example, took the following rates in 1760: ordinary person 3s; minister 5s 6d; lairds £1. (As a comparison, a weaver's weekly wage was around 8 shillings in 1750.)

The mortcloth used in Dreghorn parish (Ayrshire), purchased in 1670, cost as follows:

Item for cloath	22/10/0
Item for two point of Silk	24/00/0
Item for 6 Ell and halfe Buccrom	04/00/0
Mair for thread and making of it	01/18/4
Item for making the fringe	08/00/0
Item for ane wallete to cary it	01/01/0
Sumna of the Mortcloathe	61/09/4

This was Scots money, equivalent to about £5 sterling.

Many parishes used the income from the hire of mortcloths to pay for paupers' funerals, so that when the Poor Law was passed in 1845 there was no longer any real need for them. Some parishes kept them in use for a time, but virtually all had discarded them by the advent of the twentieth century.

Yet another means of paying for the poor's coffins was by charging a fee for ringing the kirk bells at a funeral. Bell-ringing was an old custom which was outlawed by the reformers but which grew in popularity again about a century later. Charges varied from parish to parish, as well as from bell to bell, for the main steeple or tolbooth bells could be afforded only by the upper classes. In 1773 Dreghorn parish charged one shilling sterling for ringing the bell. In 1698 Fenwick in the same county took a total of 20 shillings Scots, six of which went to the bellman.

Another type of bell rung at funerals was the mort bell, or deid bell, the name depending on where one lived. It was a small handbell which was tolled by the bellman throughout the town announcing a death and again

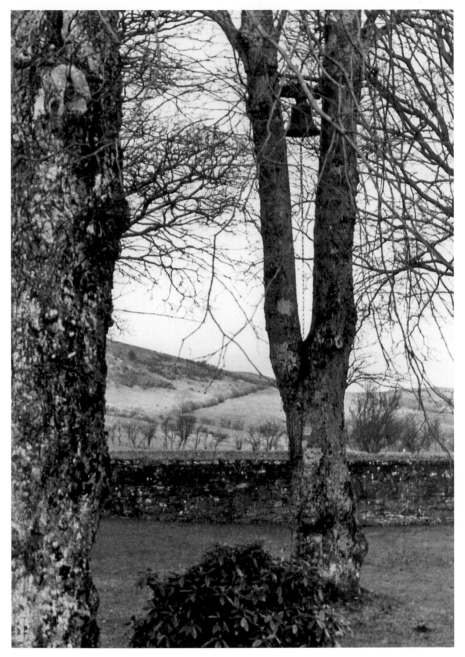

At Ewes (Dumfriesshire), when the old kirk was demolished and a new one was being built, the kirk bell was hung from a tree. The parishioners liked its quaint position, so there it stayed

on the day of the funeral, the beadle walking at the head of the procession, ringing out a solemn tone; in some parts of the country it was also used to indicate the spot where the coffin-bearers were changed. As with many funeral customs, the income from ringing the deid bell went to the kirk session, for the use of the poor, and it was hired out at something like 2d (the price of a loaf) per mile.

Transportation from the deceased's home to the place of burial was traditionally done by hand, four bearers carrying the coffin, although over long stretches these bearers were changed. In later years horse-drawn hearses were introduced in some towns, but rural communities continued the practice of carrying the corpse. Indeed, on occasions, they still do, as at Leadhills in the southern uplands. A few localities used handspokes – lengths of wood placed below the coffin, which made carrying easier. How many spokes were used determined the number of bearers required. Some areas had only four bearers, others six (using three spokes), while other communities used eight bearers, two on each end of two spokes. There are even accounts of coffins being carried by just two persons, one at the head and one at the foot, the spokes in this case arranged like the legs of a stretcher.

The distance travelled by the funeral party could be considerable. Those who died away from home were virtually always interred in their own parish, with many relatives and friends rallying round to take a share in carrying the corpse home. Even if a person died at home, the distance from some parts of a parish to the kirkyard could be many miles, particularly in Highland or southern upland parishes, which might extend to many square miles.

The old trackways which were used to carry coffins to the kirkyards still exist in some places, and many are still known as 'coffin' or 'kirk' roads. (The Reverend A. E. Robertson lists some in his booklet of 1946: *Old Tracks: Cross Country Routes and 'Coffin Roads' in the North-West Highlands*). Alongside some of these ways are cairns every so often, originally marking the places where a rest was taken and the coffin-bearers were changed. There are tales of coffins having to be abandoned along some ways, the result of treacherous weather. One such incident took place in the Galloway Highlands, when a coffin was being taken out from the shepherd's cottage of Backhill of Bush, remotely located in the Dungeon of Buchan. The funeral party carried it as far as the hill of Millfire, at over 2,000 feet, where it had to be left until the snows subsided. Several days later the bearers returned to the hilltop and continued to the kirkyard of Kells.

Hearses were at first used only by the upper classes but gradually became more common in lower social circles. The cost of hiring them was high, a

charge of 10 shillings sterling being made per mile in 1783, (well over a week's wages) more if a four-horse-drawn model was required. As with many funeral arrangements, the profits originally went into the poor fund, but over the years funeral directors set up in business with horses and hearses, introducing the undertaking firms of today. Some parishes formed hearse societies, hiring their vehicle and black horses to anyone willing to pay. In many cases this fee could be paid in instalments (although only in advance), usually one shilling at a time. There are a few kirkyards in which can be seen hearse-houses, buildings in which the horse-drawn hearse was kept between funerals, as at Ednam in Roxburghshire and Caerlaverock in Dumfriesshire.

The actual burial service which took place in the kirkyard was up until the twentieth century attended only by the men of the parish, the womenfolk remaining at home or else standing in the streets to watch as the cortege went past. In some districts, however, women also attended the service, and in recent years it has become more common for them to do so, particularly at the funeral of a close relation. Women did attend funerals on Orkney, where, when a woman died, the coffin was carried the first part of the journey to the kirkyard by women, afterwards relieved by the menfolk. The eight closest male blood relatives each held one of the cords used to lower the coffin into the ground, and in some districts two undertakers, or kirkyards attendants, assisted by holding a tape below the coffin.

Following the Reformation the singing of psalms and saying of prayers were at first banned, being seen as Popish, but they gradually found favour again, even John Knox delivering a sermon at the death of Regent Moray in 1570. Again in 1645 the General Assembly of the Church of Scotland issued an Act 'laying aside' the custom of '... praying, reading and singing, both in going to and at the grave because such were no way beneficial to the dead, and have proved many ways hurtful to the living'.

The use of incense lingered on in many parishes well after the Reformation, and the authorities of Aberdeen cashed in on this, taking the sum of 40 shillings Scots from each person who burned it in the kirkyard, and £4 Scots from those who burned it within the kirk. In the seventeenth century, when Charles I tried to introduce Episcopacy to Scotland, the burial service was legalized again, and this was one reason for the rise of the Covenanters, who saw Episcopacy as a form of Popery.

When Charles I ascended the throne of Great Britain (1625) he believed in the divine right of kings. He introduced Episcopacy into Scotland, in an attempt to make Great Britain have one single religion, and ordered the writing of a Book of Service by the Scots bishops. When it was read in St Giles Kirk in Edinburgh a member of the congregation, Jenny Geddes,

stood up and threw her stool at the minister. In 1638 a National Covenant was drawn up and signed by many, to preserve and defend the 'true religion, liberties and laws of the kingdom'. As time went on the more fanatical Covenanters signed the 'Solemn League and Covenant' (1643) and were willing to die for their faith. Many did suffer death and their story is continued on p. 98.

The 'Glorious Revolution' of 1688 brought about an end of the Episcopal Church in Scotland and a return to the ideals of Knox. Burial services returned slowly again, however, beginning merely as a grace said prior to the eating of refreshments. As late as 1880 it was felt that, if ministers had to take some form of service, this should occur in the

Monument to the Wigtown Martyrs at Stirling

deceased's home, rather than at the graveside, but by the beginning of the twentieth century, burial services at the graveside seem to have become the norm, evolving into the form of service known today – a service which many Scotsmen's ancestors would regard as very Roman Catholic. The Free Presbyterian Church, however, still refrains from graveside services, preferring to conduct them in the deceased's home, or in church, or failing that, outside the cemetery gates.

Roman Catholic burial services and custom remain different in a number of ways from the traditional Church of Scotland burial. The coffins are different to some extent, having 'RIP' on the handles and a crucifix or Sacred Heart on the lid. Inside, brown side sheets are used, and the winding-clothes may be either brown or white, depending on which clerical order the Catholic parish church is affiliated to. The night previous to the burial service the coffin is laid in the chapel from which the funeral procession leaves on the day, sometimes after a short service. Until fairly recently the burial service was conducted in Latin.

Digging the hole in the kirkyard was usually the job of the beadle or bellman, who was paid according to its size. Dreghorn in Ayrshire's records (1671): 'Appoynt that for ane old persons grave he [the bellman] shal take no more but twelve shilling Scotts and for ane child's grave eight shilling Scotts.'

An old saying has it that, should a grave be dug on a Friday, another grave will have to be dug before the year is out, another member of the same family dying. This Friday tradition goes back a long way, and many other things associated with Fridays are supposed to bring ill luck, due to the belief held by later Scots that it was on a Friday that Eve persuaded Adam to take a bite from the apple.

The cost of funerals varied tremendously from person to person, from a few pounds paid by the kirk session in the case of paupers to hundreds of pounds in the case of dukes and earls. Barr parish church (Ayrshire) paid Ion McCord £2 Scots 'for help in burying his mother' in 1657, while Arbuthnott Kirk Session (Kincardineshire) paid out the same amount for a chest and hood for a stranger woman. Some funeral accounts survive indicating where the money was spent, the following example being that of Robert Paterson, known to many as the 'Old Mortality' of Scott's novel:

Memorandum of the Funral Charges of Robert Paterson, who dyed at Bankhill on the 14th day of February, 1801.

	£			
To a coffon	£	0	12	0
To Munting for do.		0	2	8
To a shirt for him		0	5	6

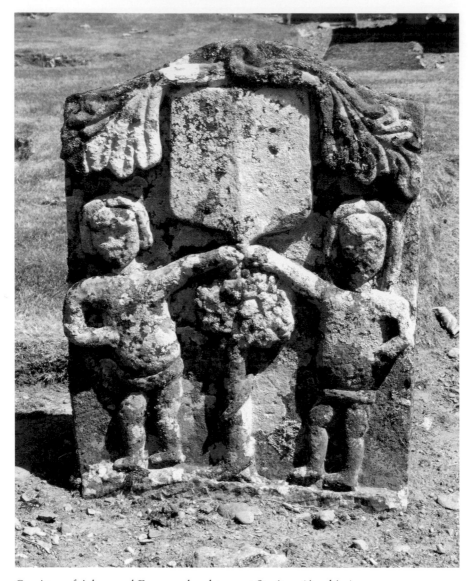

Carvings of Adam and Eve on a headstone at Straiton (Ayrshire)

To a pair of Cotten Stockings		o	2	o
To Bread at the Founral		o	2	6
To Chise at do.		o	3	o
To 1 pint Rume		o	4	6
To 1 pint Whiskie		o	4	o
To a man going to Annan		o	2	o
To the grave digger		o	1	o
To Linnen for a sheet for him		o	2	8
	£	2	1	10

Lairds' and clan chiefs' funerals cost considerably more. One reason was that many more people attended them, resulting in more food and drink being required. Other reasons were that fancier and more expensive coffins, winding sheets and the like were used, and the coffin-bearers were hired, rather than the usual friends volunteering to do the carrying. Munro of Novar's funeral in 1735 cost over £38, MacCulloch of Muldearg's £100 twenty years later.

When Lachlan Mackintosh of Mackintosh (twentieth chief of the clan), died in 1731, his corpse was kept in Dalcross Castle (near Culloden, Inverness-shire) for two months and two days to enable all his friends and acquaintances to pay their last respects. The amount of food and drink consumed by these visitors was phenomenal, costing perhaps up to £300, equivalent to a common labourer's wages for over ten years. The funeral was also held back due to Mackintosh the Younger's being abroad when his father died. When he returned, over 4,000 people joined the cortège, 3,000 of them being armed members of the Clan Chattan, and it stretched four miles from Dalcross Castle to Petty kirkyard where the corpse was laid in the Mackintosh vault. An ancestor, also Lachlan, the nineteenth chief, who died in 1704, had 2,000 clansmen bearing arms at his funeral.

When Sir Robert Grierson of Lag died in 1733, his funeral costs included £240 Scots for food and drink. Some of the items consumed, and the cost thereof, are listed below:

1733				£			
Decr 29th.	2	bottles small clarit		£	o	3	o
do.	2	flint glasses			o	1	4
Decr 30th	4	bottles small clarit			o	6	o
1734							
Janr 1st	12	bottles strong clarit			1	4	o
do.	3	bottles ffrantinak			1	6	o
do.	3	bottles shirry			o	5	6

do.	1	bottle more brandy	0	1	6
Janr 7th	18	double flint glasses			
do.	1	lb double refined sugar			
Janr 8th	4	dozn strong clarit to the lodgeing	4	16	0
do.	6	bottles ffrantinak do.	0	12	0
do.	6	bottles shirry do.	0	11	0
do.	6	more double flint glasses to ye lodgeing			
do.	12	bottles strong clarit sent out to the burying place	1	4	0
do.	12	bottles more strong clarit at night to the lodgeing	1	4	0
Janr 9th	4	wine glasses returned from Dunscore			
Janr 12th	2	bottles strong clarit to the lodgeing	0	4	0
do.	10	bottles strong clarit wt Carriel & more Gentelmen	1	8	0
Janr 14th	2	bottle clarit wt Carriel	0	4	8
	8	dozn empty bottles returned			
		The Wines amounts to	14	5	5
		The Entertainments to	6	10	0
1734		ACCOMPT. OF HORSES			
Janr 9th	2	horses of Lord Stormonds, 2 nights hay, oats & beans	0	5	0
do.	2	horses 2 nights hay, oats & beans, Sr Thomas Kirkpatrik	0	5	0
do		the smith for Sr Thomas' horses	0	2	0
		Pyd to Charles Herisse, smith, for iron work to the Hearse	0	5	6
		Mr Gilbert's horsses	1	4	6

When Samuel Johnson and James Boswell toured the Highlands and islands in the autumn of 1773, the doctor wrote that the calling of multitudes together and entertaining them at great expense had for some time been discouraged, and at that time almost suppressed, on the island of Skye. However, on Coll he recorded that in 1754, when the Laird of Coll died, thirty cows and about fifty sheep had been killed in order to feed the mourners.

Highland funeral custom could be different from the rest of Scotland's traditional burial rites. As mentioned already, the journey to a grave mouth could be a major undertaking in the Highlands, one which involved the whole family and many neighbours as well. From numerous remote croft

houses the corpses had to be transported many miles to the kirkyard, often by land and sea. At the head of Loch Nevis is the tiny burial plot of Eilean Tioram, the most recent stone there bearing the date 1838, in commemoration of 'A. McDon^d Finiskaig'. When this burial ground went out of use, the folk of Kinlochnevis had to transport their dead overland from their croft, perhaps up to two or three miles, to Camusrory, where a boat could anchor. Then it was a row down the loch five miles to Tarbet and another walk over land across the isthmus to South Tarbet Bay, on the shores of Loch Morar. A further row of almost two miles brought the corpse to Camas Luinge, from where it was a walk of a mile or so to the kirkyard of Meoble.

When Gregor MacGregor, chief of Clan Gregor, died in 1693, he was the last chief of the clan to be buried on the island of Innis Cailleach on Loch Lomond. He lived at Stucnaruagh on the shores of the loch, and his corpse was carried a mile along the lochside to Inversnaid where it was placed on a funeral galley. Flying a black standard, indicating death, and with the clan piper playing a dirge at the bow, the boat took to the waters, rowed by the lesser chieftains of the clan. The corpse was taken by boat almost fourteen miles to Innis Cailleach, where the parish kirk of Buchanan once was, for in 1643 it had been moved to Buchanan for the ease of the parishioners on the mainland. Along the length of the loch, other boats carrying mourners joined the procession. On reaching the wooded island, the boat carrying The MacGregor sailed round it three times in a sunwise direction, known as a *deiseil* in Gaelic, a relic of the old Celtic Church, which used it as a symbol of eternity and blessings for the thereafter.

This *deiseil* or *deasil* was not restricted to boats at funerals: on other parts of the west coast it was the custom until fairly recently for the coffin to be carried around the grave sunwise three times before being placed in the ground.

The dirge which The MacGregor's piper played was a *coronach*, common in the old Highland tradition at funerals, played or sung as the corpse was carried to the kirkyard. Not everyone joined in the song; usually it was just one of the family who sang of the deceased's great virtues. In some areas, however, there were what were known as 'professional mourners', usually elderly ladies who were paid a fee to sing the *coronach* at funerals. They joined the funeral procession as it left the house and sang almost continuously until the corpse was laid in the ground, the song reaching its climax at that point. To the outsider, the *coronach* seemed to be just a mixture of wailing, and a Captain Burt, who visited the Highlands in the eighteenth century, described it as a 'hideous howl, or ho-bo-bo-bo-boo'.

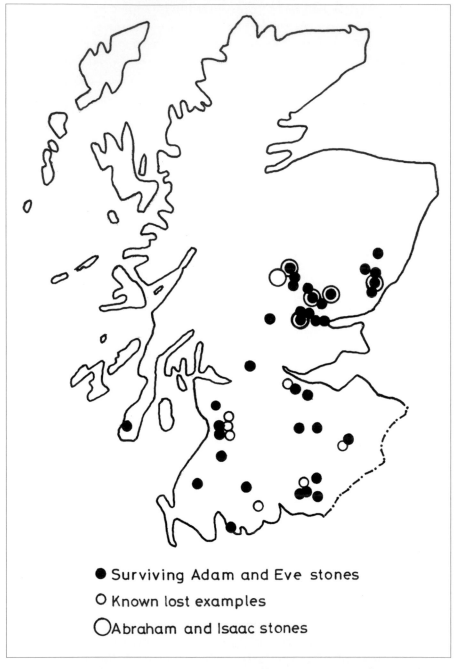

● Surviving Adam and Eve stones
○ Known lost examples
◯ Abraham and Isaac stones

Distribution of Adam and Eve and Abraham and Isaac stones in Scotland (after Willsher 1985)

As with many old customs, those involved in the burial service are dying away, affected by city living and changing attitudes. Now funeral directors undertake to perform most of the corpse preparatory work and will keep the body in a coffin in a 'rest room' until burial or cremation. The involvement of the family has declined considerably and relatives are no longer required to assist in transporting the coffin from the house to the kirkyard, this being done by motor-hearses, though they may carry the coffin the last few steps to the grave and will assist the undertakers in lowering the coffin into the ground.

Cremation was introduced to Scotland in 1895, ten years later than in England, but took many years to gain popularity. Now on average half of Scotland's corpses are cremated, but since rural areas tend to be slower in accepting change, cremations are more popular in large towns and cities than in the farming hinterlands, where an affinity with the soil perhaps affects choice of a last resting-place.

4

TOMBSTONE SYMBOLISM

The symbols found on old Scottish tombstones form an area of study which has recently gained popularity among lovers of old graveyards. They conform to three main types, namely the symbols of death and of life after death, and those representing trades. Most of these carvings date from the eighteenth century, but some are earlier, and a few continued in use into the nineteenth century, but by the Victorian years such symbolism had mostly died out. Modern tombstones contain a few examples of symbolism, usually inscribed crosses or some such symbol, but these tend to be rather obviously explained.

The symbols of death exist in a vast variety of shapes and forms. In fact, some of the designs bear no connection with death whatsoever but are employed just to represent an ending. By far the most common symbol is the skull, or 'death's head' as it is more properly known. This is one of the oldest symbols of death and can even be found on some late-medieval memorials. These skulls exist in many guises: viewed face on, from the side or from some angle in between; they can even be placed at some odd angle, such as inverted or on their side. The eyes, teeth and nose were carved in whatever way the mason found easy, so that eyes, or eye-sockets, can be only shallow cups, or perhaps deep depressions. The nose may not exist on some skulls; others may have an incised triangle or even a heart-shape. The teeth are found in many ways, sometimes like two rows of squares, like a fess-chequy in heraldry, or else in a single row, when the lower jaw is omitted, as is common. A few skulls are composed simply of the outline carved upon the stone, there being no obvious marks for teeth, eyes or nose, and weathering cannot be blamed for them all.

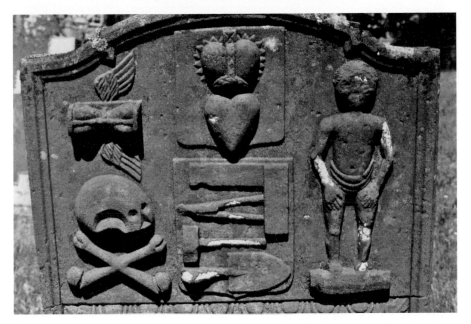

Mortality symbols on a headstone at Kells (Kirkcudbrightshire). Note the winged hourglass, the deceased standing on a coffin, the mason's tools and the crowned heart representing the Douglas clan

There exist many local variations on the death's head. For example, at Blackford in Perthshire can be seen a skull sporting a moustache, and another with what seems like long hair! At Spynie in Moray is a slab to Robert Leslie of Findrassy (died 1588) on which the skull has no lower jaw, in its place a simple bone. On a number of slabs at Kilmadock in Perthshire the skull's nose is formed of two triangles, while at Logierait in Perthshire there is one with huge eye-sockets, a small triangular nose and two layers of gruesome teeth, formed into a sad expression. On some stones there are carved the same number of skulls as there are people commemorated. For example, in the Howff of Dundee there is a stone with no fewer than sixteen death's heads, each representing one person, smaller ones for children.

There are also a rare number of skulls with angels' wings, usually only on seventeenth century slabs, this form of symbolism for some reason becoming unpopular even in the years when death symbols were at the height of funeral fashion.

Associated with the death's head are bones from the human body – usually femurs, if recognizable, but in many cases just a representation of a bone, such as a cartoonist draws for a dog. Some are crossed, immediately below the skull, as in a pirate's Jolly Roger, located to either side or placed

randomly in any position. In a number of cases only one bone is included. On stones where a figure is carved representing the deceased, the person may be standing on a simple bone, indicating that he or she has died.

Another of the most popular death symbols is the hourglass, or 'egg-timer', which is found carved on many stones. It can occur in a number of guises, all signifying the end of man's time – singularly (simply time having run out), on its side (man's life having been ended abruptly, usually prematurely), with wings (and in many cases the motto *'Tempus fugit'* – 'Time flies') or in flames (representing eternity – a rare symbol). In many cases the epitaph adjacent makes reference to the hourglass, as on a stone at Culross in Fife:

> My glas is runn, my tym is spent,
> And for my sins I should repent.

And on a stone at Keills-Appin (Argyll):

> As runs the glass,
> Man's time does pass,
> Life how short,
> Eternity how long.

A group of death symbols owe their origins to the funeral, being items used when a corpse was laid in the ground. One of the most common is the coffin, its simple six-sided shape being an easy symbol to carve. However, more ornate variations of this occur, such as crossed coffins and, in a few cases, the carvings depict coffins on the bearers' poles. Some coffins do not take the shape with which we associate them with today: for example, a stone at Logie Pert in Angus has a coffin which has slightly curved sides, tapering in width like a cooling-tower. A few old stones also have the representation of an open coffin, the corpse in its winding-sheet placed within it.

The deid bell – the bell that was rung at funerals – is another symbol that may be seen on stones, particularly in north-east Scotland, although it was rung all over the country. The bell is usually simply carved, the clapper often projecting out of it. Some bells have the round hole to which they were attached to a rope, others the handle found on handbells, which are more common.

The tools used by the gravedigger or sexton have also been used to connote death. The spade, edge-cutter, pick and sometimes scythe can occur in a variety of positions, though in most cases only two from this selection appear, in a crossed position, often to form symmetry with crossed

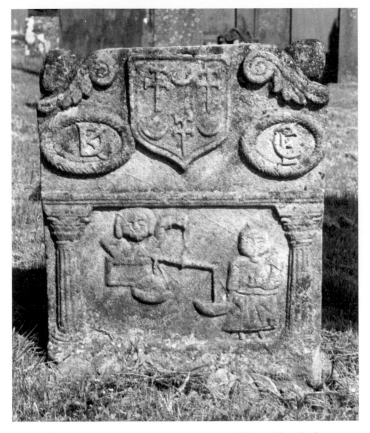

Father Time with imbalanced scales, Kells (Kirkcudbrightshire)

bones. The spades and scythe can occur also as a mark of trade, on stones to a gardener, the scythe (in its more common usage) as an abbreviated representation of Father Time.

There are many other symbols or carvings to be found on stones which signify the termination of life. The skeleton itself may be carved, usually in a rigid position, but also in a few cases in a position of jollity, dancing, when it really signifies life after death. On a few stones it is shown within a rectangle, representing the coffin, surrounded by grave clothes. Should the skeleton be carrying an arrow (actually a dart), scythe, hourglass or some such death symbol, it represents the figure of Death, known as 'the King of Terrors'. As with hourglasses, a mention of him may occur in the epitaph, as at Kettins (Angus):

The King of Terrors who dare withstand,
Who hath the glass and dart in hand.

Often occurring along with Father Time or Death are scales, held by the figure and usually tipped to one side, indicating that the balance between life and death has tipped away from the victim's favour. Scales are also used to represent traders, however; if they occur singly in a balanced position, they usually do signify them.

Death-bed scenes occur on a select number of stones, from simple representations of faces at the head of rectangles (the bed) to involved scenes where the deceased is shown in his usual occupation, oblivious to all around him – as on a fine stone in Ayr's old kirkyard, where angels are closing curtains on a scene where two men are working at a desk, one seated and writing with a quill, the other leaning over, watching the work. At Banff there is a stone showing the victim lying in a four-poster bed, while at Newtyle (Angus) the stone to John Jobson (1720) shows him in his 'DEATH BEADE', his mother by his side, his father holding a Bible.

Also indicating mortality are a number of stones on which are depicted Adam and Eve and the tree in the Garden of Eden. As the concept of death first originated there, it is not surprising that it was adopted as a means of indicating the mortal life of man. Over 45 of these stones are known to remain in existence, from as far apart as the Stewartry of Kirkcudbright to Kincardineshire, but the greatest number survive in Perthshire, where seventeen can be seen. The figures occur in a number of positions but are most commonly placed to either side of the tree, which the serpent is usually coiled around. On a number the apples can be made out on the tree, and Adam often has one in his hand.

The stone at Fettercairn, which dates from 1737, includes two lines of inscription below the scene:

ADAM AND EVE BY EATING THE FORBIDDEN
TREE BROUGHT ALL MANKIND TO SIN AND MISERY.

At Logierait (Perthshire) 'THE SERPENT DECEIVED EVE' is inscribed on one stone, 'THE SERPENT BEGUIL'D EVE' on another. At Lundie (Angus, 1710) 'The serpent beguiled me and I did eat' is inscribed below the scene.

The depiction of Adam and Eve on stones dates from the earliest of Christian times, for a carved Celtic cross at Iona dating from the eighth century has them on it, as does another in Montrose museum. The Montgomerie Aisle in Largs Old Kirk has a scene depicting Adam, Eve, the tree and the serpent, this dating from 1638. The use of the Eden scene may have originated in south-west Scotland, for here are the most early examples, from 1705 to 1707, although one in Angus is dated 1696 (Dun, near Montrose). In the county of Perth, where they remain the most numerous, the oldest dates from 1741.

Symbols of immortality, or life after death, are less numerous than those of mortality but tend to be of a similar nature and can be found on stones mixed with those of mortality.

By far the most common immortality symbol is the winged soul, an angel's face with wings, which represents the deceased person's soul winging its way heavenward. It occurs in a vast variety of forms, from simple bat-like shapes to elaborately carved cherubs, the wing feathers intricately carved, the face very human-like. Although the soul is supposed to be that of the deceased, they most commonly occur in a feminine guise or else are so simply carved that they can only be described as neuter. The wings, although usually bird-like, can occur in a variety of ways, some uncarved and simply represented by the shape, others with avine feathers. The position of the wings is almost as diverse as there are winged souls, for they can be turned up or down or crossed over or even occur one wing up, the other down, depending on how much room the mason has allowed on the stone. These souls most commonly occupy the uppermost part of a headstone and can be the only symbol used on a stone at all, the rest of the tombstone filled with inscription.

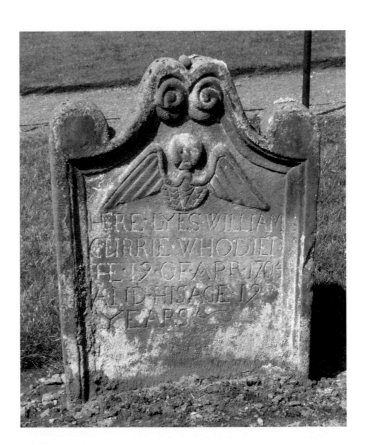

Winged soul
on a headstone
at Dolphinton
(Lanarkshire)

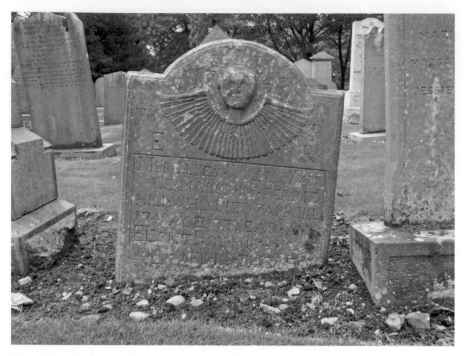

Winged soul on an eighteenth-century headstone at Aberdeen

What may look like winged souls with trumpets in their mouths are in fact angels of the resurrection, from the verse, 'The trumpet shall sound and the dead shall rise.' In a number of cases the complete angel is included, and quite often the corpses arising also, usually dancing. A few cases have the rising bodies waving goodbye to those who are still alive.

A snake can represent life after death just as it can indicate death, the difference being in the position it takes. Eternal life is shown by having the snake biting its own tail, so that it forms a ring, symbolizing eternity, there being no beginning or end. The earliest known use of this symbol is from 1525, when it was carved on the tomb of Admiral de Bonnivet at Oiron in France.

Skulls indicate life after death only if some form of grass or other type of greenery is seen sprouting from its head. When this is the case, the figure is known as 'the Green Man'. It is a very ancient symbol, believed to have originated in the pagan masks worn over the face, from which leaves and branches sprouted, although it was adopted by Christians to indicate that from death a new life begins.

There are a few other symbols or scenes used on stones which have meaning, other than trade symbols (which will be dealt with later). One of the more spectacular is a scene which shows the sacrifice of Isaac by

Abraham. Only eight of these are known to exist in Scotland, although there were more at one time, and all occur in either Perthshire or Angus. They are somewhat synonymous with the Adam and Eve scene, their distribution being similar and the masons involved probably being the same.

The scene usually includes four objects or figures, Isaac at the altar, Abraham with the knife, the goat with his horns stuck in a thicket, and the angel of the Lord intervening just in time (usually represented only as a winged soul). On the stone at Lundie in Angus the relevant Biblical passage is inscribed alongside: 'And Abraham stretched forth his hand & took the knife to slay his son & he looked & behold behind him a ram caught in a thicket.' This is the same stone of 1710 on which Adam and Eve is depicted, although on different faces. At Logierait (Perthshire) the angel is holding Abraham's arm, preventing the slaying. An open book describes the scene here also: 'Abraham offering up Isaac is stayed by the Angel.'

In Lothian a fairly common scene is that of the sower and the reaper, especially on memorials to farmers. Two figures occur, one in the act of spreading seeds upon the ground, the other gathering together lengths of corn to build stacks.

The deceased can also be depicted on the stones, although, unlike those already mentioned, he or she can be represented as they were in life. Many stones like this occur. On a tablestone at Kirkpatrick Irongray

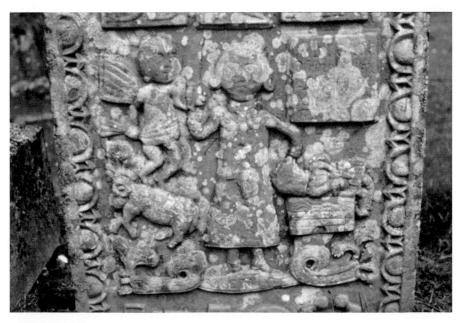

Abraham and Isaac on a headstone at Logierait (Perthshire)

(Kirkcudbright) is depicted Bessie Edgar (died 1707, aged nineteen) holding a Bible. At Straiton (Ayrshire) are carved nine children in one family, all of whom died in their youth, their names squeezed into the spaces surrounding them. A similar scene occurs on a tablestone at Keills in Appin, dating from as late as 1825 – symbolism lasted longer in the Highlands: as well as the names of the eight children of John MacDougall being carved below their representations, a rather grand winged soul presides over them all. Temple (Midlothian) has a stone of 1742 on which are carved a farmer, dressed in his good jacket, with his two children by his side, a rather fine carving. In the Borders there exist a number of stones on which are carved the upper torso of a figure, holding a book which no doubt is the Bible. At Innerpeffray (Perthshire) a stone of 1707 has carved on it two grieving parents, at the head of the stone, and below them ten children, all of whom died in infancy.

The symbolism used to represent trades occurs in three main forms: depicting the person at work, the tools he used in his trade, or symbols or objects which represent a trade in some way. Many of these objects are fairly self-explanatory, but there are a few which need a bit of knowledge of the job to enable them to be deciphered.

The masons perhaps deserve to be listed first, for it was they who were responsible for all the stones in the first place; were it not for their skill, we would have less exciting graveyards in which to explore today. The tools used by masons occur on their stones very often, the mallet and cold chisel being the two most obvious. At Anstruther Wester (Fife) they are seen on a tablestone support, along with a hammer and mortarboard, sun and moon, seven stars, T- and L-shaped squares, dividers and a ladder. There is also carved an example of what the mason would have worked on, a set of stone gate-piers. A similar example of the mason's work occurs on a stone at Durisdeer (Dumfriesshire), which was erected by 'WILLIAME LVKVP, MR [master] OF WORK IN DRUMLANGRIG, 1685'. This depicts the mason in person, holding his chisel and mallet, standing between the columns of a triumphal arch.

The millers use two main items to represent their trade, the millstone itself and the mill rind, the metal device which supports the upper millstone. The rind can occur in a number of ways: singly, two crossed over or even more elaborately shaped, looking like an I or X. Millstones appear like doughnuts and in a few cases are shown with the rind placed in the centre. Other symbols used by millers include a stack of corn, brushes and scales, the miller having to take a percentage of the crop as his fee for grinding the corn.

Smiths – or 'hammermen' as some stones call them – are represented by horseshoes, hammers, pincers, anvils, tongs and other such tools. The

Incorporation of Hammermen included many lesser trades which involved working metal, such as saddlers and gunsmiths, glovers and watchmakers. Their symbol was a heavy hammer below a crown, and the hammermen regarded their profession as one of the most important in the eighteenth century, as stated on the following couplet which occurs on a stone at Tayvallich (Argyll):

> Of all mechanics we have renoune,
> Above the Hammer we have the Crown.

Similarly, the following occurs at Kenmore (Perthshire) and elsewhere:

> By hammer and hand,
> All arts do stand.

A number of smiths' stones simply have a hammer surmounted by a crown, while one at Alloway (Ayrshire) has a complete scene showing the smith at work, John Tennent by name, with a horse, pincers and death symbols.

The stones to weavers often have the shuttle carved on them, one at Arbuthnott (Angus) also including the motto: 'MY DAYS Are SUIFter Than WEAVERS SHUttle.' Some stones include a magnified section of the weaver's work, showing the interlaced pattern their apparatus creates. A few stones include the weaver's stretchers (or tenterhooks) or even the shuttlecock, while others depict most of the loom, including a row of

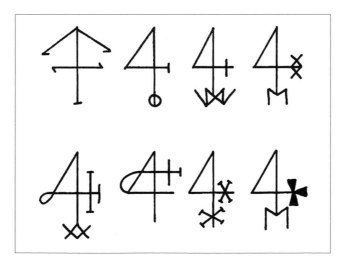

A selection of merchants' marks [*Top Left to Right: Dundee 1579, Dundee 1582, Perth, Kilmadock, Kells, Greenock 1675, Banff 1738, Perth 1745*]

circles and a chequered section. In a rare number of cases the weaver is depicted at his loom; one example survives at Monikie (Angus).

Associated with the weavers were the waulkmillers, people who prepared woollen material, softening and pressing it. Perhaps the best example of a waulkmiller's stone – and these are rare – can be seen at Kirkmichael (Ayrshire), where the miller is working at the machine, here represented in some detail, with enlarged carvings of his fulling pot and shears above. From one side enters a figure carrying an hourglass, peering closely at it, as if watching the last grains of sand pass through the constriction. This stone dates from 1737, commemorating one 'JOHN McKERGOR, LATE IN KEIRS MILN', and on it also appear coiled serpents, with stings in their tails.

The bakers (or 'baxters') have two main items of symbolism: the peels which were used for placing and removing loaves from the oven, and the loaves themselves. The peels sometimes appear crossed over, the loaves often sitting on their blades.

Maltsters and brewsters were responsible for the manufacture of alcoholic drink, and they formed themselves into a guild early on. Symbols on their tombstones tend to be simply the tools they used, such as the large shovels for turning grain, the brush for sweeping grain, a shovel with slats (mash hook), also for turning grain, and a 'weedock', which was used to stoke the fires. At Dalmeny two brewers are shown carrying a barrel, their crossed shovels below.

The coopers – barrel-makers – had the special cooper's hammer on their stones, often with a pair of dividers. They supplied not only the whisky-distillers but also the fisherman, for much of the sea-catch was stored and transported in barrels.

Shopkeepers and other merchants had a symbol of their own, based on the figure 4, which could be reversed. These 4 symbols are most commonly carved within shields and have crosses or letters adjoining them. In some cases the letters are from the merchant's initials, in other instances it is the letter M, standing for merchant. Like the masons, who were famed for their individual mark, the merchants had a special mark so that their belongings could be identifiable, in particular at the ports. The 4 mark used by merchants in Scotland was first adopted by the Stirling Guild of Merchants, and it spread from there, being most commonly seen on east-coast gravestones. The 4 mark did not originate in Stirling, however, for it has been used in other countries, including England (Merchant Adventurers' marks and also woolstaplers' marks), Germany (house marks in Saxony) and India (used by the East India Company to mark bales of tea). Merchants' marks have been found on tombstones dating from 1579 to 1849.

Merchants also had examples of the items they dealt with, or things they used, on their stones. Scales could indicate a merchant, if these were not

imbalanced, and there exist examples at Panbride (Angus) and Dunblane (Perthshire) where the 4 mark and a pair of scales are conjoined. Other merchants' symbols include the quill and ink-pot used to note sales, some even having on them the sextant or cross-staff used by sailors, indicating that the merchant dealt in foreign wares.

Mariners and fishermen tend to have ships or small boats on their tombstones, or else items relevant to their trade, such as anchors. The variety of vessels to be found on eighteenth century stones is remarkable; in fact, no two seem alike, the mason somehow managing to carve a fairly accurate representation of a ship, with masts, riggings and sails. Ships continued to be fairly popular on fishermen's tombstones well into the nineteenth century, by which time other trade and death symbols had become rare. Mariners who travelled afar often had sextants and cross-staffs on their stones. Other items which can be seen include mermaids, compasses, coiled ropes, oars, nets and fish, the latter three attributed to fishermen.

Merchant's mark on a headstone at St Michael's kirkyard in Dumfries

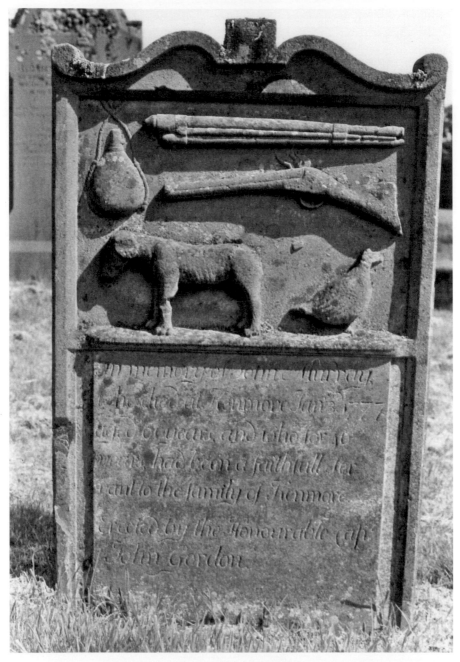

The headstone to John Murray, gamekeeper on the Kenmure estate, showing articles associated with his trade. This can be seen at Kells (Kirkcudbrightshire)

Fishermen tended to have much smaller boats, often without masts or sails, such as the cobble pictured on a headstone at Kinnoull in Perthshire, although that memorial was raised in memory of Alexander Duff, who operated a ferry across the Tay. Rhynd in Perthshire has a stone with a plan view of a boat, within which lie two fish (dated 1733), and at St Vigeans (Angus), on a headstone of 1743 to John Cargil, two fish are surmounted by a crown. A line explains: 'The Royal Company of Fishing, being an Imperial Crown and under it two Herring.'

Lighthouses occur on very few stones, one notable example being that at Kilchoman on, Islay, erected in 1845 to James B. Scott, the assistant keeper of the Rinns of Islay Lighthouse. At Kirkmaiden (near Drummore, Wigtownshire) a tombstone of 1852 is shaped like a lighthouse.

Farmers' stones often have ploughs on them, although some have as little as the plough coulter, others as much as a ploughing scene, with a

Plough scene on a headstone at Straiton (Ayrshire)

plough, plough-herd and usually four horses pulling the plough. Ayrshire is particularly rich in the latter. A tablestone at Liberton in Midlothian (1754) has a scene from the farm: two horses and four oxen pulling the plough, two horses pulling harrows, a man scattering seed and another figure; in the background are the farm buildings and a range of hills, no doubt the Pentlands.

Stones to shepherds are far rarer. The best is located in Sorn kirkyard (Ayrshire) but is no longer in its original position, now standing against the kirkyard dike, near the gate. On it are carved the shepherd and his collie, the shepherd's boots being rather fine; he is carrying a crook, and stalking behind him, over the dog, is a skull, perhaps implying that he died while on the hill.

The best stone to a gamekeeper is undoubtedly that at Kells (Kirkcudbright) which was erected in 1777 to John Murray, keeper to John Gordon of Kenmure Castle. On it are carved Murray's powder flask, gun, fishing-rod, and dog, and a grouse. The epitaph, too, is of note, having been the subject of a competition, which was won by John Gillespie, the parish minister, with the following lines:

Ah John, what changes since I saw thee last,
Thy fishing and thy shooting days are past,
Bagpipes and hautboys thou canst sound no more,
Thy nods, grimaces, winks & pranks are o'er,
Thy harmless, queerish, incoherent talk,
Thy wild vivacity and trudging walk,
Will soon be quite forgot; thy joys on earth –
A snuff, a glass, riddles and noisy mirth –
Are vanished all. Yet blest I hope thou art,
For in thy station, weel thou played the part.

At Ruthwell (Dumfriesshire) is an old stone to Gilbert Conder, factor (farm manager) to Viscount Stormont for forty-one years, who died in 1709. The stone, which is made of sandstone, is very ornate, having trees, bushes and flowers carved on it, as well as thistles and tassles. Laurencekirk (Kincardineshire) has a stone of 1679 to a mossgrieve – the estate worker responsible for superintending the cutting of peat on the laird's moss for the use of the tenants. The stone, to 'John Wallentine', has on it a hand holding a coiled measuring-line.

Gardeners' stones are more common, for every estate at one time had a squad of gardeners of varying importance employed to tend the lawns and borders, the kitchen garden and ornamental grounds. The most common implements used by these men were the symbols used on the tombstones,

items such as the rake, spade and shears, as well as the string used to plant vegetables and other plants in straight lines. At Dundonald (Ayrshire) there is a stone with a rich floral pattern on it, surrounding a panel on which are carved the spade, rake and shears of a gardener, who is shown leaning against a tree trunk, with the added rarity of a lawn-roller. At Greenock, in the Old West churchyard, is a mural stone erected in 1754 by the Greenock 'Gardners Society' on which are carved a crossed spade and rake, level, string reel and bush or tree.

There are many other trades represented on the stones of Scotland's kirkyards, some by only one known example, such as the small headstone at Kirkcudbright on which are carved crossed spoons and rams' horns, erected in memory of 'William Marshall, tinker who died 28th Novr 1792 at the advanced age of 120 years'. Edinburgh's Canongate kirkyard has a memorial erected by the Society of Coach-Drivers, on which are carved a stage-coach and horses crossing a bridge. Dundonald in Ayrshire has a stone with bees, flowers and a beehive. Some Victorian stones to artists and musicians have

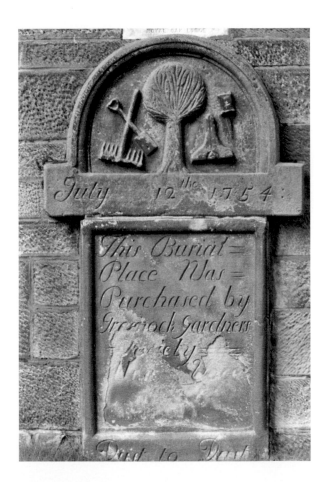

Stone marking the plots owned by the Greenock Gardners' Society, Old West Church, Greenock (Renfrewshire)

paint palettes and brushes or fiddles and harps on them – even the modern stone of 1948 to James Wintour, architect and photoprinter (at Aberlady, East Lothian), having a violin, T-square, dividers, adjustable set-square and a number of other items on it. Of artists' and musicians' stones, mention should be made of that to James Faed (died 1920) which has an artist's paint palette and brushes in bronze on a stone cairn (at Kells kirkyard, Kirkcudbright), and the headstone to the Reverend Hamilton Paul (died 1854) at Broughton in Peeblesshire, on which is carved a fiddle. Some poets and writers also had harps carved on their stones, two examples being that to James Hogg at Ettrick and that to Mary Macdonald at Inverness.

Other well-known Scottish tombstones which bear some form of symbolism are one-offs – or, at least, only one example of them appears to survive. One quite famous stone is the 'Faith Hope and Charity' in the Greyfriars burial ground in Perth, which dates from 1651. It commemorates someone called 'John Sh----', the name having been obliterated in 1828 when Robert Naismith 'revised' the stone for his own use. John appears to have been a tailor, for within two shields are a pair of scissors and an inverted iron. But the symbols above are of more interest, for many are strange and unexplained: there are two anchors, a set of scales, two winged souls, and a dove, three strange figures holding up their left hands, two of which support chalices, the third probably being a youth because of its size. Two birds in flight peck at an inverted heart, and a human-like cockerel is in the process of crowing. One bust of a person is holding a large crown, and there is an unusual ornate gateway, comprising three pillars supporting two arches. Two other figures are shown, one with long

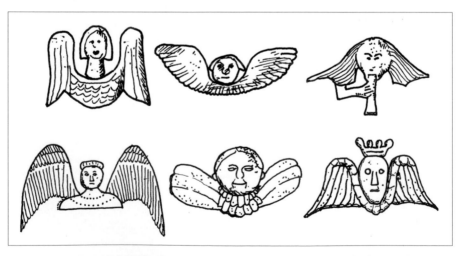

A selection of winged souls [Top Left to Right: Sorn (Ayrshire), Alvah (Banffshire), Straiton (Ayrshire), Keills (Argyll), Kells (Kirkcudbright), Old Calton (Edinburgh)]

hair, the other seemingly whispering to the first. A small bird is drinking from the uppermost chalice. Also on this stone are a Greek cross, crossed bones and the initials IS and I II I.

At Logie Pert in Angus is the only known Scottish example of the wheel of eternity. Four figures are placed on a wheel, whose hub is square. Two of these figures wear crowns, the others hats. Adjacent to them is the motto 'I shall ring, I do ring, I did ring, I once rang' – 'ring' being the Scots for 'reign'. In the available space the mason has carved ten flowers, some seeming to grow from the figures' cars!

Another fine tombstone is to be seen on the island of Eilean Munde in Loch Leven (Argyll), erected in memory of Duncan MacKenzie. Carved on this slab is a very detailed scene from the Battle of Prestonpans, at which he fought. It shows a kilted MacKenzie sporting a circular targe (shield) and pointed sword, in the act of slaying a dragoon who is falling from his horse and whose curved sword has fallen from his hand.

The Victorian period produced some symbolism, although in most cases more for its artistic quality than as a reminder of death. White marble statues of angels can be seen in many larger churchyards, and granite 'broken pillars' are also common. Urns with sheets draped over them surmount circular-section pillars, and stone chests may be found, not containing bodies as sometimes thought, an example in Ayr's old kirkyard having a worn stone knight's helmet on top. In Tibbermore kirkyard is a mural memorial to James Ritchie (died 1840) on which are carved a vase with flowers, bull, sheaf of corn, broom and two curling-stones. In Glasgow's Necropolis is a memorial stone to William Dick, secretary of the Scottish Football Association, who died in 1880, on which is carved a leather football.

A series of memorial stones can be seen all over Great Britain and beyond which bear carvings of badges. These are military graves, all similar in size, with a limited inscription, embellished by a carved representation of the deceased's regiment at the top. Hundreds of these stones exist, in some burial grounds laid out in rows to commemorate folk killed together. In some places foreign regiments are also represented. At Ballantrae (Ayrshire) is a military tombstone to an unknown sailor; at Dryburgh (Berwickshire) another is to Field Marshal Earl Haig.

Symbolism is very rare on modern tombstones, the cost of carving probably being the most obvious reason. However, a few examples are known, such as the memorial at Thurso (Caithness) on which appears a dustcart, and the monument to Maggie MacIver (died 1958) in Riddrie Park cemetery, Glasgow, which is shaped like a barrow filled with fruit. It was she who founded the street market known as the Glasgow 'Barras'.

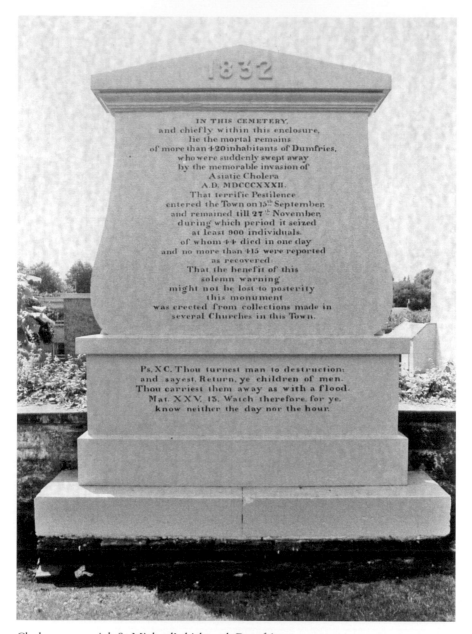

Cholera memorial, St Michael's kirkyard, Dumfries

CAUSE OF DEATH

Tombstones contain a vast wealth of untapped sources of local history, for on them are recorded little facts which, when assembled together in chronological order, can give a surprisingly accurate historical account of a town or parish. Stones do not just record a person's name, age and date of death but can also indicate to which trade he or she belonged, either by telling us straight or by using symbols, as explained in the previous chapter, and even the cause of death, if it was not just old age. The cause of death recorded on the tombstone can form one of the most fascinating facets of kirkyard study, for death in infancy, of disease, accidents and murders, through to longevity are all recorded in stone.

The main epidemics of disease which have swept through Scotland are bubonic plague, typhoid, smallpox and cholera. Cholera was one of the most recent, killing thousands in the first half of the nineteenth century, after which sanitary conditions were vastly improved and a fresh supply of drinking water was established in many towns and cities, thereby getting rid of many of the sources of the disease.

Although many people died of cholera, very few stones record this. One reason was that in many cases half a town was wiped out, and in an exceptionally short space of time, so that mass graves had to be dug, no stones being erected due to the numbers, and because families could not afford the number of stones required. Even where stones were erected, cholera's being the cause of death would not be recorded because it was seen as shameful, as a reflection on the cleanliness of the family and their home, rather than on the purity of the public water supply, which the main root of the problem was later discovered to be. Many towns had people in authority who had to see the corpse to verify whether or not 'pestilence' was the cause of death. If it was,

the whole house was subject to a cleaning, undertaken by the authorities, by use of fire and boiling water. The corpse was taken away without the honour of the bellman and hurriedly buried at night, often in an open field.

One of the few stones which do mention cholera is found within the town of Dornoch (Sutherland), erected over the spot where a supposed victim of the disease was buried, having been refused burial in the graveyard. The stone records that, 'It was supposed he died of cholera but afterwards contradicted by most eminent doctors'.

The considerable number of cholera victims meant that mass graves had to be created, sometimes in a corner of the parish kirkyard, in other cases in unconsecrated ground. One such is in Dumfries (St Michael's kirkyard), a largish stone memorial erected many years after the epidemic had subsided. It records that: '1832. In this cemetery, and chiefly within this enclosure, lie the mortal remains of more than 420 inhabitants of Dumfries who were suddenly swept away by the memorable invasion of Asiatic cholera, AD MDCCCXXXII. That terrific pestilence entered the town on 15th September and remained till 17th November, during which period it seized at least 900 individuals, of whom 44 died in one day, and no more than 416 were reported as recovered ...'

In Kilmarnock (Ayrshire) the number of victims of a cholera epidemic was so great that the kirkyards could not cope with the corpses, resulting in a corner of the public park being used as a mass grave. A memorial stone in Howard Park is 'Sacred to the memory of those inhabitants who died from cholera during the epidemic of 1832 and are here interred'.

In Dundee is a stone to 'William Forrest Esquire, Lieutenant Colonel in the HEIC Bengal Army, for many years inspector of their military stores in London, who died of cholera morbus on 29th July in the fatal year 1832 on his passage from London to Dundee'. It is to be seen in the Howff burial ground, as is that to 'John Grant, seaman, who arrived at Dundee with the *Friendship* from Davie's Straits, 4th October 1833 in good health and was seized with cholera on 8th October and died 9th October 1833'.

Bubonic plague spread over much of Scotland in phases from the fourteenth to the eighteenth centuries, and claimed many victims in the towns and countryside. Known to the masses as 'the Black Death', most of its victims were placed in mass graves, often without coffins, for the authorities made rules preventing their use, so that these graves could hold more bodies. At Cumbernauld (Dunbartonshire) in 1500, the plague so annihilated the populace that a special plea was issued to the See of Glasgow to allow them to establish a cemetery of their own, rather than have to walk the eight or so miles to the parish kirkyard at Kirkintilloch – the application was successful, the new graveyard being the site chosen for the new parish church of Cumbernauld when it was erected in 1650.

Memorial in Howard Park, Kilmarnock, marking mass grave of Cholera victims

Memorials to victims of the plague are far rarer than those to cholera victims, simply because it struck in a more remote period. However, at Brechin Cathedral, affixed to a wall, is a tablet erected years after the plague of 1647 had subsided, to the 400 victims of it who are buried in the cathedral yard.

Another tombstone to a plague victim exists at Largs, although it is not within a kirkyard but situated remotely in the Noddsdale valley, north-east of the town. Known locally as 'the Prophet's Grave', the stone commemorates one 'William Smith, minister at Larges, a faithful minister of the Gospell, removed by the pestilence, 1647'. The tablestone, which is still readable in parts, has been renovated a number of times, the last in 1956 when a plaque containing the inscription was erected nearby.

Two more tombstones of victims of the plague can be seen at Stonehaven in Kincardineshire. Like that at Largs, these are not located within a kirkyard but on the southern outskirts of the older part of the town, where they are built into a wall. A number of plague victims were interred here, but only these two stones were erected, or at least survive. One reads: 'Heir leys ane honest man, Magnus Tailliovr, seyman, qvha died in Stanehaven in the time of pest, 1608.'

Typhoid was another deadly disease which spread among the people of Scotland, particularly in the 1640s, between 1694 and 1707 (which were known as 'King William's ill years') and again in 1847. During

the 'ill years' virtually no tombstones were erected at all, even to non-victims, for it was a time of severe famine, and cash was at an all-time low. One solution, used at Easdale (Argyll), was to place all the victims in a mass grave and then erect a large cairn of boulders over them, thereby helping seal the ground in the hope that it would prevent any further outbreak.

Diphtheria claimed many victims all over the country, and one of the saddest memorials to victims of it can be seen in the tiny graveyard of Kilmory, on the island of Rum. One of only two 'modern'-type headstones here was '... erected by Murdo Matheson in memory of his beloved children, Rebecca who died Sept 1873 aged 12 years, Christian-Ann who died Sept 1873 aged 8 years, Murdo who died Sept 1873 aged 6 years, William John who died Sept 1873 aged 4 years, all of which died of diphtheria between the 7th and 9th Sept 1873'. A fifth child, Archibald Duncan, had died in 1871 at the age of seven months. The Matheson parents subsequently emigrated to New Zealand, no doubt this island having too many sad memories for them. A surviving son gave Lake Matheson its name.

Of other diseases recorded on tombstones some originated in foreign climes. One such was yellow fever, mentioned on the tombstone to the Small family at Broughty Ferry's Barnhill Cemetery (Angus), which records that Ormond Maxwell Small died at Georgetown, Demerara, of yellow fever in 1853.

Many parish kirkyards all over Scotland have an area within them free from memorials, and these are often still referred to as 'the cholera ground', even though other epidemic victims may have been placed there. The soil over these graves is never disturbed, for fear of letting the disease escape again. Recently, at Kirkintilloch (Dunbartonshire), when a new road was being created through an old burial ground, specialists with masks and gloves had to be brought in to remove the remnants of the victims, placing the remains in a new grave in the modern cemetery.

The victims of 'pestilence', as the various diseases were collectively known, were not allowed a proper burial, if they were allowed interment in the kirkyard at all. A number of parishes designated parts of open fields where pest victims were to be interred, such as those at Stonehaven and Largs. In some cases it is known that widows dug graves for their husbands with their bare hands, no one else living wishing to risk infection. In other cases victims of the pest were taken away and hidden from the public eye, so that they could die unseen, and therefore the people could not tell if they had died of disease or of other causes. A number of such cases resulted in fines or even hanging for the head of the family who had failed to report the death.

Other causes of death recorded on tombstones are more numerous than the rare memorials recording death by pestilence.

For example, kirkyard tombstones near the coast give drowning as the main cause of 'unnatural' death. In some kirkyards these are numerous, and in not a few instances a single tombstone can record two or more drowned victims, each in a different disaster. Hundreds of sea drownings are recorded on stones, and the following can be little more than a tiny selection of the many.

At Portpatrick (Wigtownshire) the kirkyard has many memorials to drowning victims: the *Orion* sank in 1850 with the loss of over fifty lives, the *Lion of Boston* in 1835. In Ayr's old kirkyard can be seen the fine sarcophagus of 'George MacKenzie, Lieutenant and Adjutant, 22d Bengal Native Infantry, who was drowned off Barrackpore on the 22d March 1844 aged 25 years and 3 months'. St Michael's kirkyard near Faslane

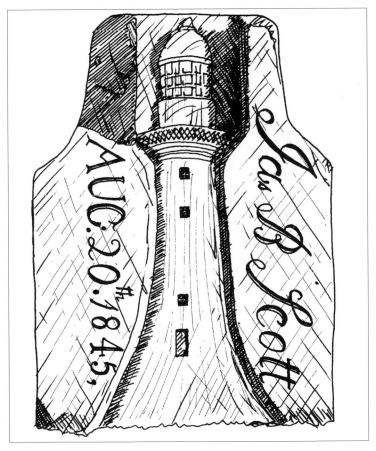

Headstone at Kilchoman (Islay) depicting a lighthouse

(Dunbartonshire) has a number of gravestones of victims of the *K13* submarine disaster which occurred during trials in the Gare Loch in 1917, killing thirty-two sailors and shipbuilders. On Islay a small graveyard was created at Kilchoman in which were buried the victims of the sinking of the *Otranto* in 1918: there are seventy-four stones to the servicemen whose bodies were washed ashore. At Fort Augustus (Kilchuimen) in Inverness-shire there is a headstone to John Anderson, the 'Jo' of Burns' song, and his son-in-law, James Grearson, who was 'lost in the *Comet* off Gourack [*sic*] Point on the 21 Octr 1826'.

An example of how many sailing victims can be found in a single kirkyard is the churchyard of Doune, within Macduff (Banffshire). On a visit there I counted no fewer than twelve victims of shipwrecks, sinkings and so on, between the years 1823 and 1911. St Mary of the Storms chapel near Stonehaven (Kincardineshire) has a memorial to members of the Stonehaven lifeboat team who perished while trying to save the crew of the *Grace Darling* in 1874. In Broughty Ferry's St Aidan's kirkyard (Angus) there is a stone to four members of the same family who were lost at sea – Robert and Agnes Williamson, who died in 1861, Alex Smith in the same year, aged sixteen, and Thomas Small in 1872. Eyemouth (Berwickshire) has stones to many of the victims of the Eyemouth disaster of 1881, when 129 of the village fishermen were killed during a single storm, leaving the male population decimated. The kirkyard also contains a monument to all the victims of this tragedy.

Just as the sea claimed many sailors' lives, so the coalfields have claimed many mine-workers. Being in a coal-mining area, many kirkyards in the towns and villages near my home, at Cumnock, have numerous stones to men who were killed when shafts or tunnels collapsed, or gases ignited. In recent years there have been a couple of memorials erected to all the victims of mining accidents, much in the same way as villages erected memorials to victims of war. These exist at Kirkconnel (Dumfriesshire), New Cumnock and Cumnock (both Ayrshire).

Mention of New Cumnock brings to mind the Knockshinnoch disaster of 1950, in which thirteen men were killed when the mineshaft burst and the peaty moss above it filled it in – this becoming the basis of the film *Brave Men Don't Cry*. Most of the victims were interred in the village's new cemetery, at the mouth of Glen Afton, which also contains at least fourteen other stones recording deaths in that mine and others.

At Dailly in the same county is a memorial to John Brown, who was not exactly a mining accident victim but was virtually so. The tombstone, which stands by the south wall of the old kirkyard, tells his story: 'In memory of John Brown, collier, who was enclosed in Kilgrammie Coal Pit by a portion of it having fallen in, Octr 8th 1835, and was taken out

alive and in full possession of his mental faculties but in a very exhausted state, Octr 31st. Having been twenty three days in utter seclusion from the world, and without a particle of food, he lived for three days after, having quietly expired on the evening of Novr 3d aged 66 years.'

Many other tombstones record victims of accidents which occurred while the person was at work. Policemen killed when on duty are commemorated on a number of stones, one modern one at Strathblane (Stirlingshire) coming to mind, in memory of Iain Purdie, killed in 1981, and an older one at Greenock (Renfrewshire) to Lachlan MacKinnon, Inspector of Police, ' ... who was by violence and while in the discharge of his duty suddenly deprived of life on 1st January 1869 aged 39'. In Girvan's old kirkyard (Ayrshire) is a stone to Alexander Ross, a special constable, signed on in anticipation of trouble during an Orange walk to be held in the town. He was shot just outside Girvan, on the road to Ayr, where a boulder marks the spot, and was buried in the old kirkyard, where an obelisk was ' ... erected by 500 of the inhabitants of Girvan to the memory of Alexr Ross who, while discharging his duty as a Constable, was shot by an Orangeman on the 12th of July 1831'. His murderer was afterwards hanged at Ayr.

Quarry-workers' deaths in accidents are recorded on stones the length of the country, particularly in areas where the stone proved to be a popular choice for building. Cumnock has a number of stones recording victims of quarry accidents, particularly in the Benston quarry. One stone records that John Miller died there on 16 January 1815 at the age of twenty-six and goes on to record the death of his brother, Matthew, aged twenty-eight, who was killed in the same place a few months later, on 3 April. Also killed in a quarry, but not as workers were Hugh Prichard, his wife and child, 'an infant at the breast'. He was a soldier but had been discharged due to blindness, and became a wandering minstrel. On the night of 20 April 1816 they took shelter in a gravel pit near Twynholm (Kirkcudbright) which collapsed in a storm, killing them. At the time no one in the parish knew who the people were, so a stone was erected over their grave by local ministers. In later years it was discovered that the minstrel had been Hugh Prichard, from Llandegai in Wales. In 1946 a second stone was erected at the foot of the grave announcing this and also noting the fact that ' ... the nameless minstrel was the original of "Wandering Willie" in Sir Walter Scott's novel, *Redgauntlet.*'

At Tweedsmuir (Peeblesshire) a stone was erected ' ... to the memory of the men who died during the progress of the Talla Water Works, 1895-1905, of whom over thirty are interred in this churchyard'. At Ayr (Holmston cemetery) is a memorial to twenty-six victims of a fire at Ayr Carpet Works, which occurred in 1876, and at Bridgeton (Glasgow)

another can be seen to a number of victims of a fire in a warehouse in 1856. At Elvanfoot (Lanarkshire) a tablet records that thirty-six men were killed in 1847 while constructing the railway from Clydesdale over the Beattock Summit to Annandale.

Single incidents of people killed while working exist in almost every kirkyard or cemetery within Scotland. Only a few examples from different occupations can be mentioned here, but the reader has only to visit a couple of kirkyards himself to add to this list. In the newer half of Glasgow's cathedral yard is a stone to Neil Reid, a bricklayer, who was killed when he fell from a chimney stalk in 1818; Catrine (Ayrshire) has a stone to Thomas Hector, killed in the *Daphne* disaster (a ship capsizing at launch) at Govan in 1883, aged sixteen (146 men were lost in that incident, and stones to them are more common in Govan and Clydeside); James Hunter Wright, steeplejack, fell from a church steeple in Jedburgh in 1765 and was interred at Lilliesleaf (Roxburghshire); George Tait (Longside, Aberdeenshire) was 'killed by the fall of a stack of timber at Peterhead' in 1758; Archibald Bain was killed in 1879 when the Tay Bridge collapsed, and was interred in Dundee's West Cemetery. James MacGeorge and John Goodfellow, postmen, were killed in a blizzard near the Devil's Beef Tub while trying to carry the mail onwards to Edinburgh; a memorial marks the spot, and two stones to them can be seen in the kirkyard of Moffat (Dumfriesshire).

Shepherds, by the nature of their occupation, have often been caught out in blizzards while trying to rescue sheep caught in snow drifts. Stones to them can be seen at Barr (Ayrshire – Christopher MacTaggart, 1913) and Kilmun (Argyll – Archibald Clerk, 1854). There are also some to gamekeepers who died in the snow, such as that to David MacMath (Carsphairn, Kirkcudbrightshire, 1925).

Children who died in infancy are recorded on numerous tombstones. The various causes of death can sometimes be recorded, but most often 'died in infancy' is all that is stated on the tombstones, very often because the cause of death was not rightly known. There are a surprising number of stones all over Scotland in which a whole family of children were wiped out in their youth, and a visit to any kirkyard will reveal this. One example is the following inscription from a tombstone in Mauchline kirkyard (Ayrshire): ' ... William Alexander who died 1855 aged 73 years and his children; Robert aged 2 years, Janet aged 2 months, Jane aged 9 months, Katherine aged 9 years, William aged 1 year, Mary aged 8 years.' They were the grandchildren of John Richmond, writer, in Mauchline (1732-1816) a friend of Robert Burns. That at Doune kirkyard, Macduff (Banffshire), was erected by Barbara MacKay who died on 31 August 1844, aged forty-eight, 'having had eleven of her children, all under 5 years, interred before her'.

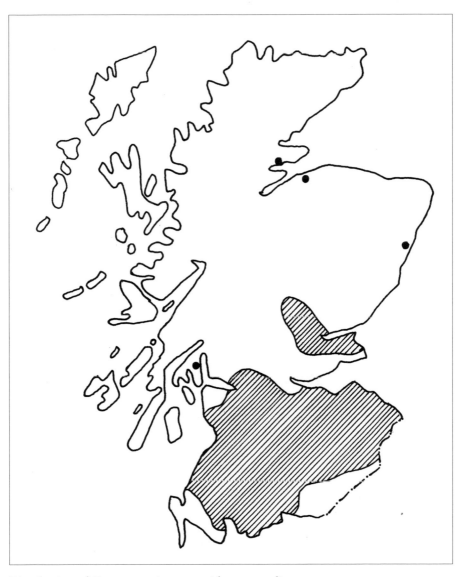

Distribution of Covenanters' graves with some outliers

A few stones record children with no names, who were born and died before any name was given to them. Some record a series of children with the same name, particularly in the case where it is a son, named after his father or grandfather, for the Scots had a fairly well-organized system of naming, the eldest son being named after the grandfather on the paternal side, the second after the father, any other sons for uncles or the maternal branch of the family. Therefore a son could be named James for his grandfather, only to die soon after, the next son would again be named James, and if he died, a third son born after his death could be christened James also. There are also a few stones recording stillborn births.

A stone at Cambusnethan (Wishaw, Lanarkshire) was erected to the memory of James Weir, who died in 1821, aged seventeen months. The inscription goes on to add that, 'This child, when only thirteen months old, measured 3 feet 4 inches in height, 39 inches round the body, 20½ inches round the thigh, and weighed 5 stone. He was pronounced by the faculties of Edinburgh and Glasgow to be the most extraordinary child of his age upon record.'

A memorial stone in the kirkyard of Kenmore at the foot of Loch Tay (Perthshire) was erected in memory of an infant son of the Maharajah Duleep Singh, late ruler of the Sikh nation, Punjab, India, and of the Maharanee his wife. He was born on 4 August 1865 and died the day following.

Murder is commemorated on a number of stones all over Scotland, by far the greatest number of such being those to the Covenanters, who sought religious freedom in the latter half of the seventeenth century. These 'hill-men' had to leave their homes and find refuge on the mountains and moors because it was deemed illegal and a killing offence not to attend the parish kirk regularly, these having been taken over by the Government and run by 'curates', ministers appointed by the Crown. A fair number of ministers who had formerly held the parish charge were 'ousted' for non-compliance – that is, for not agreeing that the King had superiority over the Kirk in Scotland, and they fled to the hills. There, famous preachers – such as Richard Cameron, Alexander Peden, Donald Cargill and James Renwick – held 'conventicles' which were attended by hundreds, and in some cases thousands, of Covenanters. At first the authorities were lax regarding these goings-on, but in time it became illegal even to carry a Bible in the country, for to do so would strongly indicate Covenanting adherence and that the suspected person might be off to join a conventicle. The so-called 'killing years' of 1684 and 1685 were the most vicious of the long struggle, hundreds of people being executed for no crime other than the fact that they would not conform to Episcopacy.

Kirkyards all over Scotland have tombstones to victims of the years of Covenanting persecution, but no area is as rich in them as the south-west

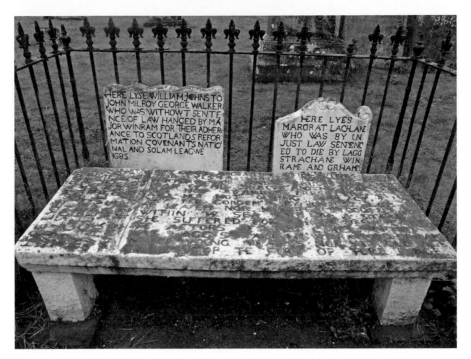

Gravestones at Wigtown to the Wigtown Martyrs

corner of Scotland, particularly the counties of Ayr, Lanark, Kirkcudbright and Dumfries, where virtually every parish kirkyard contains at least one Covenanter's grave. Many more are to be seen on the moors and hills which the Covenanters were forced to frequent, the bodies of the shot hill-men being buried where they fell, for burying the body in the kirkyard could result in another death.

Only some of the more noted Covenanters' graves can be mentioned here; others are listed in the Appendix: Notable Graves; those wishing to find out more about the many which can still be seen should read the author's *The Covenanter Encyclopaedia* which lists all graves and monuments, with short details on how to reach them, or join the Scottish Covenanter Memorials Association, which cares for those monuments and gravestones.

At Wigtown, on the south coast of Scotland, there are three gravestones within a single enclosure in the old kirkyard. Two of these commemorate female martyrs, a rare occurrence, the third being to 'William Johnston John Milroy George Walker who was without sentence of law hanged by Major Winram for their adherence to Scotland's reformation covenants national and solemn league, 1685'. (The poor grammar is typical of many of the older tombstones.) The two women commemorated are Margaret

Wilson and Margaret Lachlane (or MacLachlan), the former just eighteen years old, the latter sixty-three. Margaret Wilson's tombstone has the following epitaph, which tells something of her story:

> Let earth and stone still witness beare,
> Their lyes a virgine martyre here,
> Murter'd for ouning Christ supreame,
> Head of his church and no more crime,
> But not abjuring presbytry,
> And her not ouning prelacy,
> They her condem'd, by unjust law,
> Of heaven nor hell they stood no aw,
> Within the sea ty'd to a stake,
> She suffered for Christ Jesus sake,
> The actors of this cruel crime,
> Was Lagg, Strachan, Winram and Grhame
> Neither young yeares nor yet old age,
> Could stop the fury of there rage.

Two of the 'actors of this cruel crime' in the above epitaph were among the most bloody perpetrators of the King's wishes. Graham was 'of Claverhouse', also Viscount Dundee, the 'Bonnie Dundee' who was killed at the Battle of Killiecrankie in 1689 and who is interred in the Atholl vault at Old Blair kirkyard, within Blair Castle grounds (Perthshire), Lagg, or Lag, was Sir Robert Grierson of Lag and Rockhall, created a baronet after the 'killing times', mainly for his work during them. He was buried at the old kirkyard of Dunscore (Dumfriesshire), but not until some nefarious happenings had supposedly occurred (mentioned in Chapter 9).

In Hamilton old kirkyard is a tombstone to 'the heads of John Parker, Gavin Hamilton, James Hamilton and Christopher Strang, who suffered at Edinburgh, Decr 7th 1666':

> Stay passenger, take notice what thou reads;
> At Edinburgh lie our bodies, here our heads,
> Our right hands stood at Lanark, these we want,
> Because with them we swore the Covenant.

Carved on the stone are four heads, originally displayed in the town as a warning to others. A similar sort of thing occurred at Cupar in Fife, where a headstone is carved with the heads of Laurence Hay and Andrew Pitulloch, and the hand of David Hackston.

Tweedsmuir kirkyard (Peeblesshire) has three stones in memory of John Hunter, a Covenanter shot at the Devil's Beef Tub while he was visiting a sick friend. Two of them mark the head and foot of the grave, the third being an obelisk standing near the kirk door.

Fenwick (Ayrshire) has a fine selection of stones to martyrs, perhaps the most noted being that to James White, which contains an epitaph which Sir Walter Scott memorized at an early age and could never forget. It was no wonder, when we read of the gruesome spectacle.

This martyr was by Peter Ingles shot,
By birth a tyger rather than a Scot,
Who, that his monstrous extract might be seen,
Cut off his head & kick't it o'er the green,
Thus was that head which was to wear a crown,
A football made by a profane dragoon.

A Covenanter's tombstone in the kirkyard of Galston (Ayrshire) shows Andrew Richmond pointing at an open Bible, while a soldier is taking aim with his rifle, a sword hanging round his waist, and a steel helmet upon his head. Between the two is an hourglass.

At Ayr there is a headstone to seven martyrs who were executed in the town as a warning to the townspeople of what would happen if they joined in any of the uprisings. The men were not of the county but were brought here and hanged as an example, the same happening in Dumfries and elsewhere. There were originally eight men to be hanged, but the burgh hangman disappeared, and the hangman brought from Irvine refused to do it, even under threat of torture. Therefore the authorities announced that one of the men could go free if he would agree to hang the remaining seven. Cornelius Anderson agreed, if only his associates would offer him forgiveness. This was forthcoming, and following the execution Anderson emigrated to Ireland, where he died insane.

The number of Covenanters' graves to be seen in the kirkyards of southern Scotland is far too numerous to enable more to be mentioned here. Suffice to say that they are all recorded in various books, particularly old guidebooks, and are usually well known by the locals, who can easily direct an inquisitive visitor to them. Many are exact copies of the original stones erected some time after the revolution of 1688, so the inscriptions and epitaphs are of an early date. A recent example is the small headstone to be found within a wood in Glen Trool (Kirkcudbrightshire) which was 'highly venerated as being the first to be erected by 'Old Mortality' according to Sir Walter Scott. It recently suffered destruction by wanton vandalism, but has been replaced by an exact copy, including the same

ungrammatical inscription and use of ligatures, only this time in white Creetown granite, rather than the softer red sandstone of Nithsdale, from where 'Old Mortality' originated.

Old Mortality was the by-name of Robert Paterson, a quarrier and mason who left his home and family to travel Scotland erecting and repairing the memorials to the Covenanters. He gained his nickname from this devotion to erecting graves and the tale was used by Sir Walter Scott in his Covenanting novel, also called *Old Mortality*.

Of the tombstones of other victims of murder, all over Scotland, a selection follows.

At Portpatrick (Wigtownshire) is a stone to Sir James Montgomery, who died in 1652, the cause of death being recorded in his epitaph:

Sir James by pirates shot, and therefore dead,
By them i' the sea was solemnly buried.

Near Newcastleton (in Ettleton churchyard) a memorial stone records that William Armstrong of Sorbytrees was 'shot without challenge or warning in 1851 by the Revd Joseph Smith, incumbent of Walton, Cumberland'. Bridgeton (Glasgow) has a memorial to victims who were killed in the weavers' riots of 1787; it is located within Abercrombie Street burial ground. Another stone to a murdered weaver can be seen in the Howff burial ground, Dundee, which records that, 'James Hill, weaver, Dundee ... was barbarously murdered in Chapelshade Dundee on the evening of the 1st or early on the morning of the 2nd January 1799 at the age of 21.' A memorial in the kirkyard of Teviothead (Roxburghshire) was erected in 1897 to the memory of 'John Armstrong of Gilnockie and a number of his followers, who were treacherously taken & executed at Carlanrigg by order of King James the V during his expedition to pacify the Borders in July 1530'. At Slains (Aberdeenshire) is a tombstone to Philip Kennedy, '... one of a band of smugglers who long carried on their illicit traffic with success. One night he & his brother were attacked by the Excise – Philip's skull was struck open by a sword – he rushed home & died there. The Excise Man was tried for murder & was acquitted.'

Several kirkyards have memorials to the victims of 'disasters' – often a single memorial to all the victims, when bodies were unidentifiable and were placed in a mass grave. In Rosebank cemetery (Leith, Midlothian) there is a mural monument to the many soldiers killed at Quintinshill, near Gretna (Dumfriesshire), on 22 May 1915, when a troop train, carrying soldiers from Edinburgh and, in particular, Leith, to fight in the Great War in Turkey, crashed head-on with a service engine, with the loss of 227 young soldiers' lives. The bodies of the victims were buried at Leith

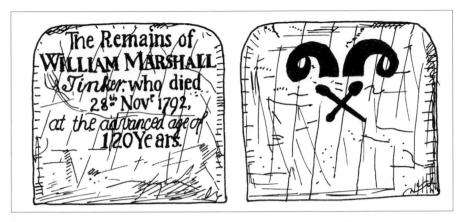

Billy Marshall's tombstone at Kirkcudbright with tinker's symbols

Grave of John Taylor, who died aged 137, Leadhills cemetery (Lanarkshire)

on the 24th, the funeral procession taking over three hours to reach the cemetery.

Civilians who were killed in air raids are commemorated at Greenock (Renfrewshire), Clydebank (Dunbartonshire) and elsewhere. Greenock's memorial is found within the Craigstop Hill cemetery, the white granite stone commemorating victims of the air raids of 1940 and 1941. That at Clydebank is found within the Dalnottar cemetery and is '... dedicated to the memory of the citizens of Clydebank who lost their lives through enemy action in March 1941'. A number of parishes also have their war memorial or cenotaph located within the parish cemetery, New Cumnock, Cumnock and Auchinleck (all Ayrshire) being examples.

In Paisley (Renfrewshire) there is a monument in the Hawkhead cemetery 'To the memory of the seventy-one children who lost their lives in the Glen Cinema disaster, 31st December 1929'. It lists all the children's names, in some cases three from a family.

In contrast to those who died prematurely, as the result of accident or disease, are those who lived longer than the biblical 'three score years and ten'. A vast number of people have lived to be much older than seventy years, and so only those who have survived longer than a century are worth mentioning. Very often the age of the deceased is noted on the tombstones with some pride, especially those who lived into their second century.

Dunbar (East Lothian) has a selection of stones commemorating people who died in their eleventh decade, including Lieutenant Colonel William Stiell of Belhaven, who died in 1810, aged 104. Also interred here are some of the Reid family, one of whom died aged 104, another aged 105 and a third, Magnus Reid, in May 1786, aged 114. Longevity did not, however, run in the Reid family, for Magnus's two grandchildren died in infancy. Roxburgh kirkyard (Roxburghshire) has the grave of Andrew Gemmels, better known to Scott readers as 'Edie Ochiltree' of *The Antiquary*. He died in 1793 at the age of 106, and his headstone, erected in 1845, depicts 'the gentleman's beggar' with his stick, dog and bag. Preston kirkyard (Berwickshire) has a stone to William Carlisle, a coachman, who died on 16 September 1831, aged 108, with the distinction of having had his portrait painted by Thomson of Duddingston when he was 100 years old.

Braemar kirkyard (Aberdeenshire) has a stone to Peter Grant, who died in 1824, aged 110. At the age of 106 he successfully petitioned George IV for a pension, signing himself 'His Majesty's oldest enemy', since in 1746 he had fought at Culloden for the Stuarts. At Kirkcudbright is a small headstone to William Marshall (mentioned in Chapter 4), who died at the age of 120. Leadhills (Lanarkshire) has a tablestone to John Taylor, who died 'at the remarkable age of 137 years'. He is known to have been still working in the lead mines well after his hundredth year, but some locals

reckon that he was in fact only 134 when he died! Inverlussa (Jura) has a stone to Mary MacCrain, who died in 1856 at the age of 128, and also commemorates Gillouir MacCrain, Mary's antecedent (who was actually buried at Keils kirkyard, on the same island), stating that he '... spent 180 Christmases in his own house and ... died in the reign of Charles I'. There has been some speculation as to whether Gillouir did live to be 180, some people claiming that Christmas was celebrated twice in some Highland parts, once with the old calendar and again with the Gregorian calendar, so that he was in fact only ninety when he died. Others are convinced that he was more than 180 years old, for if he spent 180 Christmases at home, what age must he have been if he spent other Christmases elsewhere?

6

EPITAPHERIE

The inscriptions which occur on tombstones can form a most interesting aspect of kirkyard study, and their information is often of considerable use to the local historian, the genealogist or just the curious. Even the style of script used on the tombstones can be of interest, different masons employing different styles, different areas fostering different layouts. Examples include the ornate form the word 'Erected' takes at the head of the tombstone, usually with impressive curlicues surrounding it, the rest of the inscription being written in simple script, and the use of ligatures, the practice of joining two or more letters so that the mason had less work to do, for an upright stroke could suffice for two letters. Robert Paterson, 'Old Mortality', used this means often on the many tombstones he carved for the martyrs for the Covenant, although other early masons used this method also.

By far the most common aspect of tombstone inscriptions for study are the epitaphs, the rhyming verses composed in honour of the deceased or warning the reader of the inevitability of death. Many tombstones of the seventeenth, eighteenth and nineteenth centuries contain epitaphs, but they have become rarer in modern times because of the expense of each letter, although a number of modern stones do contain verses. It is sad that epitaphs do not receive the same depth of study as the symbolism on stones, perhaps simply because to the average visitor the symbols are at once obvious, whereas they often have to strain to make out the inscription, and also because many of the epitaphs are rather uninteresting or, at least, not so fine as those famous ones which have been written in books for years.

There are some epitaphs which can be found all over the country, others which were written for a single person and therefore are unique. Who the

authors of the epitaphs were is generally unknown, but in many cases it is reckoned that the local minister or the dominie (schoolteacher) was responsible, one known case being that at Kells (Kirkcudbright) which was written by the minister in memory of John Murray, who died in 1777 (See Chapter 4). In a few cases minor, or not so minor, poets wrote verses for stones, some of these being mentioned later in this chapter.

It is interesting to work out possible sources for some of the more common epitaphs, by plotting dates when they occur and the places where they are to be found. One of the most noted is the following:

> Remember man, as thou goes by,
> As thou art now so once was I,
> As I am now so must thou be,
> Remember man that thou must die.

This transcription is the version found at Straiton (Ayrshire) on a headstone with no legible date, but I have noted many examples of this same epitaph from all over Scotland. The earliest is perhaps that at Laurencekirk (Kincardine) which is dated 1656 and is in memory of William Lawson, who died at the age of thirteen:

> Readers consider wel that he,
> Who lyes heir nov, was one as ye,
> As he is nov so ye must be,
> Remember al that ye mvst die.

The original of this verse is to be found on the tomb of the Black Prince (d. 1376) in Canterbury Cathedral, which has a long inscription in French. John Weever, who wrote *A Discourse of Funerall Monuments* in 1631, translated it into English, the relevant lines running:

> Such as thou art, sometime was I,
> Such as I am, such shalt thou be.

Following this the epitaph was copied on many tombstones throughout Britain, with various adaptations made to suit local taste.

Another common epitaph runs as follows:

> Afflictions sore long time he bore,
> Physicians were in vain,
> Till God did please to give him ease,
> And free him from his pain.

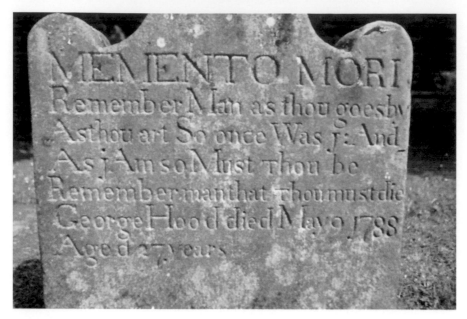

'Remember man' epitaph at Loudon Kirk (Ayrshire)

This one comes from Dundee's Howff burial ground (1812), where at least two more in the same vein can be seen. The words could be changed to suit different persons, such as 'she bore', 'they bore', 'we bore', etc., or else altered a fair amount, as on the following from Carmyllie (Angus):

> Worn by disease, and rack'd with pain,
> Physician's aid was all in vain,
> Till God, in his great love, saw meet,
> To free him from his sorrows great.

An often-quoted epitaph from the burial ground of Elgin Cathedral is found on the tombstone of John Geddes, glover, who died in 1687, which depicts his scissors, a glove and crossed bones. It is not unique to Elgin, however, for similar lines occur on stones elsewhere in Scotland, as well as in England. Elgin's, however, is the earliest and, as it occurs on a very fine stone, deserves to be the most quoted:

> This warld is a cite full of streets,
> & death is the mercat that all men meets,
> If lyfe were a thing that monie could by,
> The poor could not live & the rich would not die.

Also quite common is the following epitaph, this version taken from the gravestone of Robert Johnston, smith, who died in 1732 and was buried in the kirkyard of Manor (Kirkton Manor) in Peeblesshire:

Death is a debt to nature due,
Which we have paid, and so must you,
Life how short, eternity how long!
Then haste, oh haste! make no delay,
Make peace with God for the great clay.

Writing in 1700, Sir Henry Chauncy stated that, 'Monuments serve for four uses or ends: They are Evidence to prove descents and Pedigrees. 2. To shew the time when the party deceased. 3. They are examples to follow the Good, and eschew the Evil. 4. Memorials to set the living in mind of their Mortality.' The same four ends are relevant to the epitaph, and we find examples of each on tombstones. The 'third end', calls from the grave to passers-by to repent their sins and make peace with God, is very common on tombstones, such as the following example from Edinburgh's St Cuthbert's kirkyard:

Hark from the tomb a solemn sound!
'Prepare, prepare,' it cries,
'To drop your body in the dust –
Your soul to mount the skies.'

And that from Dunbar (East Lothian):

In dust I lie as you must all,
O be prepared when God will call;
If not prepared what shall we say,
When we meet Christ on judgment day?

The Reverend John Middleton of Rayne (Aberdeenshire), who died in 1653, has on his grave the following warning:

As late I stood in pulpit round,
And now I ly alow the ground,
When as you cross my corpse so cold,
Remember the words that I you told.

Chauncy's fourth reason for memorials was to remind the living of their mortality, another aspect reflected in epitaphs. Perth has a tombstone which bears the following statement:

Reader, one moment stop and think,
That I am in eternity, and you are on the brink.

At Dollar (Clackmannan), a stone warns that:

'Thou mayst be the nixt that dies!'

Life after death is also mentioned in a number of epitaphs, reminding the reader that death is not a sad time but a period of rejoicing as the soul wings its way to heaven to be in the company of its maker. At Minnigaff (Kirkcudbright) a stone of 1777 asserts:

This grave is but a finning pot,
Unto believers arise,
For when the soul hath lost its dross,
It like the sun shall rise.

At Kirkland of Morton (Thornhill – Dumfriesshire) a stone of 1660 has the verse:

Man is grass, to grave he flies,
Grass decays and man he dies,
Grass revives, and man cloth rise,
Yet few then appreciate the prise.

That all are equal in death is noted on a number of tombstones, although it is noticeable that it most often occurs on those of commoners, rather than on those of knights and peers. Verses claiming equality in death date back to the time of Ancient Rome, for Horace wrote: *Pallida Mors, aequo pulsat pede pauperum tabernas Regumque turris* ('Pale death, with impartial foot, strikes at poor men's hovels and the towers of kings'). Versions of these lines occur on many tombstones, as at Dunfermline in Fife:

Time cuts down all,
Both great and small

– at Campbeltown (Argyll):

This little spot is all I've got,
And all that kings acquire ...

– and at Cupar (Fife):

Through Christ I'm not inferior
To William the Conqueror.

Eassie (Angus) has a rather down-putting epitaph on a tombstone:

Remember man, that against death
There is not an antidote,
Be rich or poor, or what you may,
You'll die and be forgot.

In the same county the kirkyard of Farnell has the following two lines as
the start of a longer epitaph:

'Tis here the fool, the wise, the low, the high,
In mixed disorder, and in silence lie.

The Scot has always been proud of his ancestry, ever since the years of the
clan system, when clansmen could recite from memory their ancestry for
generations backward, and Sir Henry Chauncy listed family pride as the
first reason for erecting monuments. In this vein, Wigtown kirkyard has a
stone announcing:

Frazer MacCrachan near this stone here lyes,
Twelve generations, many familys,
Those ancient clans each age to dust did come,
May teach that here is not our fixed home.

Aberlemno (Angus) has a stone to the Spence family, dated 1756, which
states that:

Here lyes an honest old race,
Who in Balgavies land had a place
Of residence, as may be seen,
Full years three hundred and eighteen.

In the same county, a branch of the same family is pleased to announce the
extent of their ancestry on the same lands, taken from the kirkyard of Guthrie:

Beside this stone lye many Spences,
Who in their life did no offences,
And where they liv'd, of that ye speir,
In Guthrie's ground four hundred years.

And then there are those who claim to have the most honourable ancestry of all, as on a tombstone in St Cyrus kirkyard (Kincardine):

> If honour wait on pedigree,
> And ancient blood we boast,
> I claim descent from Adam,
> Who of mankind was first.

Epitaphs which include dates of death can also be found (Chauncy's second reason). Prestonpans (East Lothian) has the following example:

> William Mathison here lies,
> Whose age was forty-one;
> February 17 he dies,
> Went Isabel Mitchell from,
> Who was his married wife,
> The fourth part of his life.

Husbands and wives often composed stirring lines in memory of the deceased partner, or copied others from different kirkyards, for epitaphs of this sort can be seen in a number of cemeteries. One of the most notable is the following:

> She was ...
> But words are wanting to say what,
> Think what a wife should be,
> And she was that.

This verse could, of course, be altered slightly to suit deceased husbands, or even to the wording seen in Paisley:

> He was ...
> But words are wanting to say what,
> Think what a friend should be,
> And he was that.

An epitaph on a memorial in the old graveyard at Cumnock (Ayrshire) is in honour of Ann Menzies, spouse of James Johnston, who, tradition has it, less than appreciated her while she lived but following her early death wrote a stirring passage claiming that she was 'surpassed by none'. The composer of the following epitaph, however, believed to occur at Biggar, had not changed his opinions after his wife's death:

On a cold pillow lies her head,
Yet it will rise again 'tis said,
So prudent reader watch how thy walk,
For if she rise again – she'll talk!

Child deaths were very often commemorated by epitaphs in their honour. A vast variety of these exist, some simply stating how devoted their parents were to them, others being calls from the grave, the child reminding passers-by that death can and does strike at any age and that no one knows when the time will come. An example of the former can be seen in the kirkyard of Dundrennan (Kirkcudbright):

He was a manly pretty boy,
His father's hope, his mother's joy
But death did call, and he must go,
Whether his parents would or no.

This epitaph is found on the headstone of Douglas Crosby (died 1789, aged seven), who was the original of the poem 'The Boy and the Snake', by Charles and Mary Lamb. Colvend in the same county has another example of the warning, as:

In youth prepare thyself to die,
For life is short, and death is nigh,
Death did me little warning give,
Therefore be careful how you live.

Edinburgh's Greyfriars kirkyard has the following epitaph on the grave of a young girl:

The sweetest children are but like fair flowers,
Which please the fancy for some days and hours,
They soon spring up, but ere they be well grown,
They fade away, their place is no more known;
Only their death, sure, leaveth such a smart,
That griefs engraven on the parents' heart.

The following verse (from Duns, Berwickshire) is to be found in a number of versions all over Scotland:

Beneath this stone three infants lie,
Say are they lost or saved?

If death's by sin, they sinned, for they are here;
If heaven's by works, in heaven they can't appear,
Revere the sacred page, the knot's untied –
They died, for Adam sinned, they lived, for Jesus saved.

There is a quite common epitaph which describes the different lengths of
man's life by comparing it with a single day. This epitaph can be seen in
Stirling and Canonbie (Dumfriesshire) and elsewhere:

Our life is but a winter's day,
Some only breakfast and away,
Others to dinner stay and are full fed,
The oldest man but sups and goes to bed,
Large is his debt that lingers out the day,
He that goes soonest has the least to pay.

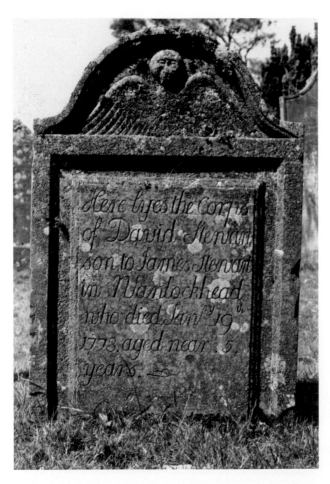

Headstone at
Wanlockhead
(Dumfriesshire) to a
child who died 'near 5
years'

The goodness of a man or woman was commonly mentioned on a gravestone inscription – 'Here lyes ane honest man ... ' or 'his virtuous and obedient wife' – and within the epitaph, as on the stone of Thomas Stoddart, Peebles:

> Thomas Stoddart lyes here interr'd,
> Who liv'd and died an honest herd.

A fairly common example is the following:

> They may write epitaphs who can,
> I say here lies an honest man.

At Duffus parish kirkyard (St Peter's, Moray) Robert Logie, carpenter, is commemorated by the lines:

> He was a just and pious man,
> And to say more is unnecessary,
> And to say less would be ungrateful.

By far the favourite epitaphs amongst hunters are those which are humorous or contain puns. Although a few examples of these can be seen in Scotland, they were not as popular as they were in England, at least far fewer survive. In many districts the kirk session had to approve of each inscription so any humorous verses appearing on Scots tombstones tend to be accidental or else of a rather pawky sort of humour. Some of the more hilarious ones to be found within anthologies of epitaphs are fictional or else the tombstones on which they occurred have disappeared.

Charles Rogers, in *Monuments and Monumental Inscriptions in Scotland*, lists some examples which were in existence in his day (1871), as well as a few reported earlier which had disappeared. From his two volumes we have the following:

> In memory of a brother,
> And if ye dinna ken the name,
> Yell just look at the muckle stane,
> But see ye dinna pu' the thyme,
> I planted it in 'forty-nine.

Crichton, Midlothian.

Here in a lonely spot the bones repose,
Of one who murdered rhyme and slaughtered prose;
Sense he defied and grammar set at nought,
Yet some have read his books and even bought ...

Tweedsmuir, Peeblesshire, on the stone of Edward Aitcheson, an itinerant minstrel.

And his son John, of honest fame,
Of stature small, and a leg lame,
Content he was with portion small,
Kept shop in Wigtown and that's all.

Wigtown kirkyard, on the stone of John Taggart.

Here lies, retired from mortal strife,
A man who lived a happy life –
A happy life – and sober too,
A thing that all men ought to do.

Cults, Fife.

In this churchyard lies Eppie Coutts,
Either here or hereabouts;
But whaur it is nane can tell,
Till Eppie rise and tell hersel'.

Torryburn, Fife.

Some epitaphs contain puns on the person's name – for example, on the following two from St Andrews kirkyard (Fife). The first is to Christian Brydie:

Thovgh in the tombe my bones rotting ly,
Yet read my name for Christ ane bryde am I. 1655.

The second is to Henry Sword, 'ane of the bailles of this citie who depairtd thies lyfe vpon the tent day of Ianevarie in the yeare 1662 and of his age 50 yeires':

Ins name a svord was sein,
Ins office is the lyke,
Even ivstice svord I meane,

Eivell doers for to strick,
The svord doeth often kill,
And shedde the guiltles blood,
This svord doeth no svch eivell,
But to this citie good.

Erroll kirkyard (Perthshire) has the following epitaph to the Reverend William Bell, who died in 1665, aged sixty-one:

Here ceast and silent lie sweet sounding Bell,
Who unto sleeping souls rung many a knell,
Death crackt this bell, yet doth his pleasant chiming,
Remain with those who are their lamps a-trimming,
In spite of death, his word some praise still sounds,
In Christ's church, and in heaven his joy abounds.

Some epitaphs also compare the deceased person with someone of note who bore the same name. In Dumfriesshire a stone at Hoddom to the Reverend Matthew Reid contains an example of this:

His name from St Matthew took,
His skill in physicke from St Luke,
A reed of John the Baptist kind,
Not wavering with every wind,
Ever a true Nathaniel,
He preached, lived and dyed well.

From the same county is the epitaph on the grave of the martyr Daniel MacMichael, buried in Durisdeer kirkyard:

As Daniel cast was in lyons den,
For praying unto God and not unto men,
So lyons thus cruelly devoured me,
For bearing witnes to truth's testimony,
I rest in peace till Jesus rend the cloud,
And judge twixt me an those who shed my blood.

New Abbey kirkyard (Kirkcudbright) has a stone to Thomas Black (died 1711), with the epitaph:

I Thomas-like sometimes did doubt,
Yet Christ I owned without dispute,

Black was I, but comely through his grace,
I'm glorious now, for still I see his face.

Puzzles can appear on some tombstones, although these are very rare. Perhaps the most common was the use of acrostics, using the initial letter of an epitaph to spell the person's name. Double acrostics could also be found, when the last letter of each line also spelled out some name, and even multiple acrostics could be formed, by using middle letters also. These last two forms are extremely rare, however. At Glamis kirkyard (Angus) are two stones bearing acrostics, one to David Kid, elder in Glamis kirk, who has the letters 'DAVID KID ELDER G' as the initial letters of his epitaph, the other to James Bruce:

I am no inter'd beneath this stone,
Ah, death's propitious to none,
My name was James, my surname Bruce,
Exasperate against each abuse;
Sure sanctify my life decor'd,
Bent to obey my Noble Lord,
Rest, O my soul, in sacred peace,
Whereas from sin I find release,
C... read and praise,
Each providential act thou sees.

Note that J was often written I, U as V or W: this was not only to give the verse-composer an easier job, for most of the printed material from this age swapped the letters freely around. Another common swap was f (or a letter very similarly shaped) for s, as in 'fhall, for 'shall'. Not every s was replaced by an f: ss usually had one of each, as in 'blefsed', and a hard s remained as s, as in 'fpouse'.

Another near acrostic exists in the kirkyard of Newbattle (Midlothian), spelling 'IHMES CHIRNSYDE' (1682), and one at Newtyle (Angus), spelling 'GILBERT MILLE' (1675). Edinburgh's Greyfriars kirkyard had an acrostic made up of letters from every second line, spelling 'THOMAS FISHER' (1711). Although not in a kirkyard, the grave of John Brown, the Covenanter who was martyred in front of his family at Priesthill, Muirkirk (Ayrshire), contains an acrostic:

In death's cold bed the dusty part here lies,
Of one who did the earth as dust despise,
Here in this place from earth he took departure,
Now he has got the garland of the martyr,

Butchered by Claverse and his bloody band,
Raging most ravenously over all the land,
Only for owning Christ's supremacy,
Wickedly wronged by encroaching Tyranny,
Nothing how near soever he to good,
Esteemed, nor dear for any truth his blood.

Another quite common form of puzzle was the anagram, where part of a line could spell the person's name. Charles Rogers noted the following from the kirkyard of Holyrood Abbey (Edinburgh):

Ah me, I gravel am and dust,
And to the grave descend I must,
O painted piece of living clay,
Man be not proud of thy short day.

The name was Graham, formed from the first eight letters of the first line (minus the I), as 'Grahame'. In the same city, the Greyfriars kirkyard has a stone to Jean Stuart, whose name is found in the first ten letters of the first line:

A true saint I live it,
So I die it,
Tho men saw no
My God did see it.

Another form of pun was to compare the person's life and subsequent death with his trade. These trade epitaphs are fairly common, the same verses being found in different kirkyards throughout the country. One of the most noted was that to the blacksmith, the following transcription coming from Bothwell kirkyard (Lanarkshire) on the grave of Robert Stobo:

My sledge and hammer lies declined,
My bellows pipe has lost its wind,
My forge's extinct, my fire's decayed,
And in the dust my vice is laid,
My coals is spent, my irons gone,
My nails are drove, my work is done.

A different version of the above can be seen at Botriphnie (Banffshire), on the grave of Robert MacPhail, smith in Nova Scotia, which adds to it two more lines:

My fire-dried corpse lies here at rest,
My soul, like smoke, sours to be blessed.

Sailors have a selection of trade epitaphs to choose from, such as the
following from the stone of Robert Cairns, Ayr:

Though Boras blasts and raging waves
Has tost me to and fro,
Yet at the last by God's decree,
I harbour here below,
Where at an anchor I do rest,
With many of our fleet,
Hopeing for to set sail again,
Our Admiral Christ to meet.

Inveresk (Musselburgh, Midlothian) has the following:

Through life's perplexing seas,
His course he steered,
With steady hand,
He all those dangers cleared,
Till anchored here,
When all the storms are o'er,
Has driven we hope
Safe on Emmanuel's shore,
Where dangers cease,
And storms assail no more.

A pillar in Broughty Ferry old kirkyard (Angus) to John Kid, shipmaster
(died 1801), has the following epitaph:

This voyage now finish'd, he's unrigged,
And laid in dry-dock urn,
Preparing for the grand fleet trip,
And Commodore's return.

A clockmaker is commemorated on a slab in Hoddom kirkyard
(Dumfriesshire) with the following humorous epitaph:

Here lyes a man, who all his mortal life,
Past mending clocks, but couldna mend his wyfe,
The larum o' his bell was ne'er sae shrill,

As was her tongue, aye clacking like a mill,
But now he's gane, oh whither? nane can tell,
I hope beyond the sound o' Matty's bell.

Alloa (Clackmannanshire) has a stone to a bookseller, James MacIsaac, died 1834, which contains the lines:

For all the books I've bound,
Here now with valley clods,
In sheets I'm rotting under ground,
Death makes as mighty odds!

There is also in Edinburgh's Greyfriars kirkyard a stone to Adam Williamson, pressman-printer, who died in 1832, aged seventy-two, which contains a long epitaph, the following being but extracts from it:

Military headstone at Ballantrae (Ayrshire) to an anonymous seaman, washed ashore following the wreck of the *Godetia*

All my days are loosed;
My cap is thrown off, my head is worn out,
My box is broken;
My spindle and bar have lost their power ...
My press is totally down,
The volume of my life is finished,
Not without many errors,
Most of them have arisen from bad composition,
And are to be attributed more to the chase than the press ...
When the machine is again set up,
Incapable of decay,
A new and perfect edition of my life will appear,
Elegantly bound for duration, and every way fitted
For the grand library of the Great Author.

Most epitaphs were written by people who have remained anonymous, but there are some epitaphs which have been composed by famous poets. Robert Burns wrote many epitaphs to amuse himself and others, usually of such bad taste and disrespect to the deceased that they remain only within his complete works and are not to be seen on tombstones. There are a couple of exceptions, however, such as that to Thomas Samson, Laigh kirkyard, Kilmarnock (Ayrshire):

Tam Samson's weel-worn clay here lies,
Ye canting zealots! spare him,
If honest worth in heaven rise,
Ye'll mend, or ye win near him.

Burns also composed the verses on the gravestone erected over the body of Robert Fergusson, a noted Scots poet, buried in Edinburgh's Canongate kirkyard:

No sculptured marble here, nor pompous lay,
No storied urn, nor animated bust,
This simple stone directs pale Scotia's way
To pour her sorrows o'er the poet's dust.

Sir Walter Scott caused a number of gravestones to be erected over the unmarked burial places of some of the originals he used in his novels. 'Jeannie Deans' of *The Heart of Mid-Lothian* is buried at Kirkpatrick Irongray (Kirkcudbright), where 'the Author of Waverley' caused a stone to be erected. 'Old Mortality' (Robert Paterson) was interred at Bankend

of Caerlaverock kirkyard (Dumfriesshire), where a stone was erected by Scott's publishers, including a verse from 'The Wallflower' by John Langhorne:

> Why seeks he with unwearied toil,
> Through death's dim walks to urge his way,
> Reclaim his long asserted spoil,
> And lead oblivion into day

Scott's threatened epitaph on Peter Matheson, his coachman, was never carved on stone:

> Here lies one who might have been trusted with untold gold,
> But not unmeasured whisky.

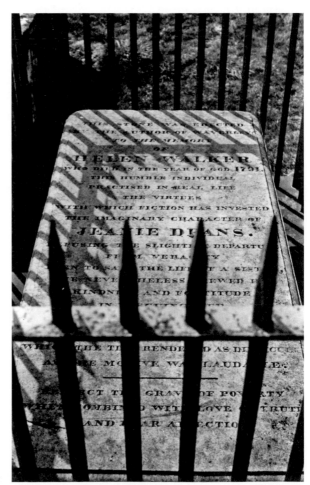

Jeannie Deans' grave, Kirkpatrick Irongray (Kirkcudbrightshire), erected by Sir Walter Scott

His grave can be seen in Melrose, however, near one in memory of Tom Purdie, forester at Abbotsford.

Many other epitaphs were the work of minor poets, people who wrote verses for amusement and to entertain and who were consulted by the relatives of the dead when they wished a verse for a gravestone. In most cases the authors of these lines have become forgotten, but occasionally they are known. Examples include Adam Brown Todd (grave of 'Winsome Willie' Simpson in Cumnock) and the Reverend Ebenezer Erskine, responsible for one of those puns on names:

> Here lies within this earthen ark,
> An Archer, grave and wise,
> Faith was his arrow, Christ the mark,
> And glory was the prize.

Although inscriptions are not strictly part of an epitaph, this seems to be the best place to mention some interesting aspects of them – errors and blank spaces.

Errors exist in a surprising quantity. During recent graveyard surveys carried out in Ayrshire, the participants were amazed at just how many mistakes could be found on tombstones, particularly those of the eighteenth and early nineteenth centuries. These mistakes were not the spelling errors of early stones (which in many cases were written by illiterate people simply how the words sounded or were even spelled at that time) but on headstones with lines of correct English inscription, where a single letter could be omitted. These exist in their hundreds, and a visit to any kirkyard will supply the reader with many examples. In many cases the mason, or perhaps the commissioner of the tombstone, must have noticed the error, for it is common to see words written with the missing letter placed over that part of the word where it should have been located.

At Aberlady (East Lothian) a memorial on the kirk wall commemorates Lord Elibank and his wife, the inscription in Latin. Lord Elibank had written it in English and given it to Dr Samuel Johnson, who translated it into Latin, and then the mason carved this onto the slab. However, at some point an error crept in, and it is not known whether Johnson's Latin was wrong or whether the mason copied it from his translation erroneously.

A more common type of error is typified by an example from Sanquhar (Dumfriesshire), which states that Isabella Gilmour died on 31 April 1862, there being, of course, no such date. Another stone in this kirkyard states that Robert Brown died on 9 November 1889, aged 180, this being in error for eighty. An inscription on a headstone in the old graveyard at

Cumnock (Ayrshire) begins, 'In Momery of Sarah McLatchie, daughter of Hugh McLatchie, mason, Cumnock'. Whether or not Hugh McLatchie was responsible for his daughter's stone is unknown; perhaps the error arose as a result of his grief. On the tombstone, already mentioned, of Tam Samson at Kilmarnock, the town is spelled 'Kilmarnockock'.

On the Isle of Skye, in Kilmuir kirkyard, is a headstone which contains the following inscription: 'Here lye the remains of Charles MacKarter whose fame as an honest man and remarkable piper will survive this generation for his manners were easy and regular as his music and the the melody of his fingers will' Apart from the error made by the mason in repeating 'the', it is interesting that the inscription was never completed, the story being that MacKarter's son was to pay the mason on completion but was drowned while ferrying cattle across the Minch, so the mason just packed up and left.

Cumnock (Ayrshire) also contains an unfinished inscription, in this case the relevant parts most probably supposed to have been added after the person's decease, but this was never done. It reads: John McLanachan, Nethertown, his wife Helen Lapraik, died 28th Oct 1848 aged 38 years. The above John McLanachan, died 24th Feb 1859 aged 58 years. His son George McLanachan, died 1st April 1865 aged years, his son James

An example of a mason's error with correction, commonly seen on old tombstones. This one is from Wanlockhead (Dumfriesshire)

McLanachan, died aged years.' This sort of incomplete inscription is in fact quite common, and examples of it can be seen in many kirkyards.

In the past, when time was not so readily accounted for as it is today, just how old a person was when he died was not very easily found out, unless the family had noted the date of birth in something such as the family Bible. A number of stones contain examples of this laxness, where the inscription cannot be accurate regarding the deceased's age. Monkton kirkyard (Ayrshire) has a stone to 'James Young, farmer in Tong, who died January 11 1757 aged about 40 years'. Kilmun (Argyll) has another eighteenth century stone, this one to the memory of William Buchanan, who died on 21 March 1785, 'aged 70 odd years'. A slab in Leochel-Cushnie's old kirkyard (Aberdeenshire) has the following epitaph:

Here lyes Peter Milner, a sober man,
Who neither used to curse nor ban,
Elizabeth Smith, she was his wife,
He had no other all his life,
He died in July 1784,
Aged 77, or a little more.

Epitaph to a man who was 'lost at sea', Kirkoswald (Ayrshire)

7

Other Uses for Kirks and Kirkyards

During the Victorian period, when cemeteries (that is, graveyards not attached to a parish church) were first established, they were looked upon as great parks commemorating the dead, places where one should walk along the paths and learn from the example of those who had gone before, passing on their experience in inscriptions on the stones. Many large towns laid out what were called necropolises, from the Greek *necropolis*, 'city of the dead', which were adorned by numerous trees and shrubs, had paths winding amongst the memorials and often had a gatehouse where dwelled the attendant who manicured the lawns. A fair number of these 'gardens of death' were laid out on hills, so that the paths meandered up the slopes to a prominent viewpoint, which added to their popularity for walks. Examples of these are Glasgow's Necropolis, Paisley's Woodside cemetery and Inverness's Tomnahurich cemetery.

The Glasgow Necropolis was established in 1833 by the city's Merchants' House as a place of rest for the 'high classes', for the old kirkyards of the city were too overcrowded for their liking. The Fir Park, as the ground was previously called, already had a tall statue of John Knox, but soon it was covered by a multitude of other statues, columns, pillars, mausoleums and tombstones, the plans for all of which had to be submitted to the Merchants' House for their approval. The local monumental sculptors J. & G. Mossman are said to have been responsible for manufacturing about three-quarters of the memorials in the cemetery, and notable architects were responsible for some of the designs, including Thomas Hamilton, Alexander Thomson and Charles Rennie Mackintosh.

The cemetery is divided into twenty-two sections, each bearing the name of a Greek letter or Latin number, and includes ground within its

bounds which formerly contained houses. In a number of cases the owners of the houses were given the chance to buy the plots where their houses stood, so we can see stones inscribed with such statements as 'Erected by James Mitchell, Painter, Glasgow, to mark the spot where the dwelling-place of his father and grandfather stood, which was occupied by them for a period of 48 years previous to the foundation of this necropolis and is now chosen as the final resting place of their descendants.'

The silence and serenity of the Victorian cemetery were in stark contrast to, and probably came about as a result of, the boisterous activities of previous centuries, when the kirkyard acted as a public meeting-place for various activities. Indeed, in the sixteenth century in some areas it was regarded as unacceptable to allow anyone to be buried within the church's grounds, as mentioned in a letter of 1590, which asked, 'Where learned you to burie in hallowed churches and churchyards, as though you had no fields to burie in?' However, kirkyard burial became acceptable to the masses, the lairds and heritors of the parish being interred within their own burial vaults.

One of the earliest uses of the kirkyard was as a place of sanctuary, somewhere where those who were being pursued by the law could take refuge without fear of being caught, the original idea being that, if the criminal had headed for the kirk, he must have been considering repentance. These sanctuaries, or 'girths', were common all over Scotland, particularly around the most important churches and monasteries. In Gaelic they were known as *an Teagarmachd*, the place of refuge. Many had crosses or marker stones designating their limits, sometimes quite extensive, and a few of these stones can still be seen today.

The Torphichen sanctuary (West Lothian) was centred on the preceptory of the Knights of St John at Torphichen. In the kirkyard can be seen a smallish pillar, with cup-marks and an incised cross, used to show the centre of the sanctuary. The girth extended for approximately a mile radius around this stone, and four 'Refuge Stones' survive which were used to mark its extremities. That at Gormyre is four-fifths of a mile distant from the preceptory, that at Craigmailing just over a mile. The stone at Couston is almost a mile and a half distant, the one at Westfield slightly farther.

At Dull in Perthshire was another sanctuary, centred on an ancient monastery of which now only a few stones survive. There were three crosses marking the limits of the safe ground, but only one of these survives *in situ*, adjacent to the parish kirk of Dull. The other two are now located by the ancient kirk of Weem, just over two miles to the east. They arrived there following an incident when the factor for the Menzies estates thought that they would make excellent gateposts and had them removed from Dull for such a purpose, despite warnings from the locals that he

Brechin Cathedral (Tayside) with Pictish round tower

would not long survive his interference with the crosses. It is recorded that, soon after, he suffered a violent death. Dull sanctuary was based on the College of Dull, a Culdee establishment founded on the spot where St Adamnan is thought to have been buried.

Other sanctuaries existed all over Scotland, although few now retain any visible remains such as marker stones or centre crosses. The sanctuary of Holyrood in Edinburgh is still delineated by a few modern markers in the Canongate, where the letter S is made out in stones or brass on the ground. Notable sanctuaries also existed at Applecross (Ross & Cromarty), which had a circumference of six miles, formerly marked by crosses which were destroyed as they were wrongly thought to be a mark of Popery; Innerleithen (Peeblesshire), given the right of sanctuary in 1159 by Malcolm IV; Cleish (Kinross-shire), which has a number of sanctuary stones, marked with crosses around it; and Coldingham (Berwickshire), where the sites of the crosses are commemorated in farm names – Whitecross, Cairncross, Crosslaw, Friarcross and Applin Cross.

Kirks and kirkyards have formed a place of refuge throughout the centuries, and 'refuge towers' can still be found attached to some old kirks, places where it was safer to remain during invasions by Vikings or Englishmen. The earliest refuge towers are the Celtic round towers which were contemporaneous with those of Ireland, where they remain more numerous, seventy-six as opposed to Scotland's four. These are found at Egilsay in Orkney, Iona (very ruinous), Brechin and Abernethy, the latter two being by far the better examples. The Brechin tower stands over one hundred feet in height and dates from AD 990, shortly after King Kenneth

Stobo church (Peeblesshire). The tower to the left was used as a place of refuge

II dedicated the Brechin monastery to God. The doorway entering the tower is six feet above ground level, a further security measure, the arched stone over it carved from a single block and bearing Christ on the cross, His legs uncrossed in the old Celtic manner. Abernethy's tower dates from the eleventh century and rises to seventy-two feet.

Two further round towers in Scotland can be seen at Portpatrick in Wigtownshire and Cockburnspath in Berwickshire. The former dates from 1629, the latter from the end of the sixteenth century. It has been suggested by MacGibbon and Ross in *The Castellated and Domestic Architecture of Scotland* (1887-92) that these may have been used as lighthouses, but a more likely origin for the Portpatrick example was the local laird, who originally came from Ireland.

There also survive a number of square section towers from Norman times, although all stand on the site of Culdee establishments. The tower at St Andrews dates from between 1126 and 1159, the masons employed being brought from Yorkshire, whereas those employed at Restenneth (Angus) came from Northumbria.

In the Borders a number of towers were erected adjoining kirks so that, should the English attack during a service, the parishioners could find a place of safety. Most of these towers have been demolished, but that at Stobo in Peeblesshire survives at the west end of the old Norman kirk. The tower does not lie square to the rest of the kirk, indicating that it was probably erected separately, perhaps in the fourteenth century.

The tower of St Mary's Church in Dundee was used as a place of refuge, particularly in 1651 when General Monk's army (on behalf of Cromwell)

stormed the city. A number of the town's inhabitants fled to this tower where, along with soldiers under General Lumsden, they held out for a time. Monk's men set fires of damp straw at its base, creating asphixious smoke which forced those within to surrender. Lumsden's head was severed from his body and placed on a spike on the tower's uppermost reaches, where it remained for almost 150 years.

During the 'killing year' of 1685, Sir Patrick Home, a noted Covenanter, had to hide himself from the public eye for fear of being shot or executed. He decided to occupy the family burial vault below the kirk of Polwarth on the Green, spending a whole month therein in the winter of that year. His twelve-year-old daughter, Lady Grizel, went each night to the tomb and passed in some food for her father, to keep him alive. The soldiers having moved on, thinking he could not be in the district, Sir Patrick then moved to a specially made cellar in Redbraes Castle, where he remained until he was able to flee to the Netherlands. After the troubles were over, he returned to Scotland and was created Earl of Marchmont, the new name for his Redbraes estate.

In the nineteenth century the 'Highland Clearances' – wholesale evictions of smallholders by their landlord, to establish more profitable 'sheep walks' on his land –made many people homeless. At Glen Calvie, a remote upland valley at the head of Strath Carron in Easter Ross, in 1845, the owner of that glen, William Robertson of Kindeace, served eviction notices on ninety crofts. The people had nowhere to go, other than the two local kirkyards, the parish kirk at Croick and the recently established Free Kirk at Amat, further down the glen.

A reporter from *The Times* visited the glen and described the scene at Croick: 'Behind the church, a long kind of booth was erected, the roof formed of tarpaulin stretched over poles, the sides closed in with horsecloths, rags, blankets and plaids ... A fire was kindled in the churchyard, round which the poor children clustered. Two cradles, with infants in them, were placed close to the fire, and sheltered round by the dejected-looking mothers.' The people remained there for a week, by which time the laird had made plans to have some of them transported abroad. Six families were found new places to stay within Scotland, two were given a stretch of moor near Tain on which they hoped to build cottages and grow crops, another got an old cottage in Edderton, the other three were left to occupy turf buildings near Bonar Bridge. Before many of the families emigrated, they scratched their names and dates on the windows of the kirk at Croick, and these can still be seen on the glass today: 'Glencalvie people was in the church here, May 24 1845 –John Ross shepherd – Amy Ross – Glencalvie people the wicked generation – Glencalvie is a wilderness blow ship them to colony – Glencalvie people was here.'

In the fifteenth century an Act of the Scots Parliament decreed that a Wappenschaw – a show of weapons with relevant practice – was to be held in every parish kirkyard four times a year, and that bowmarks and a pair of butts were to be made at each parish church so that shooting (archery) could take place every Sunday. The Act appeared in 1457, at a time when Scotland's relationship with England was at a particularly low ebb, and the nation was expecting an invasion from the south, but Edinburgh was still mustering a Wappenschaw in 1609, when the Edinburgh Burgh Records listed an intimation that one was to be held in Greyfriars kirkyard at 10 a.m. on 10 June.

At Kilwinning in Ayrshire an annual competition of archery still takes place within the grounds of the old abbey, held by the Ancient Society of Kilwinning Archers. They shoot at a papingo, or popinjay, from the French word for parrot, a wooden (latterly silver) representation of an ornate bird being set up to aim at. In *Old Mortality*, Scott used the shoot as a scene for part of his story, basing it on an account from the *Memorie of the Somervilles* which records: '... he marches to the church yaird, where the May-pole was sett up, and the solemnitie of that day was to be kept. There first at the foot-ball he equalled any one that played; but in the handleing his piece, in chargeing and dischargeing, he was so ready, and shott so near the marke, that he farre surpassed all his fellow schollars, and became a teacher of that art to them before the thretteenth year of his oune age'.

At Inverness the Old High Churchyard was used as a place of execution following the Battle of Culloden in 1746. Wounded prisoners taken by the Royalist troops were made to sit on a small headstone, and the executioners shot at them from another, the top part of which was conveniently shaped to allow the barrel of the gun to be supported to improve the aim. These stones are still pointed out by the locals, the one shot at bearing scars from the lead shot.

At Crail in Fife a stone which forms part of the kirk tower had such good honing qualities that it was used to sharpen arrow-heads, and this too can still be seen.

Weapons were associated with kirkyards in a number of places at various times throughout history. Kirks have been used as a place to store gunpowder, notably St Ninian's Kirk near Stirling, the powder placed there by the Jacobite forces on their retreat to Culloden in 1745. However, some accident occurred and the gunpowder was ignited, blowing up much of the kirk building, so that only the steeple remained intact and capable of being saved. A new, plain kirk building was erected nearby in 1751, remaining in use today, although it has undergone a number of alterations.

In the kirkyard of Inveresk, near Musselburgh (Midlothian), is a grassy mound reputedly covering the remains of some Roman building but

Greyfriars church, Edinburgh

certainly known to have been used by Cromwell's troops as a gun battery, and by the Duke of Somerset as a place of conference prior to the Battle of Pinkie in 1547. The morthouse at Udny Green in Aberdeenshire, after losing its function of storing bodies to prevent their being snatched, was used as an ammunition store for the local volunteer soldiers.

At Perth the burial ground of Greyfriars was visited by Cromwell's troops with instructions to remove many of the tombstones and take them to the South Inch, where they were broken up and used in the construction of the fort there. Between 200 and 300 old slabs and headstones are estimated to have been taken away, only one surviving to any degree, the date 1580 being legible.

The kirkyard of St Mary's at Leith was commandeered by Cromwell's troops also, the kirk itself being used to keep stores. This was in 1650, following the Battle of Dunbar. In 1656 Cromwell left General Monk in charge, responsible for the removal of the burial grounds surrounding St Nicholas' Chapel, but he did create a new cemetery at what is now Coburg Street to replace them, the oldest surviving graveyard in Leith today.

At St John's Town of Dalry (Kirkcudbright) the old kirk was taken over by Robert Grierson of Lag during the time of the persecution of the Covenanters as a stable for his horses. The Pentland Rising had its origins in this village, so the authorities reckoned that they had to lean heavily on the Covenanters there. In the kirkyard there is a tablestone in memory of Robert Stewart of Ardoch and John Grierson, both martyrs for their faith, 'murthered by Graham of Claverhouse anno 1684'.

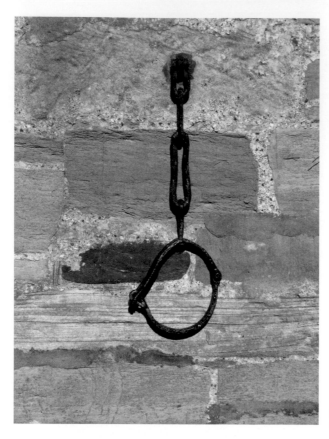

Jougs on the wall of the
kirk at Sorn (Ayrshire)

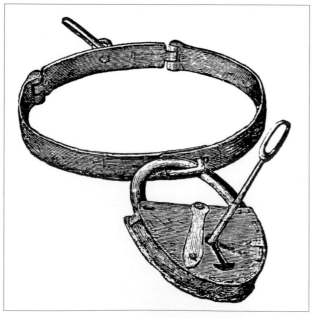

Jougs from the museum
of the Society of
Antiquaries

Kirks and kirkyards, being the only public property in many parishes, everything else being owned by the laird, were used by the authorities as courts and places of punishment. An Act of Parliament issued in 1593 pronounced that prisons, stocks and jougs (irons) should be provided not only in the main burghs and market towns but also at every parish kirk, so that idle beggars and wrongdoers could be placed in penitence, and so that those attending Sunday services could see them in their place of shame.

The most common form of imprisonment was clamping people in jougs, which were put round the neck of the miscreant, padlocked together and affixed to the kirk walls by a sturdy chain. The popularity of jougs perhaps stemmed from the fact that they were relatively inexpensive to purchase and were most effective – they can still be seen attached to a number of kirks all over Scotland. They were also affixed to town and village tolbooths and survive on those at Kirkcudbright and Kilmaurs (Ayrshire).

In the same way, a stool of penitence was often placed within the kirk, the villains being forced to sit on it all through Sunday services, which would often refer to them as a bad example in an effort to pile shame upon them. The pillar of penitence was used in a similar fashion: it stood between the kirkyard gate and the kirk door, so that those in shame would be seen by the parishioners as they walked into the kirk.

Gaolhouses were built onto a number of church buildings; perhaps the most famous being that at Greenlaw in Berwickshire, erected around 1700 to look like the kirk tower, disguising its real function. The door is protected by a heavy gridiron, and bars block the small windows. The tower was originally separated from the kirk of 1675 by a small gap, but this was filled in in 1712, when the kirk was lengthened. Attached to these buildings, at the west end, was the courthouse. The prison was known locally as 'Hell's Hole' – hence the following rhyme common hereabouts:

Here stands the gospel and the law,
Wi' Hell's Hole atween the twa.

The gaol was no longer needed after the erection of the present courthouse building in 1829, but it remains complete. Even after the gaol was no longer used, in 1834, when Mannus Swinney, an Irish robber, was hanged for stealing and assault, his body was interred within it as a mark of disrespect. Swinney's was, in fact, the last public execution held in Scotland, occurring on 2 April that year.

At Pittenweem the lower portion of the kirk tower was also used as the parish gaol, and it survives virtually unaltered since that time. Here, in the seventeenth century, during the times of the witch hunts, seven women, reputedly bearing evil powers, were imprisoned until such time as they

A corner of Greyfriars kirkyard, Edinburgh, used as the Covenanters' prison

were executed. At Kelso (Roxburghshire) an old vault of the abbey was converted into the town's tolbooth; another part of the abbey ruins was rebuilt as a school, thereby giving the pupils, who included Sir Walter Scott, a close example of what happened to wrongdoers.

The kirkyard of Greyfriars, Edinburgh, was used for a time as a prison for Covenanters captured at various places all over southern Scotland and kept there until their trial and the decision regarding their fate – death or transportation abroad. Following the Battle of Bothwell Bridge, fought on 22 June 1679, over 1,200 Covenanters who had been taken prisoner were brought to Edinburgh and locked within an enclosure which afforded them no shelter from the elements. Left there for months, a fair number of men died within this prison, but a few managed to escape, the rest having to face a biased jury and suffer execution or banishment to America, where they were sold as slaves. The enclosure, composed of tall stone walls with an iron gate, was created in 1636 and has since been used for later burials, but at the time of its use as a prison it was empty from end to end. Each prisoner was allowed four ounces of bread each day, but some of the women of Edinburgh would smuggle in other provisions after nightfall. Some Covenanters were allowed to go free if they swore allegiance to the King, but 257 men were kept there until November, when they were taken to Leith and put aboard a ship bound for the Americas. It was not even to leave Scottish waters, for it was wrecked off the Orkney islands, most of the Covenanters dying because the hatches in the hold, where they were put, were bolted closed.

The kirk authorities often had the power of holding courts, and so in some cases a courthouse was built adjoining the kirk building itself. A court building formerly stood at Greenlaw, as mentioned previously, and there was also another connected to the preceptory at Torphichen. The court existed in the eighteenth century, at the time when the eighth Lord Torphichen was alive. The courthouse was in the former crossings and transept of the church, the upper floor of which was used as a 'Prison House for the Regality'. The western leg of the cross was rebuilt in 1756 as the parish kirk, a simple, T-shaped building. The court and prison portion survive, a very castellar building, the upper part of the walls looking not unlike some of the old domestic Scottish tower houses, although there are lancet windows and buttresses on the lower storey. The building is protected as an Ancient Monument, within being a display on the life and times of the Knights Hospitallers of St John, who were responsible for the original building, which dates from before 1168, the earliest known reference to the preceptory.

In the past, particularly in the Middle Ages, kirkyards were often used as a place in which to hold markets, a practice common all over Scotland.

A few relics from this time survive, notably the market crosses which were never removed to the village centre, mainly because the villages which the kirk served were not of sufficient size to maintain the larger markets which developed. In the county of Moray there survive a number of medieval market crosses within some parish kirkyards: at Spynie, Kinneddar (Lossiemouth), Michaelkirk (Gordonstoun), St Peter's Kirk (Duffus) and Dallas. These crosses are plain constructions, rising from a solid base to over twelve feet in height, in some cases undecorated, although others, such as that at Dallas, have carved sections and an actual cross at the top.

The practice of holding fairs within the kirkyard dates from pre-Reformation times, when the festivals held by the large monasteries and kirks attracted people from all over Scotland, and it was only natural that they would wish to purchase some form of refreshment when they arrived. This supplying of food and drink gradually expanded into a full-blown market, where cattle and clothing could also be bought, and in fact many old fairs were held on a Sunday for this reason.

In 1503 Parliament issued a law forbidding any fairs to be held within the kirkyards, but they were by then so well established that it was unenforceable. The law was issued again in 1579, with stronger terms and stiffer penalties. Gradually the markets were found a location elsewhere in the village, but Sunday trading still caused a headache for some ministers. One of the last towns to continue kirkyard markets was Dornoch in Sutherland, where they are known to have taken place in 1803. There the traders built themselves shelters by pushing rods into the ground and draping canvas sheets over them. (In a number of instances these rods penetrated the coffins.) Within the kirkyard there can still be seen a large boulder on which is affixed a plaque, stating that the boulder was used by tailors as a standard measure of cloth, being marked an ell in length.

At Kirkdamdie, near Barr in southern Ayrshire, a market was held for centuries on the site of an old kirk. The kirk is first mentioned in a charter of 1404 but had probably existed for at least a century previously. The fair dated from medieval times and remained functional long after the kirk became ruinous, dying out by 1870. In the last fifty years or so it had decreased to little more than an excuse for drunkenness, but its main function was as an annual hiring fair, when farm labourers 'sold' their services to whichever farmer offered them the greatest wages for the next year's work. An old well stands above the site of the church. Kirkdamdie was replaced by a church in Barr village in 1650, which has since been replaced by the present edifice of 1878.

At Fordyce (Banffshire), within the kirkyard of St Talarican, markets were held on Sundays as late as the 1700s. The Reverend Alexander Gallie was responsible for ending them, displaying his displeasure by taking all

the bags of snuff which were offered for sale and emptying them over the kirkyard wall. He was a fair man, however, and paid those to whom the snuff belonged. The parishioners took the hint, and the markets died out shortly thereafter.

At Kincardine O'Neil (Aberdeenshire) the kirkyard was still in use as a market-place in the eighteenth century, the table-tombs being most useful as stalls. In the same county, at Invernochty, or Strathdon, kirkyard, a mausoleum door was noted in 1900 as being used as a board for advertising local turnip sales, perhaps the last lingering market tradition.

In a number of parish kirkyards the old schoolhouse survives, a relic from the time when the churches were responsible for educating children. This practice continued in many parishes until 1872, when an Act transferred control to the newly created parish school boards. At Durisdeer in Dumfriesshire the school building is attached to the cruciform church building and is more ornamental than the kirk itself, having two storeys of windows and being surmounted by a tall tower, whereas the kirk part of the building has a plain roof and rather undistinguished arched windows. Durisdeer school remained in use until 1874, when a new state school was erected to replace it. In recent years the old school, after a period of neglect, has been restored within to create small halls and meeting-rooms for the use of parishioners.

The parish school at Blackford (Perthshire) was located in the upper floor of the double-storey kirk. On one occasion in 1738, when the schoolmaster was absent from class, in a bout of rowdyism the pupils threw burning peats from the fire about the room, resulting in the schoolroom and kirk being burned to the ground. The kirk, which dated from 1617, was rebuilt and remained in use until the present parish church was built. At Moneydie, in the same county, the parish school of 1813 can be seen adjoining the kirk.

The actions of disobedient scholars caused trouble to kirk sessions up and down the country. There were many complaints regarding their behaviour within the kirkyards at interval times, when football was played between the graves, tombstones were damaged and kirk windows were broken. At Ashkirk (Selkirkshire) the donkeys on which some boys travelled to school were left to roam the kirkyard, much to the consternation of the parish heritors, who lodged a complaint.

Schoolchildren also had cause to complain on occasion. Apart from the cramped quarters in which they were expected to do their lessons, in many schools conditions of hygiene left much to be desired. At Ellon in Aberdeenshire in 1862 the parish schoolmaster had to give up teaching owing to the schoolroom's being filled with the smell of decaying corpses.

Adam Brown Todd, in his *Reminiscences of a Long Life*, recalls an incident from his school days:

> The schoolhouse was, as it were, indented into the churchyard with windows looking into it from the back and at the end, with the graves of many generations risen much above the floor of the little school of only one apartment ...
>
> Sitting one bright, sunny day at the end window getting my lessons in the 'Nine-penny', and also watching old Saunders M'Gowan, the gravedigger and beadle, making a grave close to it, I got a terrible fright, which bred no small commotion in the school ... Saunders had the grave dug nearly to its depth, and the window being betwixt us I was in no dread of him. The earth had been cast up higher than the window-sill, and close to it, and just as I had my face against the glass, he cast up a large skull which rolled down from off the dry earth and against the window close to my face. So hideous did it look and so unexpected was the act that with a loud yell I rushed to the door and, terror-stricken, ran home to Barrshouse with the speed of a hare.

Hospitals were established at a number of kirks, particularly in the early centuries of the Middle Ages. Some were run by the Knights Hospitallers of St John (their headquarters at Torphichen); a few were established at the abbeys and cathedrals by the monks as a place where their elderly and infirm brothers could be looked after, others by lairds or monarchs to serve a district. An example of the latter was the hospital which formerly stood at Kincardine O'Neil in Aberdeenshire, adjoined to the east gable of the ruined kirk which stands by the roadside in that pleasant Deeside village, doubling its length to about 150 feet. The hospital was established in 1231 by Alan, son of Thomas the Durward, as a place of rest and recovery for travellers crossing the Mounth passes. The foundations lie below the level of the grass, but the remaining part of the kirk is of immense interest, for it contains a now blocked Gothic doorway, which may date from the fourteenth century, and heavy buttresses, in all forming a more ornamental building than was typical of its time.

Kirkyards have often been a source of firewood for the poor of the parish. At New Machar in Aberdeenshire the peasantry were in the habit of collecting parts of decayed coffins from the kirkyard and storing them for use in the winter months. Wood from a different source – thirteen trees valued at £2. 19s – was used in Muirkirk churchyard (Ayrshire) in 1776 as a barter payment to a tradesman for repairing the kirk offices; in 1778 the kirkyard was replanted with timber.

Games have been played in kirkyards for centuries, the modern problem of boisterous football games within cemeteries being nothing new. At Kelso

(Roxburghshire) golf was played within the abbey yard, for it is recorded that on one occasion two players were involved in an incident when one of them inadvertently hit the other with his club while he was taking a stroke at the ball. The injury was serious, the other player dying of it. The account of the time records: 'Thomas Chatto ... within the Kirkyaird of Kelso was given ane deidlie straik with ane golf club under his left lug ... thairof he shortlie thaireftir deceissit.'

Mention of Kelso also brings to mind the fact that many tradesmen's guilds used the kirkyards as a place for their meetings. There the Glovers' Guild met regularly in the yard of the abbey ruins, but in 1650 they were to complain that the authorities would no longer allow them to stretch out their hides to dry on the tombstones there. Trade guilds (associations of master craftsmen or merchants) used the kirkyards in a number of towns and cities as a place of meeting. In fact, a few of the more noted cemeteries gained their present name from this: 'The Howff', for example, at Dundee, meant 'meeting-place', and for years a stone in the kirkyard dike there stated that, 'This is the Brabeners [weavers'] Head Room'. Dundee's Howff, properly the kirkyard of Greyfriars, remained in use as the meeting-place for the city's nine trades (bakers, bonnetmakers, dyers, fleshers, glovers, hammermen, shoemakers, tailors and weavers) until 1778, when the new Trades Hall in the city was built.

The kirkyards themselves have at times been used as a place of worship, particularly when services of commemoration have been held. The Covenanters buried within kirkyards have seen services held by their graves over the 300 years since the time when they were buried, many of those services having been organized by the Scottish Covenanter Memorials Association and the Scottish Reformation Society. In a number of kirkyards where there are no longer any kirk buildings, annual services are still held – for example, the old kirkyard of St Mary of the Lowes, located above St Mary's Loch (Selkirkshire). Here 'blanket preaching' takes place each July, so called from the blankets which are used to form a shelter for the preacher, a practice which originated in the conventicles held by the Covenanters on the hills and moors during the years of persecution. Blanket preaching also took place at Pathstruie (Perthshire) until 1862. Within the kirkyard at Tulliebole in Kinross-shire can be seen a 'communion table', little more than a raised section of grass around which is an excavated ditch, where communion was served when the smallish church building was full.

In modern times kirks and kirkyards have found a number of different uses, especially in the case of disused buildings and burial plots. They have not always become disused from the lack of an attending congregation, but generally as a result of the various religious controversies which have

occurred over the past century or two, multiplying the denominations, when the Free Kirk, United Presbyterian and other branches of Protestantism were formed, only to re-amalgamate with the parish kirk in later years in some places. In a number of cases, when the Free and parish kirks were reunited, the resulting congregation picked the better building of the two, that which was no longer required being left to ruin or else sold off to private parties. As the United Free Church building was usually of a much later date than the parish kirk building, it was often that which was used by the joint congregation, examples of this being found all over Scotland.

What happened to the kirk which was no longer used varies from parish to parish. In large towns and cities, these buildings were very often demolished, the plots they occupied being rebuilt on. In other cases they were altered to suit the needs of the new occupants. As an example of the latter, in Ayr former kirk buildings have been utilized as theatres (two), auction rooms, a dancing school, a pensioners' day centre and business premises. In small villages the community could not often support such establishments, the disused kirk buildings being used as storehouses for farms or haulage contractors, or in a number of cases as dwelling-houses. Some old kirks have been converted into museums, as at Newton Stewart (Wigtownshire), Broughton (Peeblesshire), Port Charlotte (Islay) and Fochabers (Moray).

8

THE RESURRECTIONISTS

At the beginning of the nineteenth century Scotland was in a state of great advancement. The Industrial Revolution was in full swing, and people were journeying from the Highlands and Ireland to the fast-growing cities of Glasgow and Edinburgh in search of work, precipitated by the Highland Clearances and Irish potato famine. Scotland was also seen as a great source of classic literature, music and art, supplied by such as Sir Walter Scott, the Gow family and Sir Henry Raeburn, and the period became known as 'the Scottish Enlightenment'. The medical world was making great advances also: Simpson discovered the use of chloroform as an anaesthetic; Liston made advances in surgery, performing operations never attempted before; Robert Knox, a noted and popular doctor, distinguished biologist and university lecturer in Edinburgh, studied anatomy and biology to a degree unseen in past years, using human corpses to practise on and study. Where he obtained such corpses has provided history with one of its more colourful, if rather macabre scenes: the practice of body-snatching.

In the eighteenth century, when the study of anatomy was increasing, only a couple of universities had any rights to bodies for study and dissection – for example, Edinburgh had been granted the corpses of those who died in the correction house and those of foundlings, orphans who died whilst in the city's care. The few bodies which were obtained from these sources were in no way sufficient in numbers to supply the demand which grew in the lecture rooms. In 1711, it was discovered that a grave in the burial ground of Greyfriars Church in Edinburgh had been interfered with and that a body was missing. Suspicion was immediately aimed at the Incorporation of Surgeons, but that organization denied any knowledge of the incident and claimed that it would expel from its ranks

any member found guilty of such practice. There were other such incidents, increasing over the years. In 1738 the kirk session of St Cuthbert's Church in Edinburgh authorized the building of walls eight feet in height around the kirkyard there, in order to prevent access during the hours of darkness. That these were not totally successful is borne out by the fact that in the early years of the nineteenth century a watchtower was also constructed, so that an armed guard could also guard the graves.

The demand continued to grow and the authorities' failure to come up with any other legal means of obtaining corpses meant that university lecturers had to find their own, the less direct the better. Such a source was discovered in Ireland, where the body of anyone who died a pauper was available for a measly sum, to be transported across the North Channel to Scotland, then whisked away to the city colleges. Such a practice, if not exactly condoned by the authorities, was not outrightly condemned, and for a time the supply of bodies met the demand.

Then the great upswing that biology and anatomy took from around 1820 onwards meant that corpses from Ireland failed to meet the demand. The trouble and unpleasantness of transporting corpses over 150 miles from Northern Ireland to Edinburgh also meant that those in the trade began searching for other sources – sources which brought a quicker return for less effort.

One such source was discovered in Scotland, in places as close as a few hundred yards from the universities to as far as eighty miles away (which is how far one body is known to have been carried). The kirkyard of every city, town and village was found to contain bodies suitable for dissection, the only problem being that removal of a corpse from the grave was illegal.

Bodies of people who had died naturally or of disease were most acceptable to the city surgeons so long as they reached the university within a few weeks of the time of death, before the process of decay had set in. Trade in such corpses grew to almighty proportions and was even recommended by the lecturers in anatomy to their students: should a student supply a corpse for the class's study, he was granted with a sum of money, and his chances of passing the course rose considerably. The money was also an incentive to others to supply corpses, for in many instances it was easy money, in others a much-needed income. The value of a corpse varied slightly between the type and the season of the year. On average it was between £7 and £10, a considerable sum in those days: £8 being the value in the summer months, when the heat made the corpses decay faster, and £10 in winter, when frost had the effect of a refrigerator, keeping the bodies in a usable condition for longer.

The infamous Burke and Hare's first body was not a victim of murder, as was usual with them, but that of an old man who had died in their debt; it was sold to Dr Robert Knox for £7. 10s, a figure suggested by the doctor and not subject to bargaining. When it is considered that a fairly successful fancy weaver could only earn about £40 a year in 1820 it is obvious why Burke and Hare and the resurrectionists found the supply of bodies a worthwhile crime.

Grave-robbing took place in the hours of darkness, when no one could see them digging up the corpses and when no one would be visiting the kirkyard in any case. It was not unknown for the grave-robbers to circulate stories of haunted churchyards to frighten people away from them and also to thus explain any noises they may have made in the process of removing corpses. The body-snatchers – 'resurrection men' or 'resurrectionists' as they became known – did as little damage as possible. To cause havoc would have brought unnecessary grief to the family of the deceased, and they also realized that, should they manage to remove the corpse unseen and leave the grave in a state similar to that in which it was found, people would not be aware of what was going on, the grass over the grave would grow, filling the gaps between sods, and all signs that the grave had been tampered with would be gone. From then onwards, the chances of discovery would be slim, for who in their right mind would unearth a coffin in any case?

Complete coffins were not taken from the grave, for this would have left the resurrectionists with far too bulky a load to transport and with the problem of disposing of all the coffins in Edinburgh or Glasgow. What they did was to dig at one end of the grave, the replaced turves indicating easily where newly buried corpses lay, and burst open the head of the coffin. (Which end of the disturbed soil to dig at was in most cases a simple decision, for the tradition of Scots burials meant that the head was usually placed at the western end of the grave, for reasons explained in Chapter 2.) A hole a couple of feet square would be dug down to the coffin lid, the recently laid earth making this a simple task. The head of the coffin lid would then be burst open, and the corpse dragged out head first, leaving all the soil over the body undisturbed. Fragments of wood from the lid could then be replaced, the soil back-filled and the grass sods replaced in position.

Once the body was removed, it was put into a sack – some body-snatchers developed a method by which the body was folded up, the knees and hips bent and the arms folded around them in such a way that the resultant bundle looked nothing like a corpse.

Melrose Abbey (Borders)

The corpse or corpses gathered together on an expedition could be taken to a remote spot, often a disused quarry, where they were hidden until such time as someone with a horse and cart was going to Edinburgh. In a few cases the hidden corpses were discovered before the resurrectionists had a chance to return and collect them. In 1825 a female corpse was discovered within a sack buried among loose rubble in a quarry near the village of Ancrum (Roxburghshire) by a quarryman. The corpse was taken to the kirk in Ancrum where it was later identified as being that of a girl from Bedrule whose grave had been disturbed some weeks previously. The corpse had not been taken away by the body-snatchers for the simple reason that they had been caught while raiding graves in the kirkyard of Jedburgh and had been imprisoned in Jedburgh gaol.

When it was discovered by the parish authorities that kirkyards all over Scotland were subject to such macabre happenings, they began to act in an attempt to prevent the robbing of graves. One of the simplest preventatives was to place two or more men on guard in the kirkyard each night for as long as six weeks after a body had been laid to rest, after which it was possible to ignore it, for by then it was of no use to the dissectionists. However, when a high number of deaths in a parish meant that the graveyard had to be watched constantly, small, rural parishes had problems: there were not enough men among whom the task could be shared. It was often left to the family of the deceased to watch the grave, each kinsman taking his turn to spend the night by the graveside.

Sir Walter Scott, in a letter to Miss Maria Edgeworth, describes how the grave of Lady Charlotte Scott, his late wife, was watched over after her burial. 'I learned afterwards that the cemetery was guarded, out of goodwill, by the servants and dependants who had been attached to her during life; and were I to be laid beside my lost companion just now, I have no doubt it would be long before my humble friends would discontinue the same watch over my remains, and that it would incur mortal risk to approach them with the purpose of violation.'

In a number of parishes a committee was formed to organize nightly watches, but in many cases it led to clashes between them and the kirk session, since both were simultaneously responsible for the kirkyards. In Dalkeith (Midlothian) the Committee for the Protection of the Graveyard fell out with the kirk session over who was responsible for keeping the key to the second kirkyard gate, an entrance built to allow members of the committee who were not on duty to sneak up on those who were, to check that they were not asleep while they were meant to be guarding graves. The kirk session reckoned that they should have the key, since they were ultimately responsible for the kirkyard's upkeep and maintenance, but the committee claimed they should hold it, since it was they who had arranged

for the doorway to be erected in the first place. At length the parish heritor, the Duke of Buccleuch, was called in as arbitrator. He may have decided that the additional access was not needed, for in the kirkyard today can be seen a built-up doorway in one of the walls.

The men on guard were very often armed, in some cases with batons, in others with swords and daggers, and in many instances with guns and pistols. St Cuthbert's kirkyard watchers (Edinburgh) listed among their possessions '1 gun, 1 blunderbuss, 2 powder flasks'. A warning notice affixed to the entrance gateway to the kirkyard of Coldstream (Berwickshire), a mile and a half north-east of the village beyond Lennel, read as follows: 'Take notice. An armed watch is placed here every night for the protection of this burial-ground. And has orders to fire upon any person who may enter at improper hours without permission.'

The behaviour of some of the watchers seems to have been rather suspect in a number of parishes, and there were tales of drunken men supposedly guarding the kirkyards in a number of villages. A rule board, erected at Carmunnock (Renfrewshire) within the lychgate built as a place of shelter during inclement weather for those on duty, may still be seen, a rare survivor from the period:

REGULATION FOR THE WATCH

There are two on duty each night who are to go on an hour after sunset and continue till after daybreak in winter and till after sunrise in summer. They are strictly prohibited from getting intoxicated, or leaving the churchyard during that time, and no visitor is allowed to enter on any account without giving the password for the night. They are also prohibited from making noise or firing guns except where there is cause of alarm that any of the inhabitants in such cases may be able to turn out to the assistance of the watch. Any damage that may be done to the watchhouse or furnishings is to be repaired at the expense of those who make it.
– Ordered at Carmunnock, on the 8th January 1828.

Watch-houses or towers, dating mainly from between 1820 and 1830, can still be seen in a number of kirkyards all over Scotland, and all performed the same function, providing a place of shelter for men on duty. The difference in these buildings is interesting, for builders employed various styles. At Eckford (Roxburghshire) and St Cuthbert's (Edinburgh) cylindrical towers were erected, with a crenellated parapet around them. Those at St Kessog's (Callander, Perthshire) and Baldernock (Stirlingshire) are of an octagonal plan, and that at Carmunnock was designed to look

Watch-house at Crawfordjohn (Lanarkshire) dating from the time of the
resurrectionists

Watch-house at Aberdeen

like a lychgate. The rest are rather plain rectangular buildings, such as that at Tundergarth (near Lockerbie, Dumfriesshire) which measures approximately twelve feet by eight feet internally; within are a fireplace, cupboards with shelving to either side, and a single window so that the most-used part of the burial ground could be seen from the fireside. The watch-house at Dalkeith has recently been restored and acts as a small informative museum, one of the points of interest on the town trail.

The committees formed in many parishes were paid for by the locals, who paid an entrance fee, then subscribed a figure each quarter thereafter. This entitled them to a nightly watch over the graves of that family's dead, but a member of the family was also expected to supply his services for a time as watchman. If a family felt that this was below them, they could of course pay a larger sum of money, as much as £1. 5s, which was their membership fee plus wages for those men who had to watch on their behalf. People who were not members, but who suffered a death in the family, could obtain the services of the watchmen for a one-off fee.

Tales abound of cases of body-snatching. In Glasgow Dr Granville Sharp Pattison was the main leader of the resurrectionists, directing the students of medicine in their night-time activities. Their favourite source of corpses was St David's-Ramshorn kirkyard, which survives yet in the city's Ingram Street, the nearest burial ground to the university, which was at that time still situated in the High Street.

The students were successful in taking bodies until December 1813, when it was found that the grave of a well-known and much-liked Mrs MacAlister had been desecrated. A mob comprised of her friends and relatives gathered together and worked out that the body was most likely in the university's anatomy department. They marched on the university buildings, where a riot ensued, the windows of Dr James Jeffrey's room being smashed (he being Professor of Anatomy) and general disruption created. The city officials were called out, and the riot was quelled on the promise that a thorough search of the university buildings would be undertaken. Dr Pattison showed the policemen round his rooms, where nothing was to be seen, whereupon the constables left. However, one of them suddenly thought that they should have checked the large tub of coloured water which stood in one of Pattison's rooms. The policemen returned, and within the water were found parts of the body of Mrs MacAlister amongst dismembered limbs from other corpses. These were identified by relatives, and Mrs MacAlister's dentist also confirmed that the body belonged to her by examining the teeth.

Dr Pattison was arrested along with Andrew Russell, a lecturer on surgery, and two students who had been in his room at the time. Their trial took place in Edinburgh in June 1814, where the noted advocates

John Clerk and Henry Cockburn pleaded on their behalf, claiming that the corpse discovered in Pattison's room was that of a woman who had never borne children, whereas Mrs MacAlister had given birth to a family. The doubt created resulted in the surgeon's acquittal but Pattison was by now so disliked that he was forced to emigrate to the United States. There he rose to eminence as a surgeon and physician.

The tiny village of Edrom, located on the banks of Whiteadder, a few miles east of Duns (Berwickshire), has a kirk dating from 1732 and an interesting graveyard surrounding it, in which can be seen a twelfth-century Norman archway rebuilt to form the entrance doorway to a burial vault. It was in this kirkyard that the body of one named MacGall was laid to rest in 1825, only to become the victim of resurrectionists. His body was dressed in clothes and propped up in a seated position between the two grave-robbers on their horsedrawn gig. On the route to Edinburgh they were passed by a farmer from Whitelaw and an innkeeper from Duns who were returning late from Gifford fair and to whom it seemed that the man seated in the middle of the other gig looked somewhat unusual, his position rather uncomfortable. When the farmer and innkeeper turned their cart around and began the chase, the two men in the other gig leapt from it and made across the fields. The men coming from Gifford took the corpse and gig back to Duns, where the corpse lay in the kirk until it was claimed the next day, when Mrs Mary Manuel of Manton, who had dressed it prior to burial, performed the same task again. The gig was kept by the town council in Duns for a time, until they decided to return it if claimed. However, when the townspeople heard of this, they were so incensed that they broke into the coach-house, dragged the gig to the market square and there began breaking it up and setting the wood alight. The town council had to read the Riot Act, but in vain: the people continued until the gig was completely destroyed.

That incident is one of few cases in which a stolen corpse was recovered. Others rescued between kirkyard and university included a girl's corpse which had been tied below water-level on a bridge pier on the Paisley canal in 1824, and two children's bodies taken from Channelkirk (Berwickshire), found hidden beneath a low bridge near Soutra, amid the Lammermuir Hills.

In most cases the snatched corpses were dissected and the bones buried (Dr Pattison in Glasgow buried the bones of his victims beneath the floor of his lecture theatre), so that no evidence remained, or else they had been missing so long that to begin a search would be futile. There stood a stone in the Howff burial ground (Dundee), noted in 1843, which had been placed over the grave where a stolen body should have lain and which had an epitaph composed by one with a sense of humour, even if rather warped:

Here lies Nothing.
The impious Resurrectionist
At night dared to invade
This quiet spot, and upon it
Successful inroads made,
And when to relatives the fact
Distinctly did appear,
The stone was placed to tell the world,
There's Nothing resting here.

One of the more common methods of preventing body-snatching was to enclose the coffin in a mortsafe, an iron frame which was clamped around the coffin and laid in the ground along with it. After six weeks this was raised from the grave again, and the coffin freed from the frame replaced in the hole. The weight of these mortsafes was the main discouragement to grave-robbing, for each weighed over a ton. These frames, which were hired out by the kirk session to those who needed them, can still be seen in a number of kirkyards, sometimes of different sizes to suit adult- and child-sized coffins. They cost anything up to £5 each and, considering that each parish needed more than one, sometimes up to ten even for a rural community, it was an expensive burden for the church authorities. The cost was defrayed by their being hired out to those who needed them, at a fee of one shilling per day, so that it could cost £2. 2s for a six-week hire, a high price when it is considered a Glasgow weaver spent an average of seven shillings per week on food. Most of these mortsafes were of the frame type, but a mortsafe still located within the kirkyard of Colinton (Edinburgh) has solid panels on the top and sides. Examples of frame-shaped mortsafes can be seen at Ayr, Alloway (both Ayrshire), People's Palace (Glasgow – from Ramshorn kirkyard), Channelkirk (Berwickshire), St Cuthbert's and New Calton (Edinburgh), Airth (Stirlingshire), Kilmun (Argyll), Logierait and Aberfoyle (Perthshire), Banchory-Devenick (Kincardineshire), Cluny, Towie, Echt and Tough (Aberdeenshire).

A variation on the iron mortsafe was the stone mortslab, a large block of stone, usually shaped like a coffin, which was placed over the newly dug graves and, like their iron equivalents, removed after six weeks or so. It was mainly as a result of body-snatching that graveslabs became extremely popular, perhaps regaining their popularity when mortslabs reminded the people of them, for they were common in the sixteenth century. These stones not only acted as a mortslab but were suitably inscribed and therefore served also as a memorial. The temporary mortslab could in some cases also have some iron-work attached to it, like the one to be seen in Skene kirkyard, Aberdeenshire. The coffin-shaped stone has affixed to it

Mortsafe, hanging in the lychgate of St John's kirkyard, Ayr

a frame of spikes and straps which were forced into the ground around the coffin, the stone uppermost.

Lifting the heavy mortsafes could involve several people. At Inverurie (also Aberdeenshire) is preserved a set of mortsafe tackle, now in the burgh museum. This consists of three iron rods joined onto a single ring at one end, and to three hooks at the other. The ring is supported by an iron chain and would be connected to a block and tackle, held up by three poles placed in tripod formation over the grave. Study of some mortsafes can reveal three marks where hooks or rings were located, usually two at the shoulders, and one near the foot. For safe-keeping, the Inverurie mort-tackle was kept in the town's baker's shop, where overnight workers and daytime shopkeepers would look after it round the clock.

People who had burial enclosures, the stage down from a mausoleum, often had the tops railed off with wrought-iron bars, and these can still be seen within some stone-built enclosures. In some lesser enclosures, the grilled surround rose only a couple of feet off the ground, meaning that the grass which grew within could not be cut very easily.

Another method of safeguarding corpses, employed in a number of parishes, was the use of a morthouse, a building in which the corpse in its coffin was laid for a period of six weeks until it had decayed sufficiently to be of no use to the surgeons. These buildings seem to have been most common in the north-east, where a number survive, although there are also examples at Denny (Stirlingshire) and Crail (Fife). Morthouses were sturdily built, with iron linings on wooden doors, even a skin of steel within the whole structure in some cases. A number were subterranean, or partly so. One of the most interesting surviving examples is that at Udny

in Aberdeenshire, which is built of granite in a circular plan. The roof is sugar-loaf shaped, and within the building is still a circular turntable on which the coffins were placed, then turned partly round the circumference, ready for the next coffin.

In a few cases the body-snatchers came to the conclusion that it would be easier to obtain corpses prior to their interment. Some broke into buildings where corpses lay awaiting burial, others forged a deal with unscrupulous undertakers to take a corpse from them, the coffin then being filled with stones or clay to bring it up to the weight of a dead body.

In some instances the body-snatchers went as far as failing to wait until the bodies they dealt with were deceased – committing acts of murder. By far the most infamous of these were William Burke and William Hare, who supplied Dr Knox with bodies for his anatomy classes. Despite the popular belief, neither Burke nor Hare seems ever to have been involved in taking corpses from kirkyards, instead moving directly to the act of murder. It is known that at least fifteen persons fell victim to this pair, who were finally caught when an Irishwoman, Mary Docherty, was killed, and lodgers in Burke's house could testify that he had been involved to some extent. Both Burke and Hare were captured and imprisoned, and the Lord Advocate, Sir William Rae, persuaded Hare to turn King's Evidence against Burke, thereby obtaining sufficient evidence to execute him in Edinburgh on 28 January 1829. Hare moved shortly thereafter to England, where he may have found a new life for himself, for nothing is heard of him from then on.

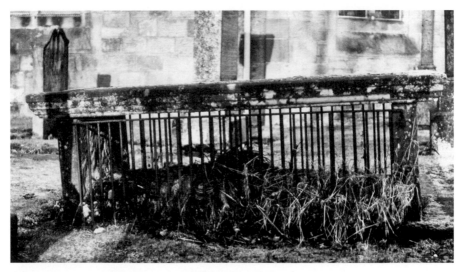

Tablestone in the kirkyard of Luss (Dunbartonshire) the sides of which have been filled in with iron railings to foil body-snatchers

When it was known that Dr Robert Knox had been the recipient of Burke and Hare's corpses, even though the court did not implicate him as an accomplice, since he did not know (or at least successfully claimed such) that the bodies had been the victims of murder, the people of Edinburgh went to his surgery at the university and destroyed much of it, and also broke the windows of his home at Newington. Before his front door an effigy of Knox was suspended from a lamp-post, implying that he should have suffered the same punishment as Burke, and this was later burnt. Throughout the streets – and particularly loudly in front of the house in Newington – the mobs yelled a piece of doggerel popular at the time:

> Doon the close and up the stair,
> But an' Ben wi' Burke and Hair,
> Burke's the butcher, Hair the thief,
> Knox the man that buys the beef.

However, Knox survived the times, dying in 1862.

Alexander Munro, Professor of Anatomy in the university, was given the 'privilege' of dissecting Burke's body after it had been removed from the gallows, a proceeding watched by many people, while thousands more who failed to get entry caused disturbances outside. Noted citizens were presented with cuttings of his skin, as mementos, and his skeleton was kept by the Royal College of Surgeons – it can still be seen in their museum.

The practice of body-snatching became defunct very quickly after August 1832, following the adoption of the Anatomy (Scotland) Act, which made provision for the use of deceased persons' bodies in the study of biology and for medical experiment, allowing the relatives to donate the bodies to the universities for experimental purposes. The law insisted that the remnants of such corpses should be given a decent burial within a coffin in a recognized place of interment, such as a kirkyard or cemetery. Certification was introduced, so that the number of bodies supplied tallied with those returned for burials, and inspectors were appointed who toured colleges and surgeries to check that the law was not being abused.

Body-snatching has provided a fascinating area of study, and it has also given birth to classic scenes in works of fiction. Mark Twain used the practice in his famous work *Tom Sawyer*, but nearer to home Robert Louis Stevenson referred to it in his story *The Body-Snatcher*, setting it in the kirkyard of Glencorse, at the foot of the Pentland Hills, a place he much loved; he also set one of the scenes of his unfinished work *Weir of Hermiston* there, and wrote home from Samoa to S. R. Crockett, minister of Penicuik and a noted author also, asking him to 'Go there and say a prayer for me.'

In *The Body-Snatcher*, two resurrectionists dig up what they think to be the grave of a farmer's wife, 'known for nothing but good butter and godly conversation'. They journeyed to Penicuik, and while paying the toll on the main road, announced that they were heading for Peebles, by way of an alibi, but returned by a by-road with their lamps extinguished. 'They were ... powerful with the spade; and they had scarce been twenty minutes at their task before they were rewarded by a dull rattle on the coffin-lid ... The coffin was exhumed and broken open; the body inserted in the dripping sack and carried between them to the gig ... As the gig jumped among the deep ruts, the thing that stood propped between them fell now upon one and now upon the other. At every repetition of the horrid contact each instinctively repelled it with the greater haste; and the process, natural although it was, began to tell upon the nerves of the companions.' At length they lit one of the lamps and were compelled to look at the corpse's face. It wasn't that of the farmer's wife, but of a traveller they had previously murdered and whose body had already been dissected.

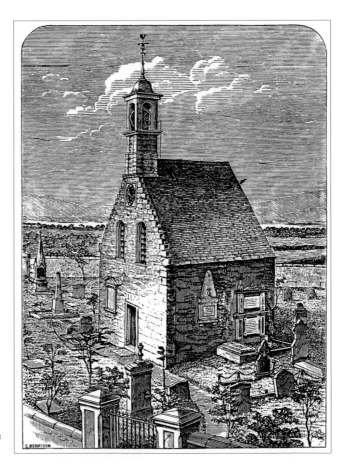

The kirkyard at Beith
(Ayrshire)

KIRKYARD TALES

Over the centuries many tales and legends have accumulated which are connected with kirkyards in some way. Some stories are purely fictitious, or seem to be so; others, although perhaps somewhat unbelievable, are completely true. The first half of the chapter will deal with tales which are either definitely true or else most probably true, the second half with tales which are more questionable, readers being left to decide for themselves whether or not such happenings could have occurred.

It should be remembered that every tale probably has two sides to it, and depending on which source one hears it from will affect one's interpretation of it. To illustrate this point, the following tale definitely occurred, the perpetrator of the prank being an old family friend of mine, but if one was a friend of the victim of the trick, a totally different and perhaps more sinister tale would be forthcoming.

The old graveyard in Cumnock is located by the side of an ascending road, the main route to Edinburgh from Ayr. Alongside this roadway there is a pavement and along its edge a tall stone wall. The graveyard level is considerably higher than that of the road, so that the other side of the wall is in places only a couple of feet high, although at one end it is of a similar height to the roadway side of it. A man was walking up the brae, returning home from one of the inns in the town, and although he wasn't absolutely full, he'd had plenty to drink. As he came in line with the graveyard, a boy within the burial ground reached out and lifted off the man's cap, taking it back with him and hiding behind the wall. The man felt his head and looked up but saw nothing. Puzzled, he continued his way up the road but in a rather less merry mood. At the other end of the graveyard the boy leaned over the wall again, replacing the cap on the man's head. Having

a quick look about him, the man reckoned that there was still nobody about, so he took to his heels and ran all the way home!

The 'killing times' of the last decades of the seventeenth century produced a number of happenings in kirkyards which were not 'normal' and thus have become well known over the centuries as 'kirkyard tales'. A few stories from this period, such as the legends surrounding the funeral of Sir Robert Grierson of Lag, were either fabricated or else exaggerated to such an extent as to seem false, and these will be mentioned later in this chapter.

A true tale from this period, however, was that of Alexander Peden's burial. Peden was a minister who had been ousted from his church at New Luce in Wigtownshire for failing to swear allegiance to the King as head of the Church. He wandered the hills and moors of southern Scotland for years, many remote spots bearing his name, such as 'Peden's Pulpit' and the like, where he held 'conventicles' – field meetings. When these were made illegal, Peden became a wanted man. However, the soldiers who spent their time chasing and killing the Covenanters never caught up with Sandy Peden, and at length he died at the home of his brother near Auchinleck in Ayrshire. His body was taken to Auchinleck kirkyard where it was interred at night near the Boswell vault. But his body did not remain there, for, forty days later, the soldiers, incensed at having failed to capture him, dug up the grave and took the corpse from Auchinleck the mile to the town of Cumnock, where they intended to have it strung up on the gallows tree. It was carried up the Barrhill to the spot where the gallows tree stood, but the local landowner intervened, managing to persuade the soldiers not to hang the corpse. Nevertheless, as a mark of disrespect the soldiers dug a hole at the foot of the gallows and buried the body of Peden there. His tombstone tells his story in brief: 'Here lies Mr Alexander Peden, a faithful Minister of the Gospel, sometime of Glenluce, who departed this life 26th of January 1686, And was raised after six weeks out of the grauf, and buried here, out of Contempt.'

In later years the site of Peden's grave was made sacred, when the old kirkyard in the Square was closed and the people of the parish buried their relatives 'amongst the ashes of the martyrs'. Within the same enclosure there are two memorial stones to another three martyrs, a granite monument to Peden and two thorn trees with which a story is also associated. Legend has it in the Cumnock area that, should the branches of the thorns intermingle, a great disaster will befall the district, although what form this will take is not stated. Every couple of years the branches of these trees are well trimmed, so as to prevent any disaster. A number of years ago, however, the trees were found to be in a dangerous condition because of their age, so cuttings were taken from each by the local parks

department and grown in their nurseries for a number of seasons until they could be replanted at Peden's Thorn, the old bushes being removed.

A similar tale is connected with Old Dailly kirkyard, in the same county, where grow a number of ash trees. Peden is claimed to have been responsible for prophesying disaster when the branches should meet, and a verse by Hugh Ainslie gives the details:

> When the aishen trees in the kirkyard kiss,
> Happy are the just that that day miss,
> For the French then will come afore it's wist,
> On a morning when the lan's in mist.

The local laird had the trees cut down some time prior to their touching, thereby avoiding Napoleon's invasion of these islands. The ashes subsequently grew again, but so far they have yet to touch.

Connected with the Covenanters was Robert Paterson, better known to Scott readers by the nickname he gave him, 'Old Mortality'. Paterson was born near Hawick but spent most of his early years at Thornhill in Nithsdale, where he was a quarryman. Over the years his interest in the Covenanters grew, and in his spare time he travelled across southern Scotland with his pony, taking a slab of red Nithsdale sandstone with him, which he placed over the martyrs' graves, carving (in ligatures) a relevant inscription, usually ungrammatical. The first stone he is said to have erected was at Caldons in Glen Trool, and when it was broken recently and sent to Edinburgh for repair, a sample was tested and found indeed to have come from the Gatelawbridge quarries near Thornhill. It is now located in Newton Stewart museum, a copy of it in granite now occupying the site in Glen Trool.

At length Paterson's fascination for martyrs' graves became an obsession, and he left his wife and family to travel across the whole country, erecting memorials and gravestones as he went and staying in the homes of the Covenanters who survived, or those associated with them, collecting information. Paterson's wife had to establish a small school in the village of Balmaclellan (Kirkcudbright) in order to keep her family, and when her son was old enough, she sent him on forays into Galloway and Ayrshire to seek his father and plead with him to return home. The son eventually met up with 'Old Mortality' in the old kirkyard of Kirkchrist, across the bay from Kirkcudbright, but none of his pleas could persuade him to return home.

Sir Walter Scott himself met Paterson on one occasion, at the kirkyard of Dunnottar in Kincardineshire, where he was engaged in chiselling an inscription on the stone to the martyrs there. Scott describes the scene:

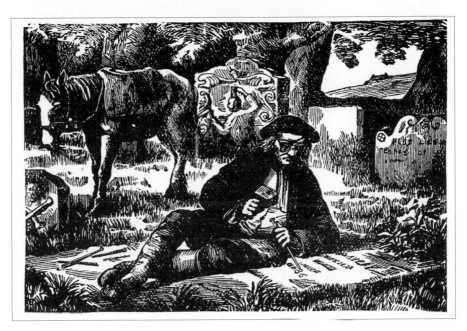

'Old Mortality' at work on a tombstone

An old man was seated upon the monument of the slaughtered presbyterians, and busily employed in deepening, with his chisel, the letters of the inscription, which, announcing, in scriptural language, the promised blessings of futurity to be the lot of the slain, anthematised the murderers with corresponding violence. A blue bonnet of unusual dimensions covered the grey hairs of the pious workman. His dress was a large old-fashioned coat of the coarse cloth called hoddin-grey, usually worn by the elder peasants, with waistcoat and breeches of the same; and the whole suit, though still in decent repair, had obviously seen a train of long service ... Encouraged by his affability, I intruded upon him some questions concerning the sufferers on whose monument he was now employed. To talk of the exploits of the Covenanters was the delight, as to the repair their monuments was the business, of his life.

When Scott had made his fortune, he tried to find the whereabouts of Paterson's own grave, with the intention of erecting a memorial over his remains, but failed to do so. After Scott's death it was discovered that Paterson was buried in the kirkyard of Bankend of Caerlaverock in Dumfriesshire, whereupon Scott's publishers arranged for a stone to be erected, which can be seen to this day, reading:

Erected to the memory of Robert Paterson, the Old Mortality of Sir
Walter Scott, who was buried here, February 1801.

Why seeks he with unwearied toil,
Through death's dim walk to urge his way,
Reclaim his long-asserted spoil,
And lead oblivion into day.

Perhaps the most famous story associated with kirkyards is that of
Greyfriars' Bobby.

Bobby was a Skye terrier which, on his master's death in 1858, kept vigil
at his graveside until his own death in 1872. No persuasion could entice
the dog away for any lengthy period, Bobby returning each day to lie on
the spot where the shepherd, Jock Gray, was buried. On one occasion
Bobby was impounded by the police for not having a licence, but such
was his fame that the Lord Provost of the time, William Chambers, paid
for the licence for that and every year thereafter, and also had made for
him a special collar, inscribed 'Greyfriars Bobby, from the Lord Provost
1867. Licensed', now to be seen in Huntly House Museum, Canongate.
Queen Victoria enquired as to the dog's well-being each time she visited
Holyrood, and a group of Americans paid for a granite tombstone to be
placed on the unmarked grave of Bobby's master, where Bobby himself
was interred on the orders of the Queen. Lady Burdett Coutts gifted a
memorial statue of the dog on a fountain to the city which stands in
Candlemaker Row, near the spot in Greyfriars kirkyard where he spent
much of his life. The story became the basis of a film, entitled *Greyfriars
Bobby*, made by the Walt Disney studios, but in it the terrier was changed
to a collie – perhaps since Gray had been a shepherd.

There are only two remaining parts of the old kirk of St Bride in Douglas,
Lanarkshire: the Douglas aisle, which contains some fine effigies, and the
roofless Inglis aisle, reached through a Gothic archway. A tale recounts
how in the Middle Ages the Inglis family gained the burial rights to this
part of the old kirk. English forces were in the district, making plans to
lay siege to Douglas Castle, the 'Castle Dangerous' of Scott's novel, but
a farmer of Weston heard the foe scheming and managed to slip away
to the castle to warn the Douglas laird. Disaster averted, the laird asked
the farmer what he would like as a reward, to which he replied that he
only wished to sleep beneath the same roof as the Douglas. The aisle was
granted to the farmer, and an inscription added to the walls stating that it
was 'The sepulchre off the Inglises in Braidlie 1432'. An old rhyme in the
district also recalls the tale:

It was gien to Inglis,
And Inglis' bairns,
And a' that lie in Inglis' airms.

One of the Inglises, however, did not wish to be interred within the vault, giving as his reason the fact that he was lame, so that, 'When it comes to the risin', the rest o' the fowk will be up ower the tap o' the Broon Hill afore I could scrauchle ower the dike!'

There are a number of kirkyards which contain objects of interest associated with the past. At Old Dailly in Ayrshire, for instance, within the kirkyard can be found the 'Lifting Stanes', mentioned in Scott's novel *The Lord of the Isles*. Many years ago these stones were used to test a man's strength, anyone able to lift one off the ground being extremely strong. It is thought that they may originally have had the purpose of marking the sanctuary of Dailly, for the kirk here occupies an ancient site. Formerly kept in the kirk building, in later years they were located within one of the burial enclosures attached to the kirk. Another story associated with them tells how, when the village of New Dailly was growing in importance, the villagers reckoned that the stones should be taken from Old Dailly and placed in the kirkyard in the new village. Many meetings were held to try to arrange the moving of the stones, but the folk who lived near Old Dailly would not let them be taken away. At length a battle between the villagers ensued, the folk of the old town winning, resulting in the stones being kept at Old Dailly ever since.

Near Lockerbie in Annandale is the old kirkyard of Dryfesdale, which was infamous for suffering from erosion. Periodically, when the Dryfe Water was in spate, the kirkyard was so eroded that corpses were uncovered and coffins were found further downstream. On one notable occasion the wedding was taking place in the kirk of a widower whose wife had died some months previously. As he made his way towards the church, he noticed the river eating at the kirkyard banking and uncovering a coffin which he recognized to be that of his recently departed wife. Reorganizing the wedding guests, he arranged for the coffin to be reburied elsewhere in the kirkyard before the party continued with the ceremony.

There are other stories of accidental disinterments from all over Scotland. Charles Rogers, writing in 1872, noted that in Lewis and North Uist the sextons allowed graves to be dug so shallow that only six inches of soil covered the coffins. In wet weather, particularly before the soil was held together by grass roots, the earth could be washed away, exposing the coffin to view. In other areas, where the soil is very sandy, the grave covering could be blown away after a lengthy period of drought.

Old Dailly churchyard (Ayrshire) where the 'lifting stanes' can still be seen

The legendary 'Blue Stanes' at Old Dailly (Ayrshire)

At North Berwick, in the county of East Lothian, the old kirkyard was located near the sea, on a former island known as Anchor Green, since joined to the mainland and forming part of the harbour. In stormy weather graves on this island were uncovered by the washing action of the large waves, revealing coffins and corpses. The site is an ancient one, however, for Bishop Acca in the eighth century is believed to have rested there on his way to St Andrews with that saint's bones. The foundations of the sixteenth century kirk were excavated in 1951.

An intentional disinterment occurred at Dumfries in 1815 when the grave of the poet Robert Burns was reopened and his body transferred from one corner of the kirkyard to another, so that admirers of his work might erect a mausoleum over the bard's grave, the north-east corner where he was originally buried being unsuitable. The committee which arranged the erection of the mausoleum then decided to have the mausoleum built in the south-east corner of the kirkyard, to house the remains of Burns and two of his sons who had since died. (His wife and other sons were interred in the mausoleum at a later date.) The building, which cost £1,500 and which resembles a Grecian temple, was the work of Thomas Hunt, a London architect, and contains marble sculptures by Turnerelli depicting the poet at the plough. Within it can also be seen the original headstone.

Early in the morning of 19 September 1815 the exhumation was carried out by William Grierson of Boatford and James Thomson (members of the monument committee), Mr Milligan (builder) and James Bogie (gardener). The coffin was said to have been made of oak, but this was found to be untrue. When the lid was opened, the poet's body lay within it nearly entire, as if he had died only yesterday, but when the straps were placed below the coffin in order to lift it from the ground, the head separated from the trunk, and the flesh fell into dust. A new coffin was procured, in which the remains were placed, and this was solemnly laid beneath the mausoleum. A number of the poet's friends and acquaintances are also interred within this kirkyard, and a plan there indicates their whereabouts.

A similar disinterment took place in 1818 of another of Scotland's famous sons. Dunfermline Abbey was being rebuilt, and while the foundations of Holy Trinity Church were being dug, on 17 February a vault was broken into. It was made of dressed sandstone slabs, the chamber seven feet long internally, about twenty-two inches wide, eighteen inches deep and covered by two sandstone slabs. When opened, it was found to contain a body encased in lead, surrounded by fine linen interwoven with gold. Remnants of an oak coffin were found within, and the skeleton was virtually entire. The breast-bone, however, was found to have been sawn apart, confirming the theory that the corpse was that of King Robert Bruce, the breast-bone

having been cut in order to have his heart removed, with the intention of taking it to the Holy Land, according to his last wishes.

A cast was taken of the monarch's skull, 'to determine the mental and moral qualities of the monarch by phrenology'. His skeleton was measured in detail, revealing that he had stood about five feet ten inches tall. Once the investigations were complete, the remains were placed in a leaden coffin which was filled with melted pitch, in order to preserve them, and this was placed in a brick-built vault over which the kirk's pulpit was located. A brass tablet depicting the King in his armour was placed over the grave, the inscription reading: 'ROBERTI DE BRVS SCOTORVM REGIS SEPVLCHRVM AD MDCCCXVIII INTER RVINAS PAVSTE RETECTVM HOC RERE DENVO CONSIGNATVM EST ANNO POST IPSIVS OBITVM DLX.' Also in commemoration of the king, the architect of the kirk, William Burn, had 'KING ROBERT THE BRUCE' inscribed on the four sides of the tower's parapet.

A number of body-snatching tales have been recounted in the previous chapter, but there is another of a different sort which took place at Dunecht in Aberdeenshire.

When the twenty-fifth Earl of Crawford died in 1880, at the age of sixty-eight and was laid to rest in the family mausoleum within the estate grounds, the vault was broken into, and the corpse removed. Although a search was undertaken, it failed to recover the body. Queen Victoria took an interest in the affair and sent her condolences to the Countess. Over a year later, the corpse was found again, buried beneath two feet of topsoil near the mansion. A local rat-catcher, Charlie Soutar, was apprehended and sentenced in Edinburgh for complicity in the crime, but it was never proved that he was responsible, nor why someone should wish to take the Earl's corpse in the first place. The story shocked Victorian society and was known as 'the Great Dunecht Mystery'.

There are a number of stories which tell of memorials being defaced or altered to suit the wishes of people of different periods. Shortly after the years of the Covenant, when Robert Paterson was erecting stones in memory of the martyrs, a memorial was erected in the kirkyard of Kirkmichael in Ayrshire commemorating Gilbert MacAdam, an ancestor of John Loudon MacAdam, the famous roadmaker, and chief of the MacAdams of Waterhead. MacAdam was a wanted man, simply for the fact that he had sheltered Covenanters at his home in the hills of Carsphairn. The authorities eventually caught him but, following trial at Dumfries, he was released on bail of £400. He was captured a second time, and on this occasion was banished to America as a slave. However, MacAdam managed to buy his freedom and returned to Ayrshire. He was attending a prayer meeting in Kirkmichael when a company of militia surrounded

the house in which it was held and shot him as he tried to escape. On his stone, 'Old Mortality' inscribed: 'Here lyes Gilbert M'Adam who was shot in this parish by the Laird of Colzean and Ballochmil for his adherence to the word of God and Scotland's Covenanted Work of Reformation, 1685.'

At the Revolution in 1688, both Culzean (as the castle is now spelled) and Ballochmyle found it prudent to change sides. Trying to cloud their past deeds, they had a mason remove the offending lines on the tombstone which mentioned their names. However, at a later date, a Covenanting sympathizer (some accounts say that 'Old Mortality' himself was responsible) returned to the kirkyard and had 'Colzean and Ballochmil' chiselled even deeper into the stone. This headstone still survives, having been inserted in the side of an 1829 monument, and the re-cut inscription is still apparent.

Of a similar nature is the tale of the effigies and memorials which for many years were to be found within the Duff mausoleum in the grounds of Duff House, Banffshire. The mausoleum was erected 1792 on the site of a Carmelite convent by the second Earl of Fife. The Duff family had risen to the earldom in a short period of time from being simple crofters and farmers, so they had no great ancestors of which to boast, but Lord Fife set about altering that.

Within the old kirk of Cullen was an effigy of a Hay, who died in 1539, and an inscriptive slab to Alexander Innes on which was an incised knight. Lord Fife, with the dubious permission of Lord Seafield, had these memorials removed from Cullen and taken to Banff, where he placed them in his mausoleum. For the effigy he had a new inscription added, claiming it to be in memory of a John Duff who died in 1404, and the Innes slab was placed within. A further effigy was obtained from the old kirkyard of St Mary's in Banff, originally commemorating a Douglas, provost of Banff for a time: likewise an inscription was devised for this tomb.

The Duff fortunes dwindled from 1800 to 1880 and eventually Duff House and its grounds were gifted to the people of Banff and Macduff, the house latterly becoming protected as an ancient monument. The folk of Cullen led the campaign to have the memorials returned to their rightful place, and in 1966 the Innes slab and Hay tomb were transported back to the old kirk. Although the Duff inscription claimed the tomb contained the remains of a Duff, nothing was found within, and no burial remains were to be found beneath the slab belonging to Innes. The Douglas effigy still remains at the mausoleum placed within a semicircular arch.

There is a story associated with a memorial in the kirkyard of Kinross erected in memory of James Rankine the Younger of Coldun, who died in 1722. The mason who was employed to carve the stone was in the habit

Greyfriars Church, Edinburgh

of boasting of his superior skill and workmanship, but his mind must have been thinking of other things whilst he was cutting the estate name onto the Rankine stone, resulting in 'Coldoch'. When someone pointed out his error, the mason was so filled with shame that he committed suicide.

Although kirkyards would perhaps seem to be a natural choice for the scene of ghostly happenings, with their associations with death and burial, this is not the case in Scotland, where there are very few tales associating ghosts and spirits with churchyards though many relating to old houses and castles. Perhaps the ghostly nature of kirkyards was a too obvious connection for tales of this sort to come about.

However, there are one or two kirkyards which have ghostly tales connected with them, and an example is the old burial ground of Kirk Cormack, or Kilcormack, on the banks of the Kirkcudbright Dee, a few miles from Kirkcudbright itself. According to tradition, the fairies were in the habit of grinding their corn within the mills on the night of Hallowe'en, making enough to keep them supplied for a year. However, tradition asserts that fairies and the like could not cross running water, so, to operate mill lades and sluices that produced the water supply required to turn the millwheels that ground the corn, ghosts of mortal men arose from their resting place to work on the fairies' behalf.

Kirkcormack Mill, and the kirk lands of thirty-three acres, were tenanted by James Thomson, who in 1827 told an antiquarian researcher of experiences he, his father and grandfather had undergone on Hallowe'ens in the past.

Thomson's grandfather's encounter with the fairies began one Hallowe'en night when he was awakened from his sleep by the sound of the millwheel

A selection of death's heads and bones [*Top Left to Right: Dalmellington (Ayrshire), Sorn (Ayrshire), Alvah (Banffshire), Douglas (Lanarkshire), Wanlockhead (Dumfriesshire), Turriff (Aberdeenshire), Lundie (Angus), Kilmadock (Perthshire)*]

turning. Realizing, from traditional stories that had been passed down to him, that it would be the fairies at work, he was willing to try to ignore the sound and return to sleep, but his wife was also awake, and she sent him down to chase the fairies away. Taking his collie, Grandfather Thomson walked to the mill, where he noticed piles of corpse-clothes around it, but no sign of any men from them. He did see the fairies, however, and they saw him, for they tried to get him and his dog to eat some of the meal they had ground. Refusing to take it, Thomson and his dog left the mill, but, as the collie passed through the mill door, it swung round and trapped its head between the door and the jamb, killing it.

The father's experience of the fairies occurred another Hallowe'en evening when the sound of water and the turning wheel woke him. He got dressed and went down to close the mill dam, but as he did so two deadly cold hands gripped him on the shoulders and pushed him back to his bed. For the rest of his life, Thomson's father was reckoned to have shoulders that could never be kept warm.

Thomson's own brush with the ghosts of Kirkcormack took place one evening shortly after he had succeeded to the farm. He was walking in the field next to the old kirkyard when he saw a figure wandering amongst the graves, dressed in the garb of the century before. The figure crossed the kirkyard and entered the field, passing straight through a herd of cows which showed no awareness of its presence. Thomson's dog, however, felt the presence of the ghost, for it began to cower and howl, eventually breaking free and returning to the millhouse, where it hid beneath a bed. When Thomson visited the kirkyard he noticed that the grave from which the ghost had appeared had been erected in memory of a miller who had died in 1578.

Another fairytale comes from Balquhidder (Perthshire). The Reverend Robert Kirk was ordained there in 1669 and spent much of his time translating the Bible into Scots Gaelic, having it published in 1690. However, he is more noted for the book he had printed the following year, entitled *The Secret Commonwealth of Elves, Fauns and Fairies*, in which he claimed to have had first-hand experience of these people, describing it in a matter-of-factual manner. They had ' ... apparel and speech like that of the people and country under which they live; so are seen to wear plaids and variegated garments in the Highlands of Scotland. They speak little, and that by way of whistling ... Their bodies be so plyable through the subility of the spirits that agitate them, that they can make them appear or disappear at pleasure'. Shortly afterwards Kirk died and his body was found on the Dun Hill near Aberfoyle, a spot supposed to be the haunt of fairies. When his coffin was taken to Aberfoyle, it is said that it had to be filled with stones, his body having disappeared. Rumour had it that the

fairies had taken it away, as punishment for his having revealed their way of life. A slab by the ruined kirk marks where Kirk's body is 'supposed' to have been laid.

The kirk of Rathen, near Fraserburgh, in Aberdeenshire, was the scene of another spiritual happening, this time as far back as 1644. On a number of days, about the time morning prayers were being said, the congregation heard a choir singing in the upper loft, with music from organs and other instruments, though there were no signs of anyone, let alone a choir, in the upper loft. The old kirk is now an ivy-grown ruin, having been replaced in 1870 by a large Gothic building.

There is a stone built into the wall of the old kirk of Kilneuair, Argyll, from the Gaelic *Cill an Iubhair*, 'church of the yew tree', which was for long believed to be haunted, particularly in the hours of darkness. On one occasion a tailor made a bet that he would spend a night within the kirk, passing his time making himself a pair of trews. Armed with a lantern, he set about his work, but about the midnight hour he was startled to see a skeletal hand rising from one of the graves. In Gaelic, a gruff voice asked him, 'Do you see this great hoary hand, tailor?' Trying to keep calm, the tailor answered that he did and that he would continue to sew his trews. Shortly after, a skull appeared from the grave and a similar question was heard, 'Do you see this large grey head, tailor?' The tailor answered in the affirmative yet again and voiced his intention to continue sewing. A number of such appearances continued, with the tailor answering in a similar manner, until at length the whole skeleton had appeared from the grave. When it did so, the tailor fled in terror, just as the skeleton stretched forth its hand to seize him. Missing the tailor, its hand struck hard against the kirk wall, leaving its impression, where it remains to this day for all to see.

There are, in fact, two other tales which are supposed to account for this handprint on Kilneuair's kirk wall. One asserts that it was made by the Devil, trying to grab someone who reached the safety of within just in time, another giving a different account of the tailor – that Satan was in pursuit of the tailor's soul, but the tailor ran towards this kirk and on reaching it turned to grab the Devil's hand and pinned it to the wall with his bodkin.

Another tale associating the 'De'il' (as he is often known in Scotland) with a kirk comes from Cortachy in Angus. When the parishioners were erecting a kirk (the predecessor to the present 1829 building), the Devil attempted to stop them and in a flight of frenzy took a large boulder from one of the Mounth hills and hurled it at the church. The boulder missed, however, landing near the River Esk, in the den below the kirkyard. 'The Devil's Stane', as it became known, can still be seen, but modern man tends to pass it off as an 'erratic', dropped by a retreating glacier.

There are a number of witches associated with kirks and kirkyards. In the sixteenth and seventeenth centuries the practice of witch-hunting grew to immense proportions in Scotland, almost everyone – from lairds and ministers down to cotfolk – being involved to some extent. The 'witches' who were burnt at the stake tended to be women who had perhaps fallen on bad times – widows, spinsters and those who perhaps had a physical or mental disability, no matter how small. They were blamed for all sorts of things, in particular when cows didn't give milk or hens wouldn't lay. James VI (r. 1567-1625) was responsible for escalating witch hunts to every part of the kingdom, for his *Daemonologie*, published in 1597, incited hunts in every parish. In the early years witches would simply be subjected to trial before the kirk session, and minor punishments, such as a period in the jougs or stocks given out, but later almost every witch was burned to death.

In 1662, in the kirk of Auldearn, near Nairn, Isobel Gowdie stood up and confessed that she had met the Devil within that very building, 'I denyed my baptism,' she said, 'and did put one of my hands to the crown of my head, and the other to my foot, and then renounced all betwixt my two hands over to the Devil.' Further confessions revealed that Gowdie and accomplices had ' ... met in the Kirkyard of Nairn, and we raised an unchristened child out of its grave; and at the end of Broadley's corn-field-land, just opposite to the Mill of Nairn, we took the said child, with the nails of our fingers and toes, pickles of all sorts of grain, and blades of trail, and hacked them all very small, mixed together. And did put a part thereof among the muck-heaps of Broadley's lands, and thereby took away the fruits of his corns.' The result of the trial is not recorded, but on these admissions the session probably could do nothing other than have her burned. Within the year, four witches were burned in the district, one of whom was probably Gowdie.

Further west along the coast is the village of Kirkhill, where another witch-hunt took place. A professional witch-hunter from the lowlands named Paterson was invited to the kirk by the parishioners, and fourteen women and one man were lined up before him. His first command was that their hair be shaved off, and this he mixed together and buried within the stone dike which surrounds the kirkyard. He then went on to prick each person with a long brass pin, supposedly finding the 'Devil's spot' on each, a place where they felt no pain. Even when asked to remove the pin, each 'witch' could not do so, which was deemed sufficient evidence on which to burn them.

In 1662 a coven of witches were said to have used Tulliebole kirkyard in Kinross-shire for a meeting around midnight, and eleven of them were burned at the stake in nearby Crook of Devon. Opposite the kirkyard of

Alloway kirk (Ayrshire) with Burns' monument

Spott in East Lothian is the Witches' Stone where a number were also put to death, including 'the last witch south of the Forth', in 1705. The last witch killed by burning in the Highlands was Janet Horne, and a small rude stone at Dornoch with the year 1722 marks where it took place.

Burns' famous poem 'Tam o' Shanter' associates the ruins of Alloway kirk with witches. When the bard wrote to Francis Grose, sending him three tales of witches from Alloway kirk, he stated that two of them were authentic but the third, on which 'Tam o' Shanter' was based, was 'not so well identified as the two former with regard to the scene'. The kirk, which was erected about 1516, was a ruin in Burns' day and gave him the inspiration for the lines:

> Kirk-Alloway was drawing nigh,
> Where ghaists and houlets nightly cry ...
> Warlocks and witches in a dance,
> Nae cotillion, brent new frae France,
> But hornpipes, jigs, strathspeys, and reels,
> Put life and mettle in their heels.
> A winnock-bunker in the east,
> There sat Auld Nick, in shape o beast;
> A touzie tyke, black, grim and large,
> To gie them music was his charge;

He screw'd the pipes and gat them skirl,
The roof and rafters a' did dirl.
Coffins stood round, like open presses,
That shaw'd the dead in their last dresses;
And, by some devilish cantraip sleight,
Each in its cauld hand held a light:
By which heroic Tam was able
To note upon the haly table,
A murderer's banes, in gibbet-airns;
Twa span-lang, wee, unchristen'd bairns;
A thief new-cutted frae a rape –
Wi his last gasp his gab did gape ...
Wi mair of horrible and awefu,
Which even to name wad be unlawfu.

There is a tale associated with a grave in the kirkyard of Chirnside (Berwickshire). When Margaret Halcrow, second wife of the Reverend Henry Erskine, died in 1674, a few months after their marriage, she was carried to the grave and interred with a valuable ring still on her finger, a fact noted by the village sexton. After the funeral service, when only a light covering of earth was placed over the coffin, the sexton returned to the kirkyard with the intent of digging up the grave and removing the ring but it was so hard to remove it from the corpse's finger that he used his knife and began the task of cutting the digit off. As he did so, the corpse sat up in the coffin, screamed, then dashed across the kirkyard to the manse, where she shouted for the minister to open the door, 'For I'm fair clemmed wi' the cauld.' The wife lived a fair number of years thereafter, giving birth to Ralph and Ebenezer Erskine, founders of the Secession Church.

Coinneach Odhar (c. 1610-70) better known as 'the Brahan Seer', predicted the creation of the Tomnahurich cemetery in Inverness. He reckoned that, 'The day will come when Tomnahurich will be under lock and key, and the fairies secured within.' This is believed to have been fulfilled after 1846, when the first recorded burial took place and when the wooded hill was enclosed and laid out as a cemetery, a wall and locked gates being erected around it.

Among the ghostly tales associated with some funerals is one about Sir Robert Grierson, first Baronet of Lag and Rockhall, an infamous persecutor of the Covenanters during the 'killing years' of the seventeenth century, who died, in 1733, at the age of eighty-eight, in Dumfries. When the cart was loaded with his coffin (it is said that part of his house wall had to be removed to get it out) the horses were able to pull it only a short distance before they halted in a state of exhaustion. Kirkpatrick of

Closeburn sent for some of his best Spanish horses, and when they were attached to the hearse, they pulled it at a great rate all the way to the old kirkyard of Dunscore, but, on reaching it, fainted and died. At Dumfries a black raven, supposedly the emblem of the Devil, landed on the coffin prior to its journey, and it took much waving about to frighten it off. It followed the funeral party all the way to Dunscore, however, and flew off only when Lag's body was in the ground.

There are a number of tales of a similar nature associated with the funeral cortege, often concerning the Gaelic tradition of folk who have the second sight 'seeing' something relating to it. One example is of a man standing by his cottage door when he noticed a group of people carrying a corpse along the road. There were no sounds coming from the party, not even the sound of feet tramping on gravel, but each face was recognizable. The funeral party went as far as a neighbour's house, where it seemed to disappear. A few weeks later a man was lost on the hills, and at length his body was found dead in the heather. When the funeral was arranged, the 'seer' was terrified when he realized that the cortège was composed of the same folk, only now they were coming *from* the dead man's house, *to* which the procession had gone, and then disappeared.

Characters of all sorts have announced their burial wishes prior to their death, and some of these can be amusing. In Anderston (Glasgow) a man who believed in reincarnation reckoned that he would return to earth as a horse, so his last wishes included the request to be buried standing up, so that he could gallop off more easily. To facilitate his wishes, two lairs had to be used to allow room for this. His wife must not have had the same inclinations, for her grave, located elsewhere in the kirkyard, was normal. Anderston kirkyard no longer exists, having been removed in 1966, when the Kingston Bridge was to be built, the remnants relocated in Linn Cemetery, along with some memorial stones.

Not located within a kirkyard, but a burial all the same, is the grave of the wife of John Inglis Harvey of Kinnettles. Harvey obtained the estate of Kinnettles (between Glamis and Forfar, Angus) so long as his wife, the heiress, 'remained above ground'. When she predeceased him, he had her corpse laid in a glass coffin within a specially built mausoleum – above ground!

In Edinburgh's Portobello Road are the Craigentinny Marbles, an ornate burial tomb erected over the remains of William Miller of Craigentinny House. The tomb comprises a Roman mausoleum with large carved marble slabs by Alfred Gatley, a memorial worthy of mention in itself, but even more surprising is the fact that Miller's body was laid forty feet below the surface. He died in 1848, when body-snatching fears were still common, and this was his method of preventing his corpse being tampered with.

APPENDIX:

NOTABLE GRAVES IN SCOTTISH KIRKYARDS

Searching for the graves of famous folk was common in Victorian times, every local guidebook of that era detailing those of importance buried in that district, and the practice is now becoming popular again. The following list gives the whereabouts of graves of some notable folk from Scotland's history (though it is by no means comprehensive). Also included are graves of the martyrs for the Covenant, where they are located in kirkyards; those with a deeper interest in the Covenanters can refer to the many specialist books, in particular *The Martyr Graves of Scotland*. Covenanters who suffered but survived have been excluded.

There are also a number of tombstones which are visited not for whom they commemorate but because of the carvings or distinctiveness of the stone, or else because the epitaph is of note. Such examples, such as the noted 'Eternity' stone at Logie Pert and John Murray's headstone at Kells, are not included in the following list but mentioned in the relevant part of the foregoing text.

The Ordnance Survey Reference of each kirkyard or cemetery has been given.

ABERDEENSHIRE

Aberdeen – St Machar's NJ 939089
James Giles, 1801-70. Artist.

Crathie NO 264947
John Brown, 1826-83. The 'devoted and faithful personal attendant and beloved friend of Queen Victoria, in whose service he has been for 34

years'. Brown was born at Crathienaird and served as ghillie to Victoria on her Balmoral estate. He died at Windsor Castle. Other stones erected by royalty here include that to James Bowman, gamekeeper.

Longside NK 037472

John Skinner, 1721-1807. Schoolmaster, then Episcopal minister at the age of twenty-one in Longside parish, which he served for sixty-four years. He wrote a number of ecclesiastical works, as well as 'Tullochgorum' – 'the best Scotch song ever', according to Burns, with whom he corresponded in verse. His son was John Skinner, Bishop of Aberdeen.

Jamie Fleeman, or Fleming, 1713-78. Known as 'the Laird o' Udny's Fool', Fleeman was employed by the Udnys of that Ilk at Knockhall Castle as a sort of jester, and saved the family from disaster when the castle went on fire. *The Laird of Udny's Fool* tells his story. His last wish was, 'Don't bury me like a beast.' In 1861 an obelisk was erected over his grave.

ANGUS

Dundee – Howff NO 401303

James Chalmers, 1782-1853. A bookseller in Dundee, Chalmers invented the adhesive postage stamp, which 'saved the penny postage scheme of 1840 from collapse'. Granite tombstone alongside another to Chalmers and his wife.

Dundee – Western Cemetery NO 379299

William Thom, 1788-1848. Known as 'the Inverury Poet'. Thom was a handloom weaver, packman and wandering minstrel. Finding a patron for his works, he went to London and was lionized but failed to look after his income sensibly. He died in Dundee penniless, and his memorial was erected by friends and admirers.

Kirriemuir NO 389544

Sir James Matthew Barrie, 1860-1937. His birthplace in the town is now protected by the National Trust. Barrie is blamed for having originated the 'Kailyard' school of novelists, of which he was one, but he is most noted for his many plays, in particular *The Admirable Crichton* and *Peter Pan*. At one time he had three different plays on London stages simultaneously.

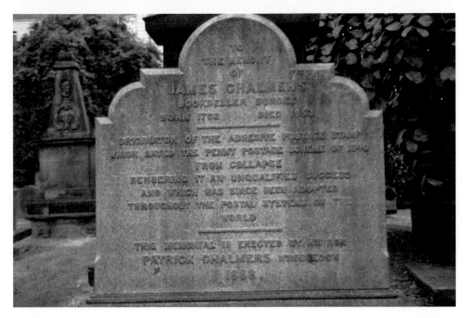

James Chalmers' grave, Dundee

AYRSHIRE

Alloway NS 331180
William Burnes, 1721-84. Father of Robert Burns, William was born in
Kincardineshire before moving to Alloway to seek work as a gardener. The
headstone, which replaces one broken by souvenir hunters, contains an
epitaph by the bard himself.

Auchinleck NS 551215
James Boswell, 1740-95. Son, of Lord Auchinleck, Boswell was a noted
diarist and biographer, his famous work being the *Life of Johnson*, with
whom he toured the Hebrides, each writing a book. Boswell succeeded to
the Auchinleck estates but continued working as an advocate. His personal
journals have only recently been published. He was laid to rest within
Boswell Mausoleum, alongside his father, who had the vault erected.

Ayr – Auld Kirkyard NS 339219
A number of acquaintances and friends of Burns are buried in the
kirkyard, including Robert Aitken, William Fergusson of Doonholm, John
Ballantyne of Castlehill, Dr Charles and the Reverend William Dalrymple,
a plan within the lychgate indicating their whereabouts.

James Smith, Alexander MacMillan, George MacCartney, John Short, John Graham, John Muirhead and James MacMillan, Covenanters, hanged at Ayr, 1666, for their part in the Battle of Rullion Green.

Ayr – Holmston Cemetery NS 348211

George Douglas Brown, 1869-1902. Born in Ochiltree of unmarried parents, Brown studied at the universities of Glasgow and Oxford. He worked as journalist until publication of *The House with the Green Shutters*, a strong novel which killed the 'Kailyard' school of writing stone dead. Brown died shortly after the novel's publication, at the early age of thirty-three.

Barr NX 276941

Edward MacKean, Covenanter, shot nearby by Cornet James Douglas in 1685. Simple headstone.

Colmonell NX 145858

Matthew MacIlwraith, Covenanter, shot in 1685 by Claverhouse's dragoons. His name is thought to have inspired Scott with 'Mucklewrath' in *Old Mortality*.

Cumnock (Old) – Old Cemetery NS 570203

Alexander Peden, 1626-86. Born near Sorn, Peden became minister of New Luce, Wigtownshire. He was removed from office by the Middleton Act, whereupon he preached to the Covenanters all over the hills and moors of southern Scotland. He died in his brother's house and was at first buried at Auchinleck, but his body was moved to Cumnock (see p.159). Two old stones and a white granite monument commemorate him.

David Dun, Simon Paterson and Thomas Richard. Covenanters shot in 1685 for their religious beliefs. Commemorated by three tombstones in same enclosure as Peden.

William Simson, 1758-1815. The 'Winsome Willie' of Burns, Simson was born at Ochiltree and trained to become a schoolmaster, first at Ochiltree, then at Cumnock. Burns wrote an 'Epistle' to Simson. Also interred here is Anne Rankine, of Burns' 'Corn Rigs and Barley Rigs'.

James Taylor, 1753-1825. Born in Leadhills, Taylor worked with William Symington and Patrick Miller to build a steam-powered paddle-boat, which sailed on Dalswinton Loch. He later moved to Cumnock to work in the mines. His headstone states that he was 'the inventor of steam navigation'.

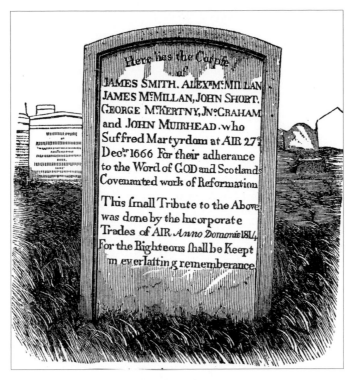

Martyrs' headstone, Auld Kirkyard, Ayr

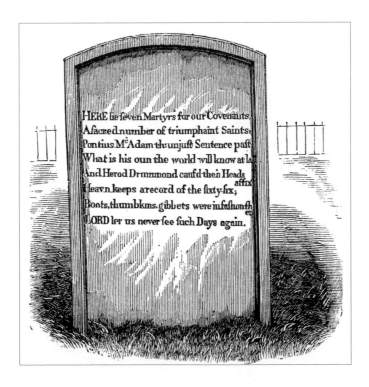

Cumnock (Old) – New Cemetery NS 571193
James Keir Hardie, 1856-1915. Hardie, born in Lanarkshire, went to Ayrshire to work in coal mines but was dismissed for campaigning for better facilities. He took up journalism and founded the Independent Labour Party, being their first MP, representing West Ham, then Merthyr Tydfil.

Fenwick NS 465435
John Fergushill, George Woodburn, Peter Gemmel and James White, Covenanters, shot in 1685 and commemorated by three different stones. There are also memorial stones to William Guthrie, Captain John Paton, Robert Buntine and James Blackwood, Covenanters, buried elsewhere.

Galston NS 500367
Andrew Richmond, martyr, shot by Claverhouse in 1679.

Irvine NS 322387
David Sillar, 1760-1830. A friend of Burns and minor poet, he was for a time schoolteacher, grocer and navigation lecturer, each without success, and a member of the Bachelors' Club. Burns regarded his work highly.

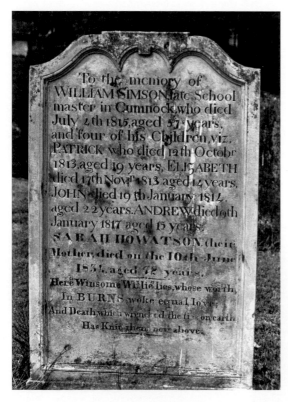

Headstone to 'Winsome' Willie Simson, a friend of Robert Burns, Cumnock (Ayrshire)

Fenwick Church (Ayrshire) Note jougs attached to gable, where they can still be seen

James Blackwood and John MacCall, Covenanters, hanged in Irvine on 31 December'1666 for their part in the Pentland Rising.

Kilmarnock – Laigh Kirkyard NS 428380
Thomas Samson, 1722-95. A seed merchant in Kilmarnock and friend of Burns, who composed Samson's epitaph while he still lived; part of it is inscribed on his tombstone. Other Burns contemporaries interred here include John Robertson and James MacKinlay, both ministers.

John Ross, John Shields and John Nisbet, Covenanters, commemorated by two stones. Ross and Shields were executed at Edinburgh and their heads set up in Kilmarnock, 1666; Nisbet was hanged at Kilmarnock Cross in 1683.

Kilmarnock – High Kirkyard NS 430383
John Wilson, 1759-1821. Printer of the first edition of Burns' poems in 1786 – all 612 copies were sold out within the month. Burns couldn't afford to pay for a second run, and Wilson was unwilling to risk it, hence the next edition being published in Edinburgh.

Kirkmichael NS 345089
Gilbert MacAdam, Covenanter, shot in 1685 at the command of Captain Kennedy for his religious beliefs. See also p.166.

Largs NS 211583
Sir William Burrell, 1861-1958. A shipping magnate and collector of many works of art and historical artefacts which he left to the city of Glasgow, along with money with which the Burrell Museum in Pollok Park was built.

Loudoun NS 493373
Thomas Fleming, Covenanter, killed at the Battle of Drumclog in 1679.

Mauchline NS 498272
Burial place of a number of Burns' friends, including Gavin Hamilton, Andrew Fisher, Mary Morrison, John Brown, John Richmond, William Auld and James Humphrey, a plan on the kirk wall locating them. Also four infant daughters of Burns and Jean Armour.

James Smith, Covenanter, died of wounds in Mauchline prison, 1684.

Muirkirk NS 700278
John Lapraik, 1727-1807. A poet friend of Burns, he was a farmer but lost money in the Ayr Bank Crash, latterly running a post office and inn in Muirkirk. Burns wrote some 'Epistles' to him.

Tibbie Pagan 1741-1821. Minor poet and innkeeper who wrote the original version of 'Ca' the Yowes tae the Knowes', a song improved by Burns.

John Smith, Covenanter, shot near the kirk by Colonel Buchan and Lockhart of the Lee in 1685.

Newmilns NS 537373
John Law, John Gebbie, John Morton, Matthew Paton, David Finlay, James Wood, John Nisbet and James Nisbet, Covenanters, commemorated by various headstones and two obelisks. Shot or executed at various places for their religious adherence.

Ochiltree NS 511213
John Tennant of Glenconner, 1725-1810. Friend of Burns and of his father. A witness at Burns' baptism. Also memorial to William Simson and his brothers – see Cumnock reference.

Old Dailly NX 225993
John Semple, Thomas MacClorgan, John Stevenson, George Martin and two unknown martyrs, Covenanters, executed for their beliefs. Two memorials and an old stone commemorate them.

Sorn NS 551268
George Wood, Covenanter, shot in 1688, the last to suffer for the cause. Mural monument on kirk wall.

Straiton NS 380049
Thomas MacHaffie, Covenanter, shot south of the village in 1685, although he was ill at the time. Two headstones.

Tarbolton NS 430271
William Shillilaw, Covenanter, shot at the age of eighteen in 1684. Also graves of acquaintances of Burns.

BERWICKSHIRE

Chirnside NT 870565
James Clark, 1936-68. Born in Fife, he moved with his family to the borders when he was six. He worked as a shepherd on his father's farm, but his great interest was in racing cars. He became world champion in 1963, driving a Lotus, and was killed in 1968 in a Formula 2 championship race at Hockenheim.

Dryburgh NT 591317
Sir Walter Scott, 1771-1832. Granite sarcophagus in abbey ruins to Scott and his family, located within the aisle of St Mary. Scott was the greatest novelist produced by Scotland, and a competent poet, although he gave up writing poetry on his novels' success and Byron's appearance. His best known novels include *Waverley, The Heart of Mid-Lothian, Old Mortality, Rob Roy* and *Redgauntlet*.

Douglas, Earl Haig, 1861-1928. Simple military tombstone carved by Pilkington Jackson. Haig fought in Egypt and South Africa and in Europe in the Great War, when he was in command of the expeditionary forces. On retiring he organized the Haig Fund, which sells poppies in aid of ex-servicemen.

Westruther NT 634500
Lady John Scott, 1810-1900. Born Alicia Anne Spottiswoode, Lady John Scott was a noted antiquarian, having excavated a number of burial cairns in the district, and songwriter, most famous for her refined version of 'Annie Laurie'.

BUTESHIRE

Sannox (Isle of Arran) NS 013454
Edwin Rose, an English holidaymaker and the victim of the Goat Fell murder in 1889. A granite boulder taken from the hill marks his grave.

DUMFRIESSHIRE

Caerlaverock NY 025692
Robert Paterson, 1715-1801. The 'Old Mortality' of Scott's novel of that name. Paterson was a stonemason who erected or repaired monuments and graves to the Covenanters. His headstone here was erected by Scott's publishers (see p.160).

Dalgarnock NX 876936
A number of stones to Covenanters who suffered for the cause, and also a white granite cross listing all the Nithsdale Martyrs.

Dumfries – St Michael's NX 976757
Robert Burns, 1759-96. Scotland's national poet, born at Alloway in Ayrshire and died in Dumfries. A Greek-style mausoleum marks his grave,

although this was moved (see p.165). Marble carvings within, as well as the original memorial stone. Burns is famous for his poems notably, 'Tam o' Shanter' and 'To a Mouse', as well as his songs, which include 'Auld Lang Syne' and 'A Man's a Man for a' That'.

A number of Burns' friends and contemporaries in Dumfries are also interred here, and a tablet locates the whereabouts of their graves. They include William Burnside, Thomas Goldie, John Harley, William Hyslop, John Bushby, James Gracie, Robert Jackson, John Lewars, William Inglis, Francis Shortt, David Staig, George Gray, John Mitchell, James MacClure, Adam Rankine, James Crichton, Robert Mundell, Archibald MacMurdo, Gabriel Richardson, John MacDiarmid, George Haugh, William Smith, William Wallace, David Williamson, John Hamilton, Archibald Blacklock, John Blacklock, Thomas White, James MacNeil, Mary MacLauchlin, Samuel Clarke, David Newall, William Clark, William Thomson and Alexander MacCulloch.

William Welsh, William Grierson and John Kirko, Covenanters, the first two executed at Dumfries for their part at Rullion Green in 1667, Kirko being shot in the town in 1685. An obelisk in memory of the Dumfries martyrs stands alongside.

Dunscore (Old) NX 927832
Sir Robert Grierson of Lag, 1655-1733. Infamous as a persecutor of the Covenanters, Grierson was the original of Scott's 'Sir Robert Redgauntlet'. After the Revolution of 1688 he was imprisoned three times and heavily fined.

Durisdeer NS 894037
Daniel MacMichael, Covenanter, shot in Dalveen Pass by Dalziel's troops, 1685.

Ecclefechan NY 192745
Thomas Carlyle, 1795-1881. Carlyle was born in the cottage in Ecclefechan which is now owned by the National Trust. He became a teacher but left the profession to concentrate on writing. He wrote many influential essays, as well as books of history and biography. He refused a baronetcy and burial within Westminster. Headstone located within railed enclosure.

Keir NX 863931
Kirkpatrick MacMillan, 1813-78. Headstone to many of MacMillan's family, the inscription finishing with his name as 'Inventor of the Bicycle'. In 1839 it was the first 'velocipede' to allow the rider to take his feet off the ground.

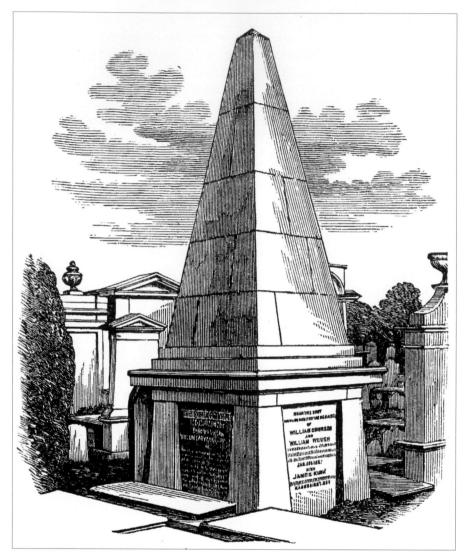

Monument at Dumfries to the Covenanting martyrs

Kirkland of Glencairn NX 809905
John Gibson, James Bennoch, Robert Edgar and Robert Mitchell, shot at Ingliston Mains, for their Covenanting adherence, 1685.

Moffat NT 086052
John Loudon MacAdam, 1756-1836. Born in Ayr, MacAdam worked in America, then returned to Scotland, where he bought an estate. He invented a means of road-surfacing which was a vast improvement on that used until then, and he became an adviser to many turnpike trusts throughout Britain. He died at his Moffat estate of Dumcrieff.

Ruthwell NY 101683
Henry Duncan, 1774-1846. Minister of the kirk here, Duncan was instrumental in rebuilding the Ruthwell Cross and also in founding the first savings bank, in 1810, which developed into the Trustee Savings Bank. White granite headstone on east wall. Also tablets within kirk.

Tynron NX 806930
William Smith, Covenanter, shot to death by Cornet Baillie in 1685. Originally interred beneath his parents' front doorstep as a mark of disrespect, but his corpse was reburied in the kirkyard after the Revolution.

DUNBARTONSHIRE

Bonhill NS 395796
Robert Nairn, Covenanter, died in April 1685 of an 'illness occasioned by severe handicaps and privations to which he was subjected for his steady adherence to the cause of truth and religious liberty'. Stone erected in 1826 and restored in 1898.

Helensburgh NS 300830
John Logie Baird, 1888-1946. Minister's son, born in the town. Inventor of the television, transmitting a Maltese cross through wires in 1924 and demonstrating infra-red television in 1926. He also started the first television station the following year, called 2TV.

Rhu NS 267840
Henry Bell, 1767-1830. Born in West Lothian, Bell worked as an engineer in various places, and in 1812 he built the twenty-five-ton *Comet*, a steamship which plied the Clyde, the first truly sea-going steamship in Europe.

EAST LOTHIAN

Athelstaneford NT 533773
Robert Blair, 1699-1746. Minister in the village from 1731 and poet, famed for his long work 'The Grave', published posthumously. An obelisk in the village also commemorates him.

Bolton NT 507701
Agnes Brown, 1732-1820. Mother of Robert Burns, Agnes outlived her husband by thirty-six years and died at Gilbert Burns' house nearby.

North Berwick NT 552852
Sir John Blackadder, 1623-85. Minister at Troqueer but removed from office for his Covenanting beliefs. He preached at many conventicles thereafter and spent some time in the Netherlands. On his return he was arrested and imprisoned on the Bass Rock, where he died.

John Blackadder's gravestone, North Berwick (East Lothian)

EDINBURGH

Canongate NT 264739

Adam Smith, 1723-90. Born in Kirkcaldy, Smith is famous for his *Wealth of Nations*, published in 1776. He was a professor at Glasgow University and later Commissioner of Customs for Scotland. Mural monument in enclosure to left on entering gates.

Robert Fergusson, 1750-74. Born of humble parentage, Fergusson was educated at Edinburgh High School, Dundee Grammar and St Andrew's University. He was of a weak constitution but found success in writing Scots poetry, a volume of which appeared in 1773. He died shortly afterwards in a lunatic asylum. Burns had his tombstone erected; it is located to west side of kirk.

Agnes MacLehose, 1759-1841. Ex-wife of a Glasgow lawyer, she moved to Edinburgh, where she met Burns. They corresponded in verse as 'Clarinda' and 'Sylvander'. Mural memorial in layer 28 of eastern section. Bronze medallion by H. S. Gamley.

Robert Hurd, 1905-63. Architect, responsible for much of the restoration of Edinburgh's old buildings, as well as others throughout Scotland. Mural memorial.

Dean Cemetery NT 238741

John Wilson, 1785-1854. Born in Paisley and Professor in Edinburgh, Wilson ('Christopher North') wrote many articles and poems for *Blackwood's Magazine* – in particular, 'Noctes Ambrosianae'. He was a friend of Hogg, Scott and Wordsworth.

William Playfair, 1789-1857. Architect, responsible for many of the Grecian-style buildings in Edinburgh, including the National Gallery, National Monument and Royal Scottish Academy, and also much of the New Town.

Henry, Lord Cockburn, 1779-1854. Law Lord friend of Scott and Lord Jeffrey, noted for his *Memorials of His Time*, a descriptive volume on Edinburgh life.

Francis, Lord Jeffrey, 1773-1850. Contributor to the *Edinburgh Review*, which he helped found and edited for twenty-five years. Lord Advocate, responsible for parts of the Reform Acts in 1832, created Lord of Session in 1834.

Sir William Allan, 1782-1850. Landscape painter and friend of Scott; noted for his historical Scottish scenes.

James Nasmyth, 1808-90. Son of Alexander Nasmyth, the painter, James was the engineer responsible for inventing the steam hammer and other machines.

James Syme, 1799-1870. Surgeon, noted for his developments in amputation and anaesthesia. Perhaps also true inventor of the macintosh, having discovered the solvent for rubber.

William Aytoun, 1813-65. Poet, born in Edinburgh, and professor at the university. Son-in-law of John Wilson, noted for his *Lays of the Scottish Cavaliers*.

Gogar Churchyard NT 168725
James Pittendreigh MacGillivray, 1856-1938. Born in Inverurie, created King's Sculptor in Scotland in 1921. Works include Byron in Aberdeen, Burns in Irvine, Gladstone in Edinburgh.

Grange Cemetery NT 256718
Hugh Miller, 1802-56. Geologist and mason, born at Cromarty. He did much to popularize the study of rocks in Scotland, making important discoveries himself. Also wrote poems and books with success.

Greyfriars NT 256733
Allan Ramsay, 1684-1758. Poet, born in Leadhills, Lanarkshire, and wig-maker in Edinburgh. Noted for his 'Gentle Shepherd' and 'Tea-Table Miscellany'. Mural memorial on south-west corner of kirk.

Duncan Ban MacIntyre, 1724-1812. Most famous of Gaelic poets and songwriters, born at Glenorchy in Argyll. He could neither read nor write and memorized all his works. Famed for 'In Praise of Beinn Dorain' and 'Mairi Bhan'. His memorial here, an obelisk with a carving representing shooting, contains some Gaelic verses.

Henry MacKenzie, 1745-1831. Born in Edinburgh and trained as lawyer. At the age of twenty-six his first novel, *The Man of Feeling*, was published, his greatest work.

Alexander Henderson, 1583-1646. Minister in Fife and one of original authors of the National Covenant. His memorial is a foursquare block surmounted by an urn whose inscriptions were obliterated at the Restoration but later restored.

William Adam, 1689-1748. Last of the truly Scots architects, father of more famous Robert, who had a hand in designing his father's memorial, a large classical mausoleum. His work survives at Hopetoun House, Haddo House and Duff House.

Joseph Black, 1728-99. Lecturer in Glasgow where he discovered the principle of latent heat and was one of first to believe that air was composed of a variety of gases.

James Gillespie-Graham, 1777-1855. He succeeded to his wife's estates, hence adoption of name Graham. As an architect he is noted for much

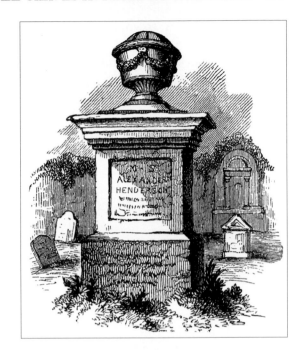

Alexander Henderson's
memorial, Greyfriars,
Edinburgh

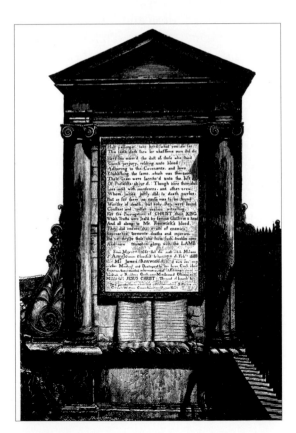

Monument in Greyfriars
kirkyard, Edinburgh to the
Covenanting martyrs

of Edinburgh's New Town, as well as some country houses. Covenanter's Monument erected 1771 to replace older memorial to the many Covenanters buried within this kirkyard.

Also memorials to John Gray, owner of Greyfriars Bobby, Greyfriars Bobby himself, James Craig (architect), John Porteous (City Guard captain who was murdered), Walter Scott (father of Sir Walter), Lord Monboddo, Robert Milne (architect), Lord Forbes of Culloden, Alexander Murray and George Buchanan.

New Calton Cemetery NT 266740

Thomas Stevenson, 1818-87. Father of Robert Louis Stevenson. Lighthouse builder.

David Bryce, 1803-76. Architect, designer of hundreds of country houses throughout Scotland, particularly in the neo-baronial style, as well as classical buildings for Edinburgh.

Old Calton Cemetery NT 260740

Thomas Hamilton, 1784-1858. Architect of much of Edinburgh's New Town, including Royal High School and Royal College, and of Burns' monuments at Calton and Alloway.

David Hume, 1711-76. Philosopher, born in the city. Wrote a *Treatise on Human Nature* at the age of twenty-six but his *Philosophical Essays* of 1748 were more successful. Also wrote a number of histories of Britain. His cylindrical mausoleum was designed by Robert Adam in 1777.

John Playfair 1748-1819. Graduated as a minister and took his father's vacancy at Benvie in Angus but became increasingly devoted to the study of maths, becoming a professor at Edinburgh University. Wrote a number of books on mathematics and natural philosophy.

Archibald Constable, 1774-1827. Bookseller and publisher, born at Carnbee in Fife. Published the *Edinburgh Review* and many of Scott's works, persuading him to finish *Waverley*. His bankruptcy in 1826 left Scott penniless also.

William Blackwood, 1776-1834. Bookseller in Edinburgh, publishing *Blackwood's Magazine* as competitor to Constable's *Review* in 1817, obtaining contributions from Hogg, Lockhart and others.

Robert Burn, 1752-1815. Architect, noted for his Gothic and neobaronial castles. Designed Nelson Monument in Edinburgh.

Sir John Steell, 1804-91. Sculptor, born in Aberdeen, noted for many statues in Edinburgh, including Alexander and Bucephalus, Wellington, Sir Walter Scott, Victoria and Albert.

Also of interest in this burial ground are the monument to the political martyrs, a huge obelisk designed by Hamilton, and the statue of Abraham

Lincoln, the first statue of him erected in Britain, unveiled in 1893 as a memorial to the Scottish Americans who fought in the Civil War.

St Cuthbert/St John's churchyards NT 249736
Sir Henry Raeburn, 1756-1823. Born in Edinburgh, Raeburn became a noted artist, particularly for portraits, of which he produced many. Almost everyone of note in Scotland at the time was the subject of his brush.

Thomas de Quincey, 1786-1859. Author, born in Manchester, noted for his *Confessions of an Opium-Eater*.

Catherine Sinclair, 1800-1864. Author, daughter of Sir John Sinclair of *Statistical Account* fame. Wrote *Holiday House* and Scottish works.

Warriston Cemetery NT 253 757
Horatio MacCulloch, 1805-67. Born in Glasgow and painter of snuffboxes at Cumnock, MacCulloch became one of the most popular artists of Scottish rural scenes.

Sir James Young Simpson, 1811-70. Born in Bathgate, Simpson became a doctor, then Professor of Medicine at the age of twenty-nine. Noted for his discovery of the use of chloroform in surgery.

FIFE

Cupar NO 373145
Laurence Hay and Andrew Pitullo, Covenanters hanged at Edinburgh's Grassmarket in 1681 and their heads buried here with a hand of Hackston of Rathillet.

Dunfermline NT 087873
Robert Bruce (King Robert I), 1274-1329. Nineteenth century brass marking spot where the Bruce lies. He fought a guerrilla war in Galloway prior to his successful defeat of the English at Bannockburn in 1314, resulting in the independence of Scotland.

St Andrews NO 514167
Samuel Rutherford, 1600-1661. Minister of Anwoth and Professor of Divinity at St Andrews. Covenanter, famed for his *Lex Rex*.

GLASGOW

Cathcart NS 588605
Robert Thom, Thomas Cook and John Urie, Covenanters, shot in the Loan of Polmadie 1685.

Cathedral NS 602656
Covenanters' grave, now located within cathedral. Commemorating nine martyrs hanged in Glasgow on 19 March 1684.

Necropolis NS 605655
William Motherwell, 1797-1835. Journalist and poet, notable for verses on Renfrewshire localities and 'Jeanie Morison'.

William Miller, 1810-72. Memorial to Miller (interred in Tollcross kirkyard), the author of 'Wee Willie Winkie'.

William Thomson, Lord Kelvin, 1824-1907. Born in Belfast, Thomson became Professor of Natural Philosophy in Glasgow, where he made many discoveries in the fields of thermodynamics, navigation and electricity. He invented the galvanometer, and the unit of temperature was named after him in honour of his discovery of absolute zero.

Alexander Rodger, 1784-1846. Poet, born in Mid Calder and died in Glasgow. Wrote 'Rob Tamson's Smiddy', better known as 'The Muckin' o' Geordie's Byre'.

Ramshorn (St David's) NS 596653
David Dale, 1739-1806. A linen manufacturer in Rothesay, Dale established successful works in Catrine (Ayrshire) and New Lanark, providing excellent accommodation and services for his employees which was unusual at the time.

St Kentigern's Cemetery NS 579698
Benny Lynch, 1913-46. Boxer, born in Glasgow, who became the 'undefeated featherweight champion of the world' in 1935. Headstone.

Sighthill Cemetery NS 602671
John Baird and Andrew Hardie, political martyrs, hanged in Stirling, 1820. An ornate foursquare memorial paid for by subscription was erected in 1847 over their remains, brought here from Stirling.

Southern Necropolis NS 594634
Alexander Thomson, 1817-75. Known as 'Greek' Thomson, he was an architect who employed many classical styles in his works, which include

Moray Place (Edinburgh) and St Vincent Street United Presbyterian Church (Glasgow).

Hugh MacDonald, 1817-60. Poet, journalist and author, *Rambles Round Glasgow* being his most successful work.

Sir Thomas Lipton, 1850-1931. Born in Glasgow, Lipton established a large grocery chain of shops and bought tea and rubber plantations. Also tried for years to beat Americans at yacht-racing, building five different Shamrocks but never successful.

John Robertson, 1782-1868. Engineer, builder of the engines for the Comet, the first successful steamboat, which was launched in 1812.

Tollcross NS 641631
William Miller, 1810-72. Poet, noted for 'Wee Willie Winkie'.

INVERNESS-SHIRE

Eoligarry (Barra) – NF 705074
Sir Compton Mackenzie, 1883-1973. Born in England, Mackenzie served in the wars as an intelligence officer. Noted for his autobiography and novels, in particular *Whisky Galore,* set on Barra, where he lived for many years.

Fort Augustus (Kilchuimen) NH 378080
John Anderson, 1748-1832. Headstone erected 1833 to Anderson, a friend of Burns who was a carpenter and who is said to have made his coffin. He was the original of 'John Anderson, my Jo'.

Inverness – Chapelyard NH 665455
Mary MacDonald, 1818-98. Headstone with carved harp to 'the Skye poetess'.

Inverness – Old High Church NH 665453
Donald Cameron, died 1868. A well-known piper in his day.

Kilmuir NG 399719
Flora MacDonald, 1722-90. Born in South Uist, Flora distinguished herself by helping Prince Charles evade capture following the Battle of Culloden, in 1746. Imprisoned for a while, then emigrated to America but returned to Skye.

KINCARDINESHIRE

Arbuthnott NO 801747
James Leslie Mitchell, 1901-35. Better known as 'Lewis Grassic Gibbon', Mitchell wrote a number of books on a variety of subjects but is best known for his *A Scots Quair*, a trilogy of books with a setting in the north-east.

Dunnottar NO 863852
Covenanters' stone, erected by 'Old Mortality' to seven men and two women (some anonymous) who died while imprisoned in Dunnottar Castle during the years of struggle.

KINROSS-SHIRE

Portmoak NO 182020
Michael Bruce, 1746-67. Poet and hymn-writer born at Kinnesswood, known as 'the gentle poet of Loch Leven'. His works were still immature, but he showed promise of genius prior to his early death. Sarcophagus-style memorial.

KIRKCUDBRIGHT

Anwoth NX 583562
John Bell of Whyteside, Covenanter, shot with others on Kirkconnel Moor in 1685 by Grierson of Lag's dragoons. Sandstone tablestone.

Balmaclellan NX 652791
Robert Grierson, shot by Colonel Douglas at Ingliston Mains in 1685 for his Covenanting adherence.

Robert Paterson, 'Old Mortality', also commemorated on his family's headstone, is interred at Bankend of Caerlaverock, Dumfriesshire.

Balmaghie NX 723663
Samuel Rutherford Crockett, 1860-1914. Born in this parish. Minister at Penicuik until resignation in 1895 to concentrate on writing. Wrote many novels in 'Kailyard' school, notably *The Grey Man, The Raiders* and *The Men of the Moss Hags*.

Covenanters' graves. Stone to two David Hallidays, one shot on Kirkconnel Moor in 1685, the other in 1685 in Twynhohn parish with George Short, who has a separate headstone.

Carsphairn NX 563931
Roger Dun, killed by mistake in clan feud in 1689 on night of Carsphairn Fair. Also suffered for his Covenanting adherence. In kirkyard is MacAdam enclosure, with inscription to James and Gilbert MacAdam, Covenanters, and John Loudoun MacAdam, inventor of road-surfacing, who is interred at Moffat, Dumfriesshire.

Crossmichael NX 729670
William Graham, Covenanter, shot in village by Claverhouse's troops, 1682.

Girthon NX 605533
Robert Lennox of Irelandtown, shot on Kirkconnel Moor by Grierson of Lag's troops, 1685, for his Covenanting sympathies.

Kells NX 632783
Adam MacWhan, John and Roger Gordon, Covenanters. MacWhan was shot in 1685, John Gordon died in 1667 of wounds received at Rullion Green, and Roger Gordon suffered but died naturally in 1662.

Kelton NX 759602
Joseph Train, 1779-1852. Born at Sorn, Ayrshire, Train worked as an exciseman, wrote a number of poems and supplied historical data to Scott and Lockhart for their works.

Kirkandrews NX 601481
Robert MacWhae, Covenanter, shot in his own garden by Captain Douglas, 1685.
 William Nicholson, 1783-1849. Poet, born near Borgue of humble parentage. Spent his time as travelling pedlar and found success with some of his own poems, in particular 'The Brownie of Bladnoch' and 'The Country Lass'.

Kirkcudbright NX 690512
William Hunter, Robert Smith and John Hallume, Covenanters, commemorated by a tablestone (Hunter and Smith) and a small headstone. The first two were hanged in the town in 1684, Hallume in 1685, at the age of eighteen.

Kirkpatrick-Durham NX 786699
John Neilson, Covenanter, hanged in Edinburgh's Grassmarket in 1666.

Kirkpatrick-Irongray NX 915795
Helen Walker, died 1791. Original of Scott's 'Jeanie Deans' in *The Heart of Mid-Lothian*, she walked to London and back to petition for her sister's release from prison. Memorial erected 'by the Author of *Waverley*'.

New Abbey NX 965663
William Paterson, 1658-1719. Born near Tinwald, Paterson founded the Bank of England and originated the Darien Scheme. Grave unmarked but memorial affixed to kirkyard wall.

St John's Town of Dalry NX 619812
Robert Stewart and John Grierson, Covenanters, shot at Auchencloy by Claverhouse's dragoons, 1684. Tablestone.

Twynholm NX 664542
Hugh Prichard, died 1816. The original of 'Wandering Willie' of Scott's *Redgauntlet*, he died when sheltering in a gravel-pit during a storm along with his wife and children. Two upright memorial stones, one inscription partly in Welsh.

LANARKSHIRE

Cambusnethan NS 768540
Arthur Inglis, shot in 1679 for reading a Bible in fields and as the soldiers thought he was a Covenanter who had fought at Bothwell Bridge.

Carluke NS 846506
Robert Lockhart and Peter Kidd, Covenanters, Lockhart being found dead after Bothwell Bridge, Kidd minister of parish, imprisoned on Bass Rock, but returned.

Glassford NS 731470
William Gordon of Earlstoun killed 1679 for Covenanting adherence as he journeyed to Bothwell Bridge.

Hamilton NS 723556
Memorial in kirkyard wall to four Covenanters whose heads were displayed in the town following Rullion Green and execution in Edinburgh, 1666.

Kirk o' Shotts NS 842629
William Smith, Covenanter, shot in 1666 for his part at Rullion Green.

Lanark NS 888432
Robert MacQueen, Lord Braxfield, 1722-99. Noted law lord who presided at trials of radicals in 1793. Gained a reputation of being a 'hanging judge'.

 William Hervi, Covenanter, taken at Bothwell Bridge and executed in the town on 2 March 1682.

Leadhills NS 884153
Alexander Laidlaw, a young boy who failed to tell the soldiers the whereabouts of a Covenanter's hideout, resulting in his own death.

Lesmahagow NS 814399
David Steel, Thomas Weir and Alexander Stewart, Covenanters. Steel was shot at his home in 1686, Weir died of injuries sustained at Drumclog, and Stewart was executed in Glasgow, 1684. Also grave of the Reverend Thomas Lining, Covenanter, who survived until 1733.

Stonehouse NS 748470
James Thomson, Covenanter, shot at Battle of Drumclog in 1679.

Strathaven NS 705446
William Dingwall, John Barrie and William Paterson, Covenanters. Dingwall was shot at Drumclog, 1679, the other two at Strathaven in 1685.

MIDLOTHIAN

Inveresk NT 344721
Alexander Carlyle, 1722-1805. Known as 'Jupiter' Carlyle, he was parish minister and an associate of Scott. His record of his own times was published posthumously.

Lasswade NT 303661
William Drummond of Hawthornden, 1585-1649. Drummond wrote numerous poems and histories and entertained Ben Jonson at Hawthornden Castle. Buried within aisle of church.

 Henry Dundas, Viscount Melville, 1742-1811. Lord Advocate for Scotland, Home Secretary and First Lord of the Admiralty. Nicknamed 'the uncrowned king of Scotland' because of his political power but became unpopular during radical risings.

MORAY

Spynie NJ 229654
James Ramsay MacDonald, 1866-1938. Born in Lossiemouth, MacDonald became a Labour politician and held office as Prime Minister in 1924 and 1929-35.

PEEBLESSHIRE

Kirkton Manor NT 221380
David Ritchie, 1740-1811. The original of Scott's 'Black Dwarf' in his novel of that name. Ritchie was born deformed, standing only three feet six inches tall. His headstone was erected by Chambers, publishers, in 1845.

Tweedsmuir NT 101246
John Hunter, Covenanter, shot at the Devil's Beef Tub by Colonel Douglas's troops, 1685. Three memorial stones in kirkyard commemorate him.

PERTHSHIRE

Balquhidder NN 536209
Rob Roy MacGregor, 1671-1734. Farmer and cattle-dealer, noted for his exploits in levying blackmail. Subject of Scott's novel Rob Roy. Died at home and interred in Balquhidder kirkyard beneath an old cross-slab.

Blair Atholl (Old Blair) NN 867665
John Graham, Viscount Dundee, 1649-89. Known as 'Claverhouse', from his estate, Graham led Government troops against the Covenanters at Drumclog and Bothwell. Personally responsible for the murder of John Brown of Priesthill in front of his wife and family. Led clansmen at Killiecrankie; although they won, he was killed in the battle. Buried within Atholl aisle.

Dron NO 141159
John Welwood, 1649-79. Covenanting minister, Welwood died in Perth but was not allowed to be buried within the town. His friends dug his grave here instead.

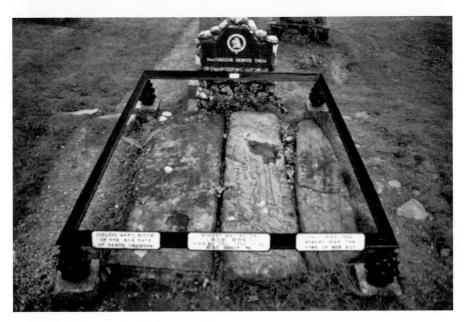

Rob Roy's grave, Balquhidder (Perthshire)

Dunkeld NO 024426

William Cleland, 1661-89. A Covenanting soldier, he led the Cameronians at Drumclog and fought at Bothwell. Successfully defended Dunkeld against Highlanders in 1689 after Killiecrankie but was killed in action. Also noted for his humorous poetry.

Ecclesmagirdle NO 108163

Thomas Small, 1587-1645. Covenanter who died for his beliefs.

Forgandenny NO 088183

Andrew Brodie, shot 1678 near Culteuchar Hill for his Covenanting sympathies. Headstone, the original of which is in church vestibule.

Gask NN 996188

Caroline Oliphant, Lady Nairne, 1766-1845. A songwriter and poet, Lady Nairne wrote many works, some under the pseudonym 'Mrs Bogan of Bogan'. Her works became famous only after her death; they include 'Wi' a Hundred Pipers', 'Will Ye no' Come Back Again', 'The Laird o' Cockpen' and 'Caller Herrin'. Buried within a private chapel.

Inchmahome NN 574005
Robert Cunninghame-Graham, 1852-1936. Born in London, 'Don Roberto', as he was known, was a Liberal MP and prolific writer.

Kincardine NS 719988
Henry Home, Lord Kames, 1696-1782. A Lord of Session and antiquarian, Lord Kames was also a notable land reformer, improving the Blair Drummond estates considerably.
 John Ramsay, 1736-1814. Owner of Ochtertyre estate, Ramsay was a friend and patron of Burns. Scott called at his home also.

Little Dunkeld NO 029422
Neil Gow, 1727-1807. Notable fiddler, born nearby. Composer of over a hundred strathspeys and reels, including 'Farewell to Whisky'. Worked for Duke of Atholl as his personal violinist. His four sons were accomplished fiddlers also. Met Burns and Bonnie Prince Charlie.

Meigle NO 287446
Sir Henry Campbell-Bannerman, 1836-1908. Liberal MP for Stirling, Secretary of the War Office, Secretary for Ireland, Prime Minister 1905-8.

RENFREWSHIRE

Eaglesham NS 574519
Gabriel Thomson and Robert Lockhart, Covenanting martyrs, shot on moors south of village in 1685 by dragoons under command of Ardencaple.

Greenock – Inverkip Street NS 275762
John Galt, 1779-1839. Born in Irvine, Galt began a literary career submitting stories to newspapers, finding success with tales of life in the west of Scotland. His *Annals of the Parish, The Ayrshire Legatees, The Provost* and *The Entail* brought him success. He emigrated to Canada but returned, dying in Greenock. His memorial is a graveslab.

Greenock – Cemetery NS 264763
Mary Campbell, 1763-86. Born in Dunoon, Mary Campbell worked in Gavin Hamilton's house in Mauchline, Ayrshire, where Burns met her. They parted on the banks of Ayr, she returning to Greenock, where she died. She was interred in the old West Churchyard, but on its removal her remains were transferred to the new cemetery. A tall memorial with carvings and an old headstone from the old kirkyard mark the spot.

Nearby is a memorial cairn to James Watt, who is interred at Handsworth.

Inverkip NS 211722
James Young, 1811-83. Gothic Revival memorial to Young, who discovered that the distillation of coal resulted in paraffin oil and wax, hence his nickname, 'Paraffin' Young.

Paisley – Broomlands Cemetery NS 471639
Andrew Park, 1807-63. Born in Renfrew, Park wrote many poems from an early age and accounts of his journeys. His most popular work was 'Silent Love'.

James Algie and John Park, Covenanting martyrs, executed at Paisley Cross, 1685, originally interred in the abbey kirkyard. Their memorials (an obelisk and old tombstone) were replaced behind the Martyrs' Church during town-centre redevelopment.

Paisley – Castlehead NS 476635
Robert Tannahill, 1774-1810. Born in the town, Tannahill wrote many poems and songs in the Scots tongue, the first edition of which sold out immediately. In 1810, however, the publishers returned his works, resulting in his burning all his recent verses and committing suicide. Noted for 'The Braes o' Balquhidder', 'Jessie the Flower o' Dunblane' and 'Loudon's Bonnie Woods and Braes'. Granite memorial of 1868.

Kirkyard originally known as the Western Relief Churchyard.

ROSS & CROMARTY

Contin NH 456558
William Laidlaw, 1780-1845. Factor to Sir Walter Scott at Abbotsford, and his amanuensis for a time, on Scott's death Laidlaw moved to Ross, where he also worked as a factor. Also noted for his song 'Lucy's Flittin''. Headstone with marble insert.

Dingwall NH 549583
Neil Gunn, 1891-1974. Born in Caithness, Gunn worked for the Civil Service until he was a successful novelist, his well-known works including *The Silver Darlings*, *The Grey Coast* and *Sun Circle*.

ROXBURGHSHIRE

Roxburgh NT 700307
Andrew Gemmels, 1687-1793. The 'Edie Ochiltree' of Scott's novel *The Antiquary*, Gemmels was a soldier during the first half of his life and a wandering beggar the latter half. Met Scott in person, and died at the age of 106. Headstone erected 1845 depicting Gemmels, knapsack and dog on verso.

Teviothead NT 403052
Henry Scott Riddell, 1798-1870. Born at Ewes, near Langholm, Minister of Teviothead, noted for his songs and poems, in particular 'Oor Ain Folk' and 'Scotland Yet'. Obelisk by kirkyard dike.

John Armstrong of Gilnockie, died 1530. Mural memorial in kirkyard wall with Armstrong arms, erected 1897 to 'Johnnie Armstrong' (subject of a well-known ballad), a Border laird executed here during James V's expedition to pacify the Borders.

SELKIRKSHIRE

Ettrick NT 259145
James Hogg, 1770-1835. Known as 'the Ettrick Shepherd', Hogg is noted for his poems and novels. A sheep-farmer, his *Hogg on Sheep* is still a standard reference book. A friend of Scott, his notable poems include 'The Queen's Wake' and 'Forest Minstrel', and his prose works, for which he is better known now, *The Brownie of Bodsbeck* and *The Private Memoirs and Confessions of a Justified Sinner*. On his headstone is carved a harp.

Thomas Boston, 1676-1732. Born at Duns, Boston was successively minister at Simprim, Ettrick and Closeburn. Wrote ecclesiastical works, paving way for the Secession Church, followers of which were known as Bostonites.

STIRLINGSHIRE

Cambuskenneth NS 809939
James III, 1452-88. Born at St Andrews, James was crowned aged nine. The country was ruled by regents until he had them imprisoned, including his two brothers, Mar and Albany, Died after Battle of Sauchieburn. Monument erected 1865 after the remains of the monarch were discovered by command of Queen Victoria.

Campsie NS 610797
William Boick, Covenanter, executed in Glasgow, 1683.

Larbert NS 856822
James Bruce, 1730-94. Bruce journeyed to the source of the Blue Nile, the first ever to do so, in 1770, writing of his travels in five volumes, which English scientists dismissed as 'fiction'. He died by falling down the stairs at his home of Kinnaird and is buried beneath a cast-iron headstone.

Stirling – Holy Rude churchyard NS 791938
John Russell, 1740-1817. Born in Morayshire, Russell began as a schoolteacher, then became minister in Kilmarnock and Stirling. He wrote a number of religious pamphlets but is remembered mainly as 'Rumble John' or 'Black Russell' in Burns' works.

 A number of memorials erected in honour of Covenanting martyrs and religious leaders can be seen, although none is buried here. These include Andrew Melville, Alexander Henderson, James Renwick, James Guthrie, Ebenezer Erskine, John Knox and the Wigtown Martyrs, the latter a very fine glass temple with statuary.

Stirling – Erskine churchyard NS 793936
Ebenezer Erskine, 1680-1754. Monument over grave of Erskine which was located in former kirk which occupied this site. One of the founder members of the Secession Church.

WEST LOTHIAN

Bathgate NS 993681
James Davie, Covenanter, shot at Blackdub by Heron while attending a conventicle, 1673. Slab seven feet by three.

WIGTOWNSHIRE

Wigtown NX 436555
Margaret MacLachlan and Margaret Wilson, Covenanters, drowned in the Solway when tied to a stake and left as the tide came in, 1685. Also George Walker, William Johnstone and John Milroy, hanged in Wigtown for their Covenanting adherence, 1685. Tombstones all located within same enclosure to north of old kirk ruins.

BIBLIOGRAPHY

Bailey, Brian, *Churchyards of England and Wales* (Robert Hale, 1987)

Boyle, Anne, *et al.*, *Ruins and Remains – Edinburgh's Neglected Heritage* (Scotland's Cultural Heritage, 1985)

Brown, Hamish, *A Scottish Graveyard Miscellany* (Birlinn, 2008)

Brown, Raymond Lamont, *Scottish Epitaphs* (Thornhill Press, 1977)

Gordon, Anne, *Death is for the Living* (Paul Harris, 1984)

Graham-Campbell, David, *Scotland's Story in Her Monuments* (Robert Hale, 1982)

Greenoak, Francesca, *God's Acre* (Orbis, 1985)

Horne, A. Sinclair, and Hardie, J. Bruce, *In the Steps of the Covenanters* (Scottish Reformation Society, 1974)

Jackson, Anthony, *The Symbol Stones of Scotland* (Orkney Press, 1984)

Jervise, A., *Epitaphs and Inscriptions from Burial Grounds and Old Buildings in North-East Scotland* (David Douglas, 1875-8)

Lamb, A. C., *Guide to Remarkable Monuments in the Howff* (Dundee, 1892)

Lindley, Kenneth A. *Of Graves and Epitaphs* (Hutchinson, 1965) *Graves and Graveyards* (Routledge & Kegan Paul, 1972)

Lindsay, Ian G., *The Scottish Parish Kirk* (St Andrew Press, 1960)

MacGibbon, David, and Ross, Thomas, *The Ecclesiastical Architecture of Scotland* (Edinburgh, 1896-7)

Proceedings of the Society of Antiquaries of Scotland – various volumes, in particular:
Vol. 36, 1901: 'The Carvings and Inscriptions on the Kirkyard Monuments of the Scottish Lowlands', D. Christison

Vol. 46, 1911: 'An Account of Watch Houses, Mortsafes and Public Vaults in Aberdeenshire Churchyards', James Ritchie

Vol. 91, 1957: 'Headstones in Post-Reformation Scotland', Angus Graham

Vol. 99, 1966: 'Kirkyards in the Laich of Moray', John di Folco

Vol. 105, 1972: 'Hogback Monuments of Scotland', J. T. Lang

Rogers, Charles, *Scottish Monuments and Tombstones* (Grampian Club – Charles Griffen & Co., 1871-2)

Simpson, W. Douglas, *The Ancient Stones of Scotland* (Robert Hale, 1965)

Stapleton, Henry, and Burman, Peter, *The Churchyards Handbook* (CIO Publishing, 1976)

Thomson, John Henderson, *The Martyr Graves of Scotland* (Oliphant, Anderson & Ferrier, 1895)

Todd, Adam Brown, *Covenanting Pilgrimages and Studies* (Oliphant, Anderson & Ferrier, 1911)

Willsher, Betty, and Hunter, Doreen, *Stones – 18th Century Scottish Gravestones* (Canongate, 1978)

Willsher, Betty, *Understanding Scottish Graveyards* (W. & R. Chambers, 1985)

How to Record Scottish Graveyards (Council for British Archaeology Scotland, 1985)

There are also numerous books about particular kirks and kirkyards, often written in Victorian times but which still prove useful for those who wish to study a particular area. Many of these were written to commemorate the centenary or another such anniversary of the church in question.

GLOSSARY

Black Letter – A form of lettering used on inscriptions after 1500 which would be termed 'Old English' today, although it was a rather elongated version of the 'Old English' type used today.

Cille – A cell or place of solitary worship in which the ancient saints would meditate and study Christ's works. Later used in Gaelic to describe churches and even churchyards, from their being commonly erected on the same site.

Cist –The chamber within a chambered cairn wherein the corpse was lain. Used to describe chambered cairns which have been robbed of their covering. From Gaelic *ciste*, hence Scots form *kist*, meaning coffin or chest.

Claymore – A single-handed longsword used by the Highlanders. From Gaelic *claidheamh mór*, meaning great sword. Often incised on medieval grave slabs.

Coronach – A dirge sung, or played by piper, *en route* to kirkyard burial.

Covenanter – A person who signed, or followed the beliefs of, the 'National Covenant', 1638, and 'Solemn League and Covenant', 1643/6, documents which disputed Charles I's claim to have superiority over the Church. Many were killed for their beliefs.

Cross Slab – A flat slab of rock on which has been incised a cross. Various versions were popular through the centuries, such as Calvary cross slabs and floral cross slabs.

Culdee – A monk who was a member of the Celtic Church in Scotland from the eighth century onwards.

Cyma Recta – A shape of moulding with two curves which is hollow on the upper half.

cyma recta

Cyma Reversa – Opposite of *cyma recta*.

cyma reversa

Dirk – Knife or dagger used by Scotsmen.

Effigy – A carved figure, usually life-sized, included in many tombs of peers and royalty. Virtually a statue depicting the corpse of the deceased person.

Girth – An area of sanctuary from the law, centring on a church or monastery.

Heritor – A landowner within a parish, liable to such public burdens as the upkeep of the kirk.

Jougs – An iron neck-ring, common in Scotland as the equivalent of the pillory. From the Old French *joug* for yoke.

Kirk – Scots form of 'church', perhaps from Old Norse or Old English versions of church.

Kirkyard – Churchyard.

Lair number – Scottish equivalent of plot number. Lair – the ground for one grave in a kirkyard or cemetery.

Ley-lines – Imaginary lines joining antiquities together, believed to indicate prehistoric highways. First discovered by Alfred Watkins.

Lombardic capitals – A style of writing used prior to 1500 on inscriptions which looked similar to the 'American Uncial' style used today on many tourist items to represent 'Celtic' or 'Gaelic'.

Manse – A clergyman's house, often overlooking a kirkyard.

Mausoleum – Building used by lairds and others erected over a crypt in which coffins were laid. These can be free standing or attached to churches.

Menhir – An ancient monumental standing stone.

Mortcloth – Shroud used to cover the coffin, at one time hired out by the kirk authorities to raise money to bury the poor.

Morthouse – Strong building in which corpses were laid until such time as they had sufficiently decayed as to be of no use to the surgeons who wanted them for dissection.

Mortsafe – Iron construction like a cage which was placed over the coffin to prevent its being burst open by body-snatchers. Also *Mortslab,* a stone version.

Necropolis – Cemetery, from the Greek *'nekros'* meaning 'dead body'.

Obelisk – A tall, four-sided, tapering stone topped with a small pyramid; commonly used as a memorial stone.

Resurrectionist – A body-snatcher, who dug up newly laid corpses and sold them to surgeons. Also known as 'Sack 'em up boys'.

Sarcophagus – Stone chamber or coffin, originally hewn out of a single block of rock, buried in the ground and covered with a grave slab. Later versions were built up with slabs of stone to create a coffin shape which was ornately carved and kept above ground.

Scotia – Shape of moulding.

scotia

Teind barn – Scots equivalent of 'tithe barn', wherein was stored the tenth part of each parishioner's income in crops, hence *teind*.

Torus – Shape of moulding, also called a round.

torus

Wappenschaw – Literally 'weapon show', a display of arms often held in kirkyards, followed by target practice.

Wheel Cross – A Latin cross with a circular ring surrounding the crossing point. Early Celtic examples began with a solid disc, but later a separate ring was made.

INDEX